RAVILIOUS

RAVILIOUS

JAMES RUSSELL

DULWICH
PICTURE
GALLERY

This exhibition has been generously supported by
The Elizabeth Cayzer Charitable Trust

Published on the occasion of the exhibition *Ravilious* at Dulwich Picture Gallery,
1 April–31 August 2015.

First published in 2015
by Philip Wilson Publishers
an imprint of I.B.Tauris & Co Ltd
Reprinted three times in 2015
London · New York
www.ibtauris.com

ISBN 978 1 78130 032 9

A full CIP record for this book is available from the British Library
A full CIP record is available from the Library of Congress
Library of Congress Catalog Card Number: available

Designed and typeset in Perpetua by illuminati, Grosmont
Printed and bound in Italy by Trento

FRONT COVER Eric Ravilious, *The Westbury Horse*, 1939.
Private collection, courtesy of Towner, Eastbourne.

BACK COVER: Eric Ravilious, *Train Landscape*, 1940.
Aberdeen Art Gallery & Museums Collections.

This exhibition has been made possible for Dulwich Picture Gallery by
the provision of insurance through the Government Indemnity Scheme.
Dulwich Picture Gallery would like to thank HM Government for providing
Government Indemnity and the Department for Culture, Media and
Sport and Arts Council England for arranging the indemnity.

CONTENTS

FOREWORD

WHEN I arrived in London for my first junior curatorial job, in the 1980s, I laboured for a short while under the misconception that being paid a salary, after years of self-employment, meant that I could now afford to buy 'stuff'. Fortunately, before the reality of life in London hit, I acquired a few very small treasures that I still have, and still value. Amongst them were a dinner plate, a side plate, a reproduction alphabet mug and a mass-produced woodcut, all designed by Eric Ravilious. None was expensive, and the last two objects were not 'originals'; but I was deeply in the grip of a huge enthusiasm for Ravilious's work that has never faded. I still drink my morning coffee from that mug.

The magnificent exhibition at the Imperial War Museum in 2003 was a turning point for the appreciation of this artist. Since then, Ravilious's reputation has steadily grown, and while the pottery he designed for Wedgwood, and his other design work for bookplates and the like, is gorgeous and will always be collect-able, I think the appreciation for his watercolours in particular has intensified. Dulwich Picture Gallery's exhibition in 2010 devoted to his friend Paul Nash, with whose style Ravilious's own very distinctive touch has much in common, was a terrific success; the time is clearly ripe for another major show devoted to Ravilious, as the latest in a series of ground-breaking exhibitions on modern British art that started back in 2003 with an exhibition on John Piper in the thirties and has shone a light on many great artists since: Henry Moore, Graham Sutherland, Ben Nicholson, Winifred Nicholson and Nash, amongst many others.

One of our most successful shows of recent years was 2012's *A Crisis of Brilliance*, which looked at the effect of the First World War on a generation of young artists including Mark Gertler, Dora Carrington, Stanley Spencer, David Bomberg and C.R.W. Nevinson. Ravilious was a more direct victim of war: he

was on active service as a war artist in 1942 when he died, aged only 39, when a plane he was in was lost off Iceland. Before that tragedy he had produced some of the most poetically resonant images of the Second World War. Not for Ravilious the grim devastation of the battlefield – his images focus on the tangential activities of war, the incidentals: officers on a lonely beach preparing to defuse a mine, the strange beauty of the control room with its maps and wireless, the lonely grandeur of Scapa Flow, or – memorably – a gigantic and beautiful ship's propeller surreally marooned in transit in the countryside.

Before the war, Ravilious produced images of an England that now feels largely lost, although the downs, the chalk figures and the tangles of fishing apparatus on beaches can all still be seen. Yet the spare magic of his dry-brush technique conjures up a real feeling of loss, nostalgia for an England that the war was to change for ever. Perhaps most mysterious are the images which seem to focus on absence – the empty rooms with their old-fashioned wallpaper, as evocative as the empty rooms of the Danish artist of a previous generation, Vilhelm Hammershøi.

James Russell – enthusiast, scholar and champion of twentieth-century British painting and design, and author of books not only about Ravilious but also Edward Seago, Peggy Angus and Paul Nash – has proved the perfect curator for this exhibition, and I am profoundly grateful to him. He was notably assisted in his research by Ravilious's daughter, Anne Ullmann, whom I cannot thank enough; the same goes to others of the extended Ravilious family. Tim Mainstone from Mainstone Press was most helpful in obtaining content for the catalogue.

As always, we are deeply grateful to the great many lenders to this exhibition – the countless private owners and family members as well as directors and trustees of museums who have parted with important works from their collections to make this exhibition tour possible. That said, special mention should be made to The Fry Art Gallery, Imperial War Museums and to Towner, Eastbourne – not only have they been the biggest lenders to the exhibition, but they have also been most generous with their help with other loans.

At Dulwich, the approach to James Russell was achieved via the enthusiasm of our own Arturo and Holly Melosi Chief Curator, Dr Xavier Bray, another fan of the artist. The exhibition itself has been organized by Exhibitions Officer Sarah Creed, with our Head of Exhibitions, Clare Simpson. The show has, as always, been supported by the remarkable Friends of Dulwich Picture Gallery, and my thanks go to the committee for all that they do for us, giving freely of their own time. This beautiful catalogue has been sponsored by the Elizabeth Cayzer Charitable Trust – many thanks.

Ian Dejardin
Sackler Director, Dulwich Picture Gallery

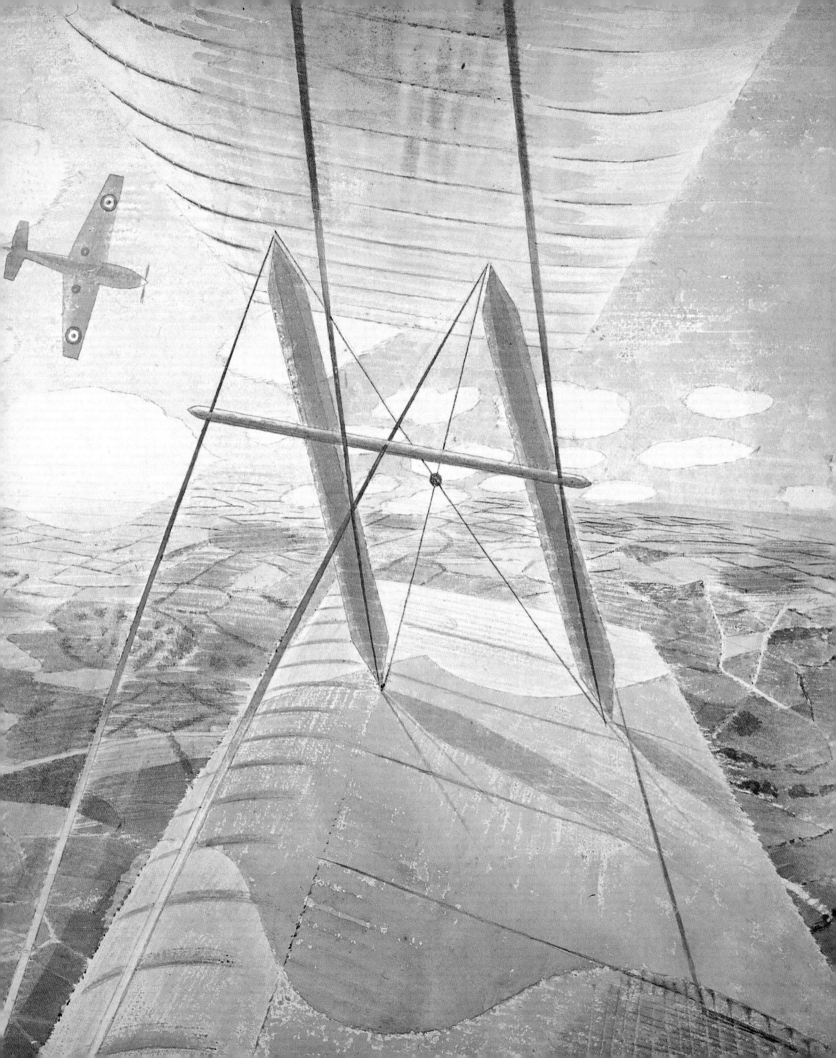

PREFACE

I N May 1939, with war looming, the prestigious London gallery of Arthur Tooth & Sons held an exhibition of watercolours by an artist known principally for his book illustrations, murals and designs for Wedgwood. In fact Eric Ravilious had already exhibited his drawings (as he preferred to describe them) at the Zwemmer Gallery in 1933 and 1936, and for those in the know the Tooth's show was eagerly anticipated. The critics turned up to view twenty-seven watercolours, with subjects ranging from bathing machines to bedrooms, and from Welsh chapels to Sussex lighthouses.

Eric Newton, the seasoned critic of *The Observer*, declared the quality of the watercolours 'almost untranslatable'.[1] For *The Sunday Times*, the equally experienced Jan Gordon noted that the artist made each subject, 'by a combination of unexpected selection, exactly apt colour, and an almost prestidigitous watercolour technique and textural variety, appear as something magic, almost mystic, distilled out of the ordinary everyday'.[2]

The war came soon after, and in September 1942 Ravilious was killed while on active service as an official war artist. He was not yet forty. Over the following decades his modest fame faded, so that by the late 1970s he was barely mentioned in a major survey of twentieth-century English art.[3] But his reputation was preserved by a small yet dedicated following, and since the impressive centenary exhibition held at the Imperial War Museum in 2003 it has rapidly grown, aided by the fact that so many of his paintings have survived, and in good condition too.

It seems almost miraculous that we were able to borrow two-thirds of the paintings exhibited at Tooth's for an exhibition at Dulwich Picture Gallery 76 years later. This is thanks principally to the unstinting labours of the artist's daughter Anne Ullmann, who, with the assistance of Alan Powers, Barry and

Saria Viney and others, has patiently tracked down numerous works. Anne has also published her father's correspondence and the autobiography of her mother Tirzah (née Garwood), and these sources, together with the memoir of Ravilious written by his lover and friend Helen Binyon, offer fascinating insights into his character and career.

So there has been ample chance to study these watercolours of lighthouses, abandoned buses and barbed wire fences, and there is no shortage of material to help us as we try to understand them. Yet the paintings remain elusive. Look, for example, at *A Farmhouse Bedroom* (p. 75), number 18 in the Tooth's catalogue. We know far more than Eric Newton or Jan Gordon about the circumstances of its production: that, for example, Ravilious was staying in Capel-y-ffin, Wales, with a family of English farmers, during a wet winter, and that he painted this bedroom shortly before it was redecorated. We know also that he shared with his great friend Edward Bawden a delight in strange and wonderful decorative objects and motifs, and that he dreamt vividly and recorded details of interesting sights with a poet's precision.

The painting appears, as do so many of Ravilious's best watercolours, to mean something. The room is presented to us in such a strange way – as geometrically distorted as a Van Gogh interior, and as visually intense as Vuillard in his pomp – that we can't help but wonder why it was painted like this. Is it saying something to us? At this point we would normally look for some statement of intent from the artist but, unlike his friend and former teacher Paul Nash, Ravilious chose not to explain his work. Despite living through an era of manifestoes and movements he made almost no public comment on any subject, and when asked by the BBC to bring some paintings from Tooth's up to Alexandra House for a television interview, he declined.[4]

Given this reticence it is difficult to understand the artist's intentions. Commentators have interpreted his work variously as light-hearted, sinister, quintessentially English, modern, emotionally distant and nostalgic. There may be some truth in any or all of these views, but it is hard to say with certainty what Ravilious thought (for example) about the Englishness of his work; he did not travel much before the war because the opportunity did not present itself, but he found painting in Wales, northern France and Norway extremely stimulating, and seriously contemplated trips to the United States, Greenland and Russia.

What we can do is look carefully at the work, the better to understand and appreciate it. One of the few public comments Ravilious did make about his watercolours was to acknowledge that he liked to work in series, so it makes sense to explore his oeuvre and his career thematically, rather than chronologically.[5] This allows us in particular to see pre-war and wartime watercolours

side by side, while giving us a chance to note recurring motifs and observe continuity and change in his work.

The second part of this book offers wide-ranging analysis of Ravilious's paintings, drawings and lithographs, grouped in sections that correspond to major themes in the artist's work. In-depth discussions of composition, influence and other technical matters are counterpointed by anecdotes and observations relating to Ravilious and his world, making this less an academic study than a journey of discovery through a remarkable life and career.

Drawing on correspondence and other sources, and making comparisons with predecessors and peers, we will make the case for Ravilious's inclusion in the first rank of twentieth-century British artists, as a watercolourist who found new ways to capture and preserve the fleeting record of passing time. We will begin, however, with a more general overview of the artist's life, character and ambitions. Who was this tantalizingly reticent artist?

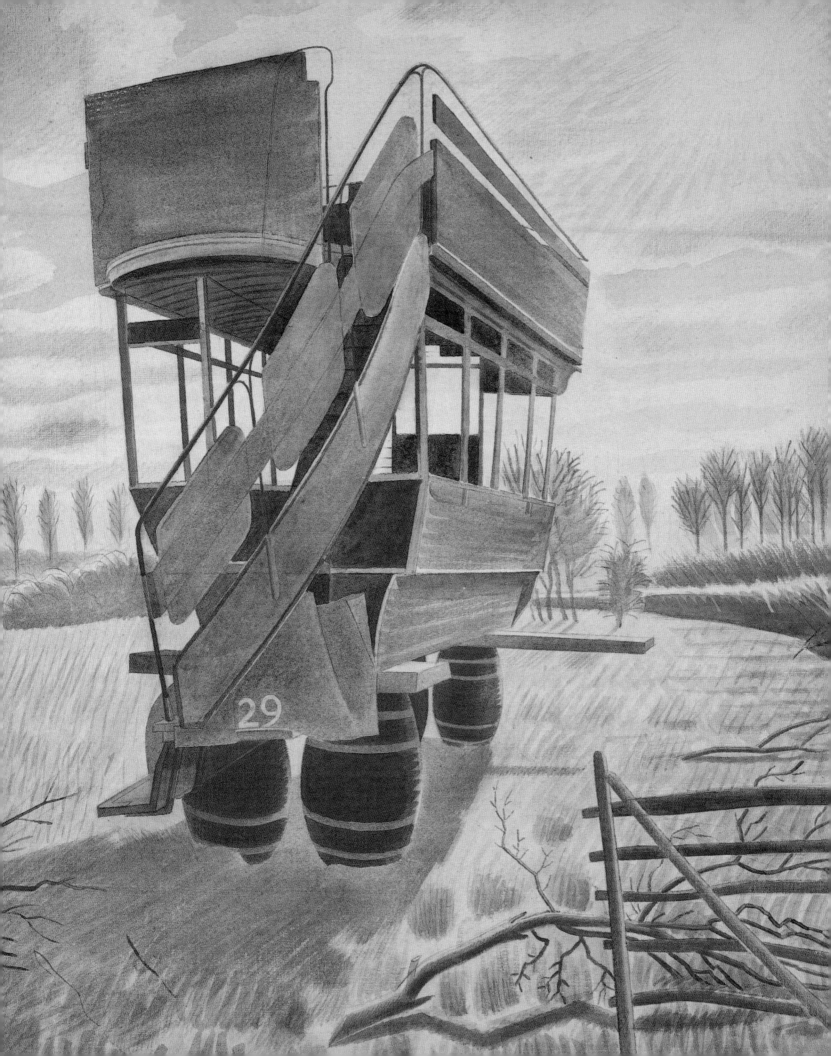

RAVILIOUS:
A PORTRAIT

Tweed-clad, fair-haired, hesitant in speech, his friendly diffidence masked
a character which enabled him to produce works of a forceful and dynamic
impact.[6]

S o Ravilious was described by artist and writer Richard Seddon, who
had been his student at the Royal College of Art in the 1930s. John
Rothenstein meanwhile noted that he was 'tall, slender, with eyes large
and dark, and an elegance of movement as well as looks. From time to time he
would smile as though at something distant.'[7]

Eric Ravilious was born in Acton on 22 July 1903, the third and by some
years the youngest surviving child of Emma Ford, who had been in service
in Tonbridge, and Frank Ravilious, who was himself the youngest of thirteen
children. While Eric's mother was a model of calm good sense, his father's
behaviour was erratic. He had started life apprenticed to his elder brother, a
coachbuilder, but abandoned this trade after a religious awakening and, having
tried and failed to emigrate to the United States, set up as a small businessman,
taking on one venture after another. A financial crisis precipitated a move to
Eastbourne, where Frank began selling and installing blinds. Native charm
and ability won him plenty of work but his lack of financial sense or interest in
money meant that the next crisis was never far away. Although he successfully
ran an antiques business for several years after the Great War, his one true
passion was religion, and Eric's childhood was dominated by constant chapel-
going and by his father's insistence on preaching to all and sundry.

Edward Bawden maintained that endless Sunday sermons left Eric with a
fear of boredom that became one of the dominant forces of his life. Otherwise
his childhood in the leafy suburb of Hampden Park was uneventful. At the
grammar school he was hardworking when motivated, indolent when not,

and a keen tennis player. The idea of becoming an artist occurred neither to his family – his mother hoped to see him employed by some safe institution like the Post Office – nor to him. However, he drew beautifully from a young age, and this superior draughtsmanship won him scholarships to the Eastbourne School of Art – where he was delighted to study alongside girls for the first time – and then to the Royal College of Art, enrolling in 1922 to study book illustration and mural painting in the Design School.

There he continued to enjoy life, rarely missing a dance and playing every sport on offer. He was known never as Eric but always as Rav or 'the Boy', the latter for his youthful spirit and refusal to take life too seriously. Fellow student Enid Marx later described him as 'the country boy who loved bird nesting and games', and recalled him dressing up in medieval garb complete with parti-coloured tights for a Christmas play.[8]

Marx was one of a distinguished cadre of artists and designers recruited to the Royal College in the early 1920s by new principal William Rothenstein (John's father). Membership of this group had a dramatic and lasting effect on Ravilious's life. Edward Bawden, Douglas Percy Bliss, Helen Binyon, Peggy Angus, Barnett Freedman, Cecilia Dunbar-Kilburn and rising superstar Henry Moore were to become lifelong friends, whose achievements and opinions influenced his own. Eric always valued Bawden's criticism highly; years later, Tirzah commented, 'So long as Eric felt that the people he admired like Paul Nash and Henry Moore and John Piper approved, it didn't matter what other critics said.'[9]

Ravilious worked hard in spite of his busy social life, completed his diploma in two years and won another scholarship, enabling him to visit Italy for the first (and only) time. He returned for a final year at the Royal College to find that Paul Nash had been appointed as part-time tutor to the Design School.

An impressively stylish figure with oiled hair and a twinkling gaze, Nash was some fifteen years his senior and both inspiring and well connected. As a fine artist who was also a practising commercial designer he encouraged his students to ignore the traditional – and deeply ingrained – distinction between the two disciplines, and he helped those with the requisite skill to find work. It was through Nash that Ravilious was elected to the newly formed Society of Wood Engravers, which brought him to the attention of publisher Robert Gibbings and other future clients.

'DOT AND SPECK AND DASH AND DAB': WOOD ENGRAVING

As a wood engraver, Ravilious showed a precocious talent, and he was only twenty-three when he illustrated his first book.[10] From then on he was increasingly in demand among publishers and commercial clients, but only rarely and

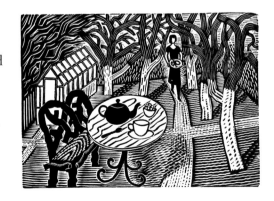

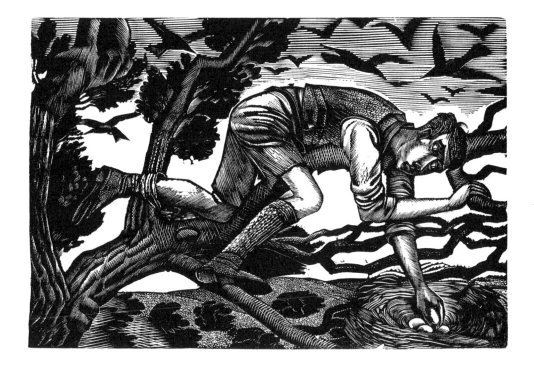

at the beginning of his career did he produce wood engravings that were not commissioned. One striking example is 'Boy Birdnesting'. Printed in 1927, it recalls Marx's description of the artist, but while there is more than a hint of the self-portrait about this engraving, it is the style and intensity of the piece which is really exciting.

Like his illustrious predecessor Thomas Bewick and contemporaries John and Paul Nash, Ravilious was a white line engraver, but his use of pattern was unusual. In his 1928 *History of Wood Engraving*, Bliss observed that his friend's work was 'very personal and felicitous',[11] adding that the artist liked to make his own gouging tools, 'scorpers' as they were known, from odd bits of metal, so that 'soon he was obtaining on boxwood these qualities of dot and speck and dash and dab in white-line with which he enriches his blocks. He will spend hours,' Bliss continued, 'covering a passage with tiny dots or flecks to get an even grey effect, such as the ground beneath the figure of his Boy Birdnesting'.[12]

Look at the wood engravings of contemporaries like the Nash brothers or Gwen Raverat and you will notice the difference straight away. The world of Ravilious's engravings is built of pattern and texture, which Bliss thought had its roots in fifteenth-century metal cuts made using a technique known as *manière criblée*; a similar stippling and patterning is found in William Blake's engraved 'Illustrations of the Book of Job' (1825–6).

For the student of Ravilious watercolours the fascinating thing here is that, after abandoning wood engraving as his principal form of self-expression, he gradually introduced pattern-making techniques into his paintings, so that

1 OPPOSITE Eric Ravilious, *Two Swans, The Shepherd, Hedge Trimming, Afternoon Tea*, wood engraved prints, Green Line Coaches, London Transport, 1936.

2 ABOVE Eric Ravilious, *Boy Birdnesting*, wood engraved print, 1927.

his mature work is full of 'dot and speck and dash and dab'. This took many years, however, and until the mid-1930s he was known principally for his wood engravings. Some, like 'The Hansom Cab and the Pigeons', show the variety of different textures and tones he was capable of achieving, and it is interesting to compare the rather less sophisticated watercolours of similar subjects he was painting around the same time. Others show a side of Ravilious that tends to be neglected: his sense of humour.

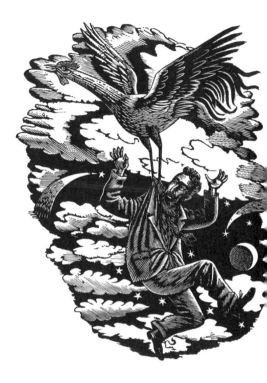

LOVE AND LAUGHTER

Ravilious's Royal College friend Cecilia Dunbar-Kilburn recalled after World War II (by which time she was Lady Sempil), 'I think of him as "the Boy" as he was often called, floating through life with a boyish gaiety and enthusiasm and the nicest sense of humour of anyone I have known. I never heard him offend in any way, nor was his humour at the unkindly expense of others.'[13]

This humour shines through in his irreverent treatment of Robert Gibbings in the wood engraving 'Ganymede'. Indeed, a love of laughter was one of his defining characteristics, underpinning a sometimes difficult friendship with Edward Bawden and manifesting itself in his favourite books and films. Yes, he read Aldous Huxley and other heavyweights of the age, but if asked to choose three writers for a desert island he would probably have picked Gilbert White (of Selborne fame), P.G. Wodehouse and Mark Twain, all of whom offer the reader style, wit and adventure on a domestic scale. *Huckleberry Finn* remained a lifelong favourite. As a keen cinema-goer, meanwhile, he was a fan of both actress Ginger Rogers and director Alfred Hitchcock – and he never missed a Marx Brothers movie.

A sense of fun was also much evident in the murals at Morley College, just across the river from Westminster, which he and Bawden were commissioned to paint following the warm reception given to Rex Whistler's murals in the dining room of the Tate Gallery. These were also unusual, compared to his later work, in the inclusion of numerous figures. Ravilious is renowned for leaving people out of his compositions, but the Morley College murals featured both theatrical characters and stylized representations of real people. Among these was a young woman observed walking up the stairs of a boarding house, which Ravilious presented with the interior open to view, like a doll's house.

This was Tirzah Garwood, the first of three women who were to play a significant role in Ravilious's adult life and in his career. They had met at East-bourne Art School, whither he had returned as a teacher after graduating from the Royal College in 1925. As her teacher he first found her to be an artist of great promise, as precociously talented in wood engraving as him. Bright, fun-loving and pretty, Tirzah came from a respectable, middle-class church-going

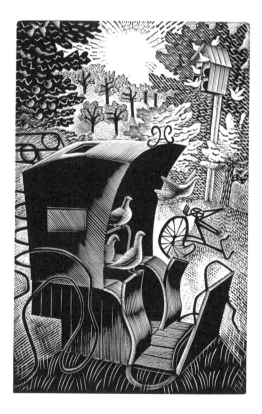

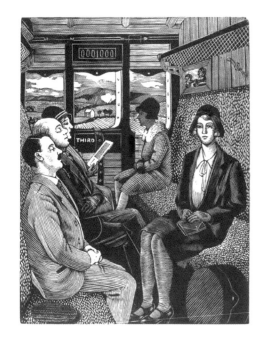

family, who considered her artistic pursuits a brief distraction from her true vocation as wife and mother. She, however, saw that art offered a way out of her parents' world, and as her friendship with Ravilious developed she left Eastbourne and moved to London to become a commercial wood engraver.

By the late twenties Tirzah was winning commissions from the BBC and other significant clients, and at the same time appeared repeatedly in Eric's work, both in the Morley College murals and in the wood engravings he produced for the Lanston Monotype *Almanack* of 1929. Their marriage the following year, just months after the successful opening of the Morley College murals, celebrated a union that transcended social and religious boundaries; they shared talent, taste and a powerful belief in personal freedom.

Neither was sentimental, both were honest, and these shared traits enabled their marriage to survive considerable stress over the following years. The extent of Tirzah's influence on Eric's work is impossible to measure. We know that they worked side by side on a set of murals at the Midland Hotel, Morecambe, in 1933, but of her impact on his watercolours we have only one or two rather startling examples. There is no reason, for instance, to doubt her claim that, in 1939, she cut and pasted together two versions of Eric's watercolour *Train Landscape*, to create the painting we know today.[14]

After their marriage the couple lived in London, first in Kensington and then beside the river in Hammersmith, and threw themselves into the social whirl of exhibition previews and parties. Ravilious loved any kind of occasion, from Bonfire Night to Royal festivities, and the highlight of the Thames year was inevitably Boat Race weekend. But although London was lively and exciting, the capital did not inspire him greatly in an artistic sense. By 1930 it was clear that wood engraving and mural painting were not enough; Ravilious needed to find somewhere to paint watercolours, and London was not that place.

WHY WATERCOLOUR?

It is tempting to see Ravilious's decision to become a watercolourist as eccentric – anachronistic – but 1920s London was in thrall to the medium. Since the end of the war, art lovers had flocked to exhibitions of watercolours by J.M.W. Turner, John Robert Cozens and John Sell Cotman, whose first major retrospective was held at the Tate in 1922. 'There is no English landscape painter,' announced *The Times*, 'so interesting to the modern artist.'[15]

Ravilious and Bawden had both tried their hand at watercolour before this; being talented draughtsmen it made sense for them to tint their drawings. But while they were studying at the Royal College the medium became increasingly fashionable; Charles Ginner took the opportunity offered by this shift in taste and in 1924 held an exhibition of watercolours at the Goupil Gallery. Given

3 OPPOSITE TOP Eric Ravilious, *Ganymede*, 1931, wood engraved print, Golden Cockerel Press.

4 OPPOSITE BOTTOM *The Hansom Cab and the Pigeons*, 1935, wood engraved print, Golden Cockerel Press.

5 ABOVE Tirzah Garwood, *The Train Journey*, 1929–1930, wood engraving.

his penchant for unpeopled streets, rooftop vistas and interiors with window views, it is not hard to see why Ravilious admired his work, but that year the watercolourist on everyone's list was Paul Nash.

Fresh from a recuperative and inspiring sojourn in Dymchurch, Kent, Nash put on a dazzling exhibition of watercolours at the Leicester Galleries. Combining tight, geometric composition with delicate brushwork these paintings offered a new vision of modernity that was structurally solid but light – like that symbol of twentieth-century progress, the aeroplane. It is perhaps no accident that Nash was obsessed with flight throughout his life, a passion Ravilious was to share in his last years.

As if that wasn't enough, 1926 saw the first major exhibition of an artist who had been almost entirely neglected since his death decades before, and whose impact on twentieth-century British art was immense – Samuel Palmer. For years every exciting painter, and every great innovation in painting, had come from Europe, and Van Gogh in particular was revered. His achievements seemed unique, unsurpassable, and yet here was an obscure English artist who had created landscapes as magical as his, some forty or fifty years earlier.

Palmer did paint in watercolour, but it wasn't his choice of medium so much as the way he used it that appealed to artists of the 1920s. After the exhibition Ravilious travelled to Shoreham – the scene of Palmer's most inventive period – ostensibly on a visit of homage to the great man. But his trip would also have confirmed that Palmer did not find his wonderful rural paintings readymade in

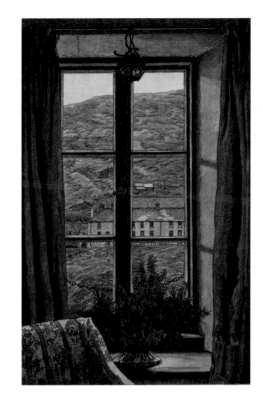

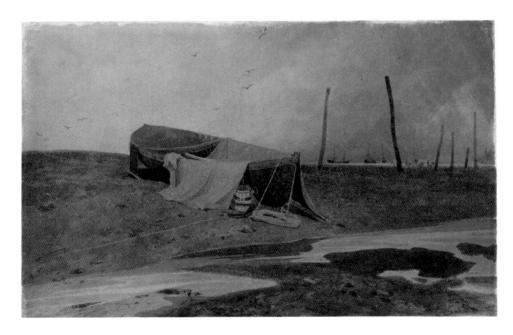

6 ABOVE Charles Ginner, *Through a Cornish Window*, *c.* early twentieth century, watercolour, Victoria & Albert Museum.

7 LEFT John Sell Cotman, *Boat on the Beach*, 1800–1842, watercolour, Victoria & Albert Museum.

Kent; what he found was the inspiration to invent them. His pictures are artfully composed, staged and stylized and unnaturally lit. They are not landscape paintings but paintings which put landscape to dramatic use, and they showed a way forward for an artist determined to find a new pictorial language.

In terms of watercolour technique, however, it was from the triumvirate of Cozens, Towne and Cotman that Ravilious learned most. While Cotman demonstrated that a painting could combine taut design with natural feeling, and Towne showed how watercolour could be handled with mesmerizing lightness, John Robert Cozens tore up the rule book of landscape composition, adopting unusual perspectives and introducing fantastic forms (wild trees or vast cliffs) that were subjugated to strict design.

Ravilious did not need to wait for exhibitions to study the work of these artists, because there were (and are) substantial holdings at the Victoria and Albert Museum – which at the time could be accessed via a private door from the Royal College next door – and in the Prints and Drawings Department of the British Museum, the Keeper of which was Laurence Binyon, Helen's father. Known today as a Great War poet, Binyon had an incalculable effect on twentieth-century British art, being the champion not only of Cotman and Towne (with the help of collector A.P. Oppé), but also of William Blake and his followers, particularly Palmer. Binyon also introduced a wide range of Asian (especially Persian and Chinese) art to Britain, and even travelled to Japan to lecture on British landscape painting.

8 ABOVE Samuel Palmer, *Landscape, Girl Standing*, c. 1826, ink and gouache on card, Tate.

9 RIGHT Francis Towne, *Part of Ambleside at the Head of Lake Windermere*, 1786, watercolour, Victoria & Albert Museum.

AN ARTISTIC FRIENDSHIP

So Ravilious had plenty to work with, and although he was less precocious in watercolour than in wood engraving he chose his path early. According to Helen Binyon, one of Ravilious's students at Eastbourne remembered him saying that 'his greatest ambition was to revive the English tradition of watercolour painting'.[16] The revival was already well under way, but this statement of intent shows that the boy who had drifted into art school was, by his mid-twenties, aware of what he might achieve. As a student he had been invited by artist and teacher Leon Underwood to evening classes at his home – an invitation also extended to Henry Moore and Barbara Hepworth but to few others – and in 1927 he showed alongside Paul and John Nash at the Modern English Watercolour Society. Few of his paintings from that time are presently known, but in *Firle Beacon* there are strong hints of what was to come.

For the next couple of years Ravilious was fully occupied with the Morley College murals, painting directly onto the walls in oils mixed with wax and

10 Paul Nash, *Channel and Breakwater*, 1923, watercolour, pencil and crayon on paper, Harris Museum & Art Gallery.

thinned with turpentine, and at the same time he experimented more widely with oils and also with tempera. His portrait of Edward Bawden is a rare survivor from this experimental phase, which seems to have left Ravilious more determined than ever to pursue his vocation as a watercolourist.

In fact both he and Bawden were set on this course and, needing somewhere quiet to paint, they spent the early summer of 1930 touring north-west Essex by bicycle, eventually finding a surprisingly substantial weekend retreat at Brick House, Great Bardfield. For Bawden that was it. For a decade he only left the village when he had to, finding much of the inspiration he needed in his own back garden; his exhibitions of watercolours in 1933 and 1938 wowed critics and collectors equally.

Bawden also married potter Charlotte Epton, to the astonishment of friends who thought there was no woman on earth who could cope with his many foibles, and for two years Eric, Tirzah, Edward and Charlotte lived together at Brick House, before the Raviliouses moved a few miles away to Castle Hedingham. Great Bardfield and the surrounding area proved a good hunting ground for painting subjects, at least initially, and by 1933 both Bawden and Ravilious had accumulated enough paintings to each hold a solo exhibition.

It says something for their place in the art world and their aspirations that they chose to exhibit at the recently opened Zwemmer Gallery, an offshoot of the celebrated Charing Cross Road art bookshop. Throughout the interwar

period, bookseller and publisher Anton Zwemmer was the most important champion of European modern art in London, and his gallery hosted major exhibitions of Salvador Dalí, Picasso and De Chirico. The first exhibition of Henry Moore's drawings was held at the gallery in 1935, a year after Zwemmer published Herbert Read's groundbreaking book on the sculptor. Eric and Tirzah were not particularly taken with the young manager Robert Wellington, but the exhibition opened in November 1933 with thirty-six watercolours and one set of wood engravings on display.

The paintings varied widely in price and subject matter, with *November 5th* priced at 25 guineas, double the average. There were paintings from London, Essex and Wiltshire, some focusing on specific objects and others on wider views of urban or rural landscape. The simple, descriptive titles were in marked contrast to the obscure lines of poetry used by Bawden to identify the work in his show, and in the paintings too Ravilious was at this stage the more modest of the pair; with his edgy brushwork and distorted geometries it was Bawden who was most obviously a modern artist.

FURLONGS: A NEW VISION

In 1936, however, Ravilious's second show at Zwemmer showed a marked development. The earlier watercolours were essentially tinted drawings, but around 1934 his technique and artistic vision began to develop rapidly. His draughtsmanship retained its almost hallucinatory clarity but he gradually started to represent the natural world of land, sea and clouds in a new manner, simplifying shapes and introducing pattern as a way of defining the structure of landscape.

What brought about this revolution? Unusually, we have Ravilious's own explanation:

> Furlongs altered my whole outlook and way of painting, I think because the colour of the landscape was so lovely and the design so beautifully obvious … that I simply had to abandon my tinted drawings and high time too.[17]

He wrote this in 1939 to Peggy Angus, who had invited him some years earlier to stay at Furlongs, her isolated cottage at the foot of Beddingham Hill in the Sussex Downs. From the moment he arrived Ravilious was captivated both by the place itself and by the spirit of its presiding genius. A Scottish painter and art teacher with deeply entrenched left-wing views and an endless repertoire of folk songs, Peggy Angus had no truck with suffocating social niceties. Life at Furlongs involved a good day's work, scratch meals and long evenings of music and song. Water had to be hauled out of a well and amenities consisted of a primitive stove for cooking and an earth closet in the garden.

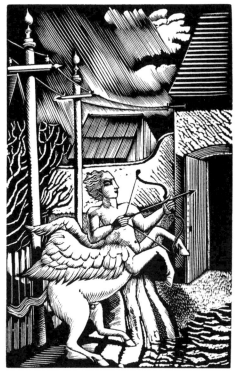

12 Eric Ravilious, illustrations from *The Almanack* published by Lanston Monotype Corporation, 1929: *Andromeda* (above), *Sagittarius* (below)

13 Paul Nash, *Event on the Downs*, 1934, oil on canvas, Government Art Collection.

Despite the cold and discomfort in winter, 'The great charm of Furlongs,' as Tirzah put it, 'was the wonderful feeling of freedom which we had there.'[18]

There are numerous artists, illustrators and designers alive today who readily admit that visiting Furlongs or meeting Peggy was a life-changing experience, because she was above all a great motivator. Ravilious was still teaching regularly at the Royal College, but in 1934 his every free moment was spent in Sussex, exploring new places and trying out new techniques away from critical eyes.

At different stages of his career Ravilious was galvanized into a new break-through by a change of scene, but he was also, often simultaneously, inspired by new love. Less than three years into their marriage Tirzah gloomily but in typi-cally matter-of-fact style recorded that Eric had fallen in love with Diana Low, a confident young graduate of the Slade who had painted, and been painted by, William Nicholson. One effect of the ensuing affair was, Tirzah noted, that he painted for a time in a much bolder, looser manner, as Diana did,[19] but the latter's marriage in 1934 brought the relationship to an end.

It was around this time that Ravilious began seeing more of Peggy's close friend, Helen Binyon. One of Laurence Binyon's three daughters, Helen had studied at the Royal College alongside Eric and Peggy, but moved in more elevated circles than her peers. While a student she was presented at Court,

and Peggy's favourite put-down was to tell her, 'Now Helen, don't be a lady.'[20] The two women made a rather odd pair, but Peggy was determined to rescue Helen from her privileged and overly sheltered upbringing; regular visits to the primitive world of Furlongs were mandatory, but nobody could have predicted the outcome.

By the end of 1934 she and Eric were lovers and Furlongs had become (unbeknown to other visitors) their amorous retreat. When separated they wrote sometimes daily letters back and forth, unwittingly leaving to posterity a vivid impression of their lives. Their relationship was evidently passionate, but something more lasting than sexual desire enabled them to be friends after the affair drifted to an end in 1938. Like Tirzah, Helen was clever and talented: a watercolourist, wood engraver and puppet-maker. It was she who had the idea of an alphabet of shops, which eventually developed into Ravilious's book *High Street*, and for a couple of years they worked excitedly on the project together. But Ravilious also discussed his painting with Helen a great deal, and particularly enjoyed visiting galleries with her. Perhaps, given her parentage and her upbringing, she helped him see his own work in a wider context, or in a more sophisticated light.

The upshot was that the exhibition of 1936 contained a mixture of tinted drawings (*Talbot-Daracq* or *No. 29 Bus*) and watercolours in the new style such as *Winter Landscape, Sussex* – known today as *Downs in Winter*. With its charged atmosphere and setting, this breakthrough painting merits comparison with Paul Nash's remarkable *Event on the Downs*, although (as we shall see) any attempt to find Surrealist intent in Ravilious's work is bound to end in frustration.

Like the previous exhibition, the show was a success, attracting an approving review from *The Observer* and no shortage of sales, but subsequently Ravilious left Zwemmer and instead arranged to exhibit work in May 1939 at the older gallery of Arthur Tooth & Sons. In 1936 and 1937, however, he barely lifted a brush, for reasons that were partly practical and partly – perhaps – a matter of inspiration. After the breakthroughs of 1934/5 it seems odd that he painted so little, and those paintings that he did produce (such as *Wiltshire Landscape*) have a melancholy quality.

ADVENTURES IN LITHOGRAPHY

Is it significant that Ravilious and Tirzah had their first child, John, in 1935, signalling an end to youthful freedom? Or that his affair with Helen began to cool the following year? Or did he simply need a change? Always restless and anxious for new experiences, he left off watercolour and threw himself into new design projects: ceramics for Wedgwood and everything from furniture to playing cards for Cecilia Dunbar-Kilburn's new shop, Dunbar Hay.

14 Front cover illustration by Helen Binyon for *The Railway Journey* by Helen and Margaret Binyon (OUP, 1949).

More significant from an artistic point of view was his introduction to lithography. For some years Barnett Freedman and others in his circle had been exploring that colourful and expressive printmaking technique, and in 1936 he was given the opportunity by Robert Wellington to produce work for a new company called Contemporary Lithographs. Established by Wellington and John Piper, the company aimed to sell lithos made by artists to schools and similar institutions, thereby giving children access to original contemporary art.

Ravilious travelled to the Curwen Press in Plaistow in September 1936 and there worked directly on the stone to create *Newhaven Harbour*, which he referred to as his 'homage to Seurat'.[21] He may have been half-joking when he made this comment, but he admired both Seurat and Derain, perhaps un-surprisingly given his career-long interest in 'dot and speck and dash and dab'. Like those early Nash watercolours, Seurat's paintings of the French coast combine powerful design with the lightest of touches.

The experience of making *Newhaven Harbour* gave Ravilious so much pleasure that he immediately ditched plans for *High Street* as a book of wood engravings, and over the next year worked tirelessly to create the twenty-four lithographs that were published in the finished book. Lithography is a fiddly business, but the layering of transparent inks and the almost endless opportunities for tinker-ing appealed greatly to an artist who enjoyed time-consuming and difficult

15 ABOVE Diana Low, *A Road Near the Sea*, 1978, oil on board, Rye Art Gallery. Quita Collard Bequest.

16 RIGHT Georges Seurat, *The Channel of Gravelines, Petit Fort Philippe*, 1890, oil on canvas, Indianapolis Museum of Art, Gift of James W. Fesler in memorial of Daniel W. and Elizabeth C. Marmon, 45.195.

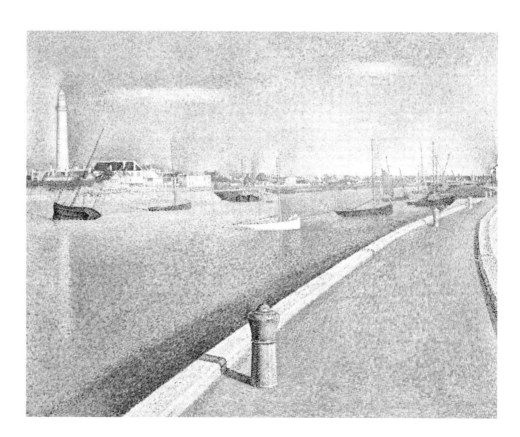

work. Considering how inexperienced a lithographer he was, *High Street* represents a stunning achievement.

The illustrations offer a different take on themes that interested Ravilious as a watercolourist. We see intriguing objects and spectacular lighting effects, various seasons and the full gamut of weather. The tone is light – 'hilarious' in the opinion of one reviewer[22] – but the inclusion of an undertaker suggests an awareness of mortality. A number of shops are shown by night, although this is in part because lithography is so ideal for nocturnal depictions, but whatever the time of day and whatever the season, whether interior or exterior, every image is richly patterned and coloured.

TRAVELS AND TRIUMPHS

High Street was eventually published in time for Christmas 1938, by which stage Ravilious was painting again, and making progress. Knowing that he had an exhibition to prepare for, and almost nothing ready, he had set off at the beginning of the year in search of new places and new inspiration. A prolonged winter stay in the Welsh village of Capel-y-ffin, though frustrating at times, proved ultimately rewarding. In paintings like *Waterwheel*, *Farmhouse Bedroom* and *Wet Afternoon* he showed a new boldness and freedom, and an ability to bring diverse techniques to bear on a range of subjects.

Further trips to the south and east coasts brought a series of beautiful paintings in which he explored exciting new developments, from the effects of light on water (*Rye Harbour*) to the contrast between exterior and interior scenes (*Room at the William the Conqueror*). He was probably inspired partly by his successful experiments with lithography, but once again the thrill of love may have given him a creative boost. That summer he got back in touch with Diana – now married to architect Clissold Tuely and living near Rye – and when she invited him to stay their affair was rekindled.

As a chronicler of her husband's achievements and failings, Tirzah was unsentimental to a fault, allowing herself only a few lines of regret for his first infidelity in her autobiography. Whatever the rights and wrongs of the situation, Ravilious hid nothing from his wife and was supportive when her own affair with the painter John Aldridge ended badly. He may have been childlike, irresponsible or, to quote John Nash's wife Christine, 'impish',[23] but he was no hypocrite. Neither was his interest in women only sexual. The three women he loved were all intelligent, talented artists, whose work he admired and whose influence on his own painting was significant – if difficult to quantify.

Tirzah wrote simply, 'this relationship with Diana was a good thing because it is always nice to have someone love you and be truthful in criticising your painting.'[24]

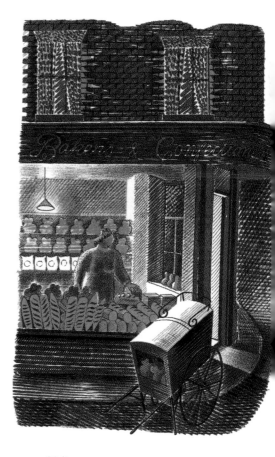

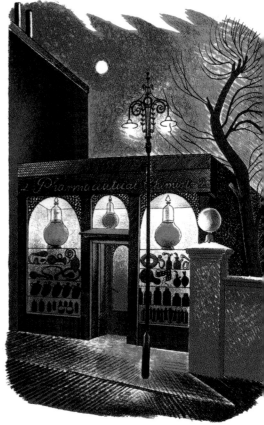

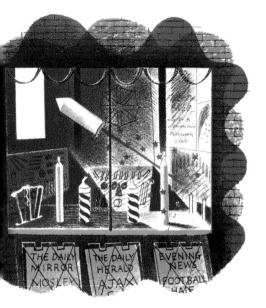

Not that Ravilious was only interested in the opinions of the women he loved. By the late 1930s he had become friendly with John Nash and John Piper, two artists who shared a fascination for place but were otherwise very different in outlook. Unlike his brother, Nash was content to paint in a recognizably modern but straightforward manner, and when he and Ravilious travelled to Bristol in the autumn of 1938 and painted side by side in the City Docks the results showed just how sophisticated an artist the latter had become. It would be fascinating, meanwhile, to know what effect Ravilious had on John Piper during the most tumultuous period in his career.

Having led the charge for abstract art in the mid-1930s, Piper returned to a more representational style later in the decade. Paul Nash had flirted with abstraction and rejected it as a dead end, and in 1937 Piper expressed a similar opinion in his essay 'Lost, A Valuable Object'. Not long before this he and his wife Myfanwy had met Ravilious through Peggy Angus and her husband J.M. (Jim) Richards, the author of *High Street*, and they became good friends, later visiting him in Capel-y-ffin – but whatever conversations they had then or previously about their art remain a mystery.

Compared to his previous exhibitions, Ravilious prepared for Tooth's with a new intensity and self-discipline, helped by his decision to give up teaching. By March 1939 he still had too few pictures, and with the opening date nearing took the advice of the experienced and successful painter Edward Wadsworth and visited Le Havre, where the threat of war was so real and immediate that he expected hostilities to begin before his exhibition could open. Instead the show went ahead as planned, the response from critics and high-powered friends like Piper so positive that it spurred him to further efforts.

There was no fallow period as there had been after his previous exhibition. Instead he returned to Furlongs for the last time in August 1939, while Tirzah awaited the birth of their second child, James, in Eastbourne. Peggy Angus was there, also expecting a baby, and there were other visits and visitors. One evening was spent at Bentley Wood with architect Serge Chermayeff, and another drinking claret with Diana Tuely in the garden at Furlongs.

In the resulting paintings, particularly *Tea at Furlongs* and *Interior at Furlongs*, Ravilious bent all the rules, distorting spaces, disobeying the laws of perspective and exploiting the dramatic possibilities of light to create visionary evocations of a particular time and place. Even the phlegmatic Tirzah described these paintings, along with *Train Landscape*, *The Wilmington Giant*, *The Cerne Abbas Giant* and *The Westbury Horse* as 'six stunners',[25] their production all the more surprising considering the upheavals and uncertainties that the outbreak of war brought in September.

17 Eric Ravilious, 'Baker and Confectioner', 'Pharmaceutical Chemist', 'Fireworks', 1938, lithographs from *High Street* by J.M. Richards.

As evacuees arrived in Castle Hedingham, work dried up. Allowing Wedgwood to terminate his contract for the duration, Ravilious accepted that he might not earn a penny as an artist for the foreseeable future. Like his father, he had never been interested in money, needing for himself only train fares and minor luxuries like beer and cigarettes, but he was so anxious to contribute in some way to the war effort that he first considered joining the Artist's Rifles – John Nash talked him out of that one – and then joined the Observer Corps and spent the autumn looking for enemy aircraft over the skies of Essex.

He contrived a few days off in December for a whirlwind tour of downland chalk figures, which resulted in at least two of the 'stunners', then came a 'kind of Christmas present from the Admiralty'.[26] News of Kenneth Clark's scheme for state-employed war artists had been circulating for some time, but Ravilious did not consider himself a likely choice, and when he was one of the first artists – along with the Nash brothers, Barnett Freedman and Edward Bawden – to be offered a six-month contract by the War Artists' Advisory Committee he was overjoyed.

The opportunity to work, to make a contribution, to explore – and, perhaps, to escape everyday life with two young children – he seized with gratitude, and over the next two and a half years he applied himself energetically and conscientiously to the task at hand. While Bawden went off to France with the British Expeditionary Force and subsequently enjoyed an adventurous life in the Middle East, Ravilious was appointed to serve with the Royal Navy and sent in succession to Chatham, Grimsby and Hull. Finally, in May 1940, came a more exciting opportunity to join a flotilla charged with recapturing and then evacuating the Norwegian port of Narvik. On returning home, he spent several weeks studying the interior of a submarine in Gosport, before travelling to Newhaven to paint the coastal defences.

During the winter of 1940/41 he worked with the printer J.S. Cowell of Ipswich on his second major series of lithographs, based predominantly on the submarine studies, then went beneath the streets of London to draw the interior of a new Command Centre, before spending the summer of 1941 in the front line port of Dover. After a trip to Dundee and Edinburgh in the autumn introduced him to the aircraft and pilots of the Royal Naval Air Service he successfully requested a transfer to the RAF. However, a proposed trip to Russia early in 1942 failed to materialize, and instead he had to make do with late winter snow at RAF Clifton, near York.

He had not been there long when he received an urgent summons home. The stresses and inevitable separations of wartime had brought him closer to Tirzah again, and the previous spring their daughter Anne had been born. With three

young children, she had then been persuaded to leave Castle Hedingham for a much grander house in the country not far from Great Bardfield. Ironbridge Farm was delightful in summer but almost uninhabitable during the bitter winters of the early 1940s, and the precariousness of Tirzah's position became fully apparent when, in March 1942, she was diagnosed with breast cancer and rushed into hospital for an emergency mastectomy.

Racing home, Eric asked for a transfer to a base nearby, and he spent the next few months at RAF Sawbridgeworth, just across the Hertfordshire border. He still yearned to travel further afield but when he was eventually offered a posting to an RAF station in Iceland he told his wife he would go only with her blessing. This she gave, and on 28 August 1942 he arrived at RAF Kaldadernes. Two days later he wrote enthusiastically to Tirzah about the unfamiliar country, but this was to be his last letter to his wife. On 2 September he joined an air-sea rescue mission, only to be lost when his aircraft disappeared off the Icelandic coast.

These, then, are the bare facts of his career as a war artist, but they tell us little of his personal and artistic achievements. One important discovery he made while travelling to and from Norway was that he could ignore the attentions of enemy aircraft and submarines just as he had always ignored the hardships of outdoor work; he was not afraid. That Arctic journey also awakened in him a sense of adventure, so that John Nash was able to say of him years later, 'He seemed avid for fresh experiences especially those where excitement or even danger were offered. It was not that he was in any way a 'fire-eater' but some of the mildest and most unheroic of us are quickened and excited by the presence of danger.'[27]

Ravilious's wartime paintings and lithographs were sometimes too decorative or experimental to be appreciated by his contemporaries as war art *per se*, and today it is more helpful to consider them simply as a continuation of his peacetime work under more trying circumstances. Whereas his eye for intriguing objects might have lighted before the war on a home-made watermill or a steamer's funnel, it now discovered a warship's propeller or a submarine lying in dry dock. Of unusual and interesting interiors he had no shortage, and his exploration of the control rooms beneath London gave us a series of watercolours that anticipate the style and atmosphere of the Cold War.

His studies of gunfire are less depictions of wartime drama than they are a new episode in the ongoing story of his fascination with fireworks and other spectacular light effects, and in the Norwegian paintings we see him perfecting techniques that had been honed on Beachy Head and in Aldeburgh. For as long as he had breath in his body, Ravilious continued to push himself, his sense of wonder and appetite for experiment undiminished, achieving a mastery of his

chosen medium that is best seen by comparing a painting from the early 1930s with one painted a decade later. By this time he had at his disposal an array of advanced watercolour techniques; he might use a wax resist or block out an area of white paper, dampen the paper from behind or scratch the painted surface with a razor blade to create points of light. Edward Bawden summed up the evolution of his work best:

> The difference between the early and the late work is not only a great dexterity in the use of a difficult medium, that was inevitable, but something else seems to happen, a change of attitude to the medium as can be seen when a freely drawn and lightly coloured sketch is compared to a later painting which is more consciously designed and has colour and textural effects carefully calculated, everything being carried out with intentional completeness. Design has permeated the whole painting and conditioned its treatment.[28]

'In other respects', he went on, 'a change is not so noticeable. The mood, even when it is most dramatic as it is in some of the war paintings, still remains lyrical.'

This perhaps explains why some people take Ravilious less seriously than Moore or Piper. His work is rarely sombre, often light-hearted, but Ravilious himself was more complex than the happy-go-lucky character the world mostly saw. His vivid imagination afforded him nightmares as well as dreams, and he did not easily share fears or troubles. This reticence, Tirzah believed, was a result of his having to cope with so many family difficulties in his youth; years later Helen Binyon described how, only months before his death, he struggled to share his feelings about a fatal flying accident he had witnessed.[29]

A WORLD OUTSIDE TIME

But Ravilious's greatest preoccupation was perhaps the passage of time. This was expressed chiefly in comments to close friends about the loss of excitement and originality suffered by many artists as they age, the earliest to Edward Bawden when they were still in their twenties. He suggested then that the early thirties were the difficult time, and on his 34th birthday Tirzah recorded in her diary an untypical event: 'Eric drunk and disorderly'.[30] Just before his 39th birthday he wrote to Helen Binyon, 'What do you think of that depressing theory of mine about middle-aged painters? Anyway let's not start applying it yet. I would very much like to be the camel that gets through the Eye of the Needle if I knew how to set about it.'[31]

This concern about ageing seems to have been an effective spur, because his work rate, willingness to experiment and sense of adventure all intensified with the passing years. Ravilious was not one of those young tyros who knows from the age of eleven that he must be an artist and then peaks at twenty-one. His

vision evolved slowly, over time and — perhaps — as his awareness of time grew, along with the accompanying shadow of mortality. A sense of time permeates the subject matter of his mature work, from the abandoned vehicles of Essex to the Sussex Downs with their prehistoric humps and hollows; his four Furlongs paintings are each set in a different season. The capture of temporary — sometimes even fleeting — phenomena was another preoccupation, seen in watercolours as diverse as *The Thames at Hammersmith* and *Firing a 9.2 Gun*. A literal reminder of the passing hours, clocks appear with increasing frequency during the war.

Being a still representation of a world in motion, a painting can trap a particular moment, but only a very good painting will preserve that moment in such a way that it transcends time, allowing future generations to share something of the artist's emotions and inspiration. It is probably significant that Ravilious painted many of his best paintings at least partly from memory, and in a way that heightens the sense of their being depictions not only of a place, but of a place in which something is about to happen, or has just occurred. He may only have included empty chairs in his interiors because he liked them, or because their shapes contributed to the design, but the effect of their inclusion is to make us wonder. Whose chair is this? Where is that person? And our curiosity removes us from the crowded gallery and pulls us into a timeless world in which the bread on the tea table will never be cut, and the butter will never melt.

This is a world to dream in, a world unlike that of any other artist. I can tell you where a watercolour like *Tea at Furlongs* was painted, and when, and I can suggest ways of looking at the painting – but there is no right way to do so. There are no correct interpretations with Ravilious; nobody has yet defined what it is about his work that is 'untranslatable', 'mystic' or 'magic', which is one reason why looking at it closely is always so exciting. More than seventy years after the artist's death, the empty chairs and barbed-wire fences, abandoned buses and geraniums still quiver with mysterious life.

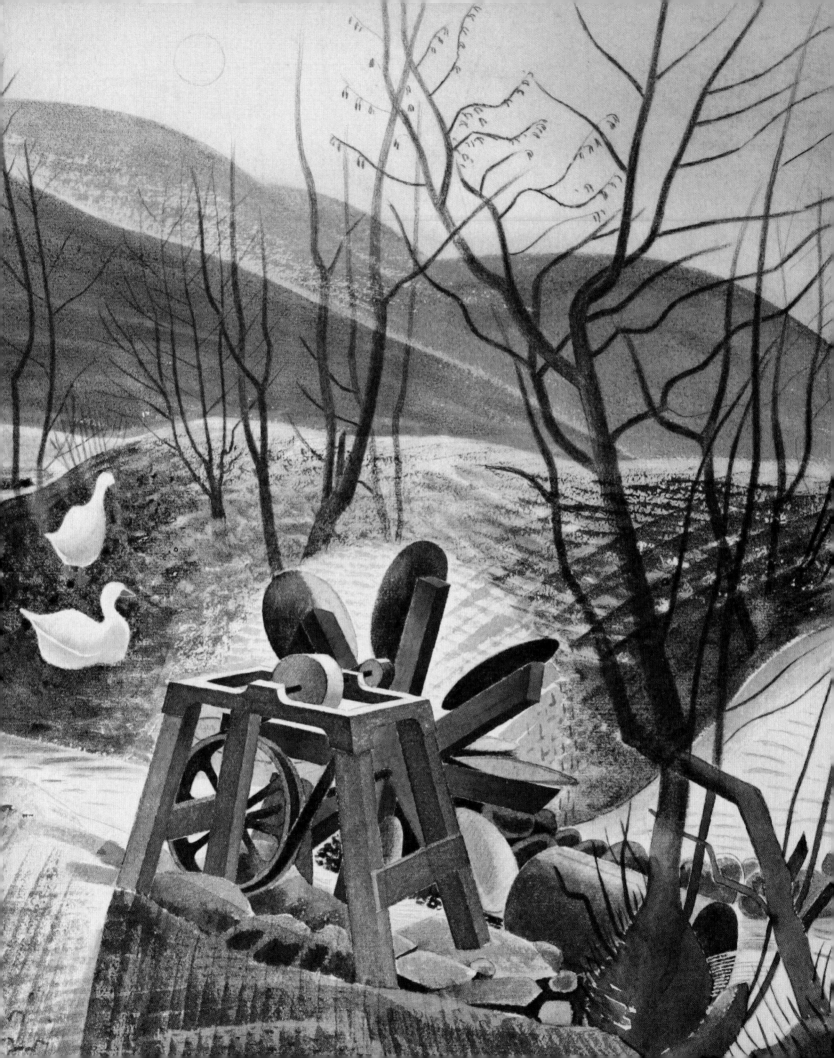

RELICS & CURIOSITIES

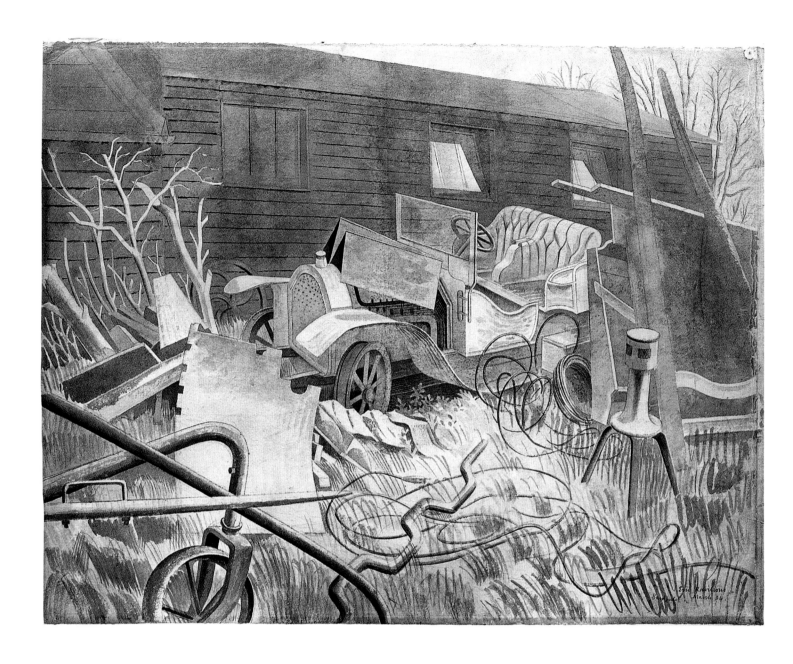

TALBOT-DARACQ

1934, watercolour and pencil on paper, 45.7 × 55.9 cm, Towner, Eastbourne.

In her autobiography Tirzah noted that, just round the corner from Brick House, there lay a big yard 'filled with derelict farm engines of all kinds and the remains of a very early car ... Eric was very thrilled with the yard and set to work drawing the engines and the car, afterwards tinting in watercolour his very careful drawings.'[32]

The dramatic contrast of light against dark was an important feature of Cotman's Yorkshire watercolours. The car here is a ghostly presence against the darker background of the shed, but at the same time it is drawn with wonderful attention to detail. Look, for instance, at the upholstery of the seats, which stand out so clearly against the jumble of foreground detritus.

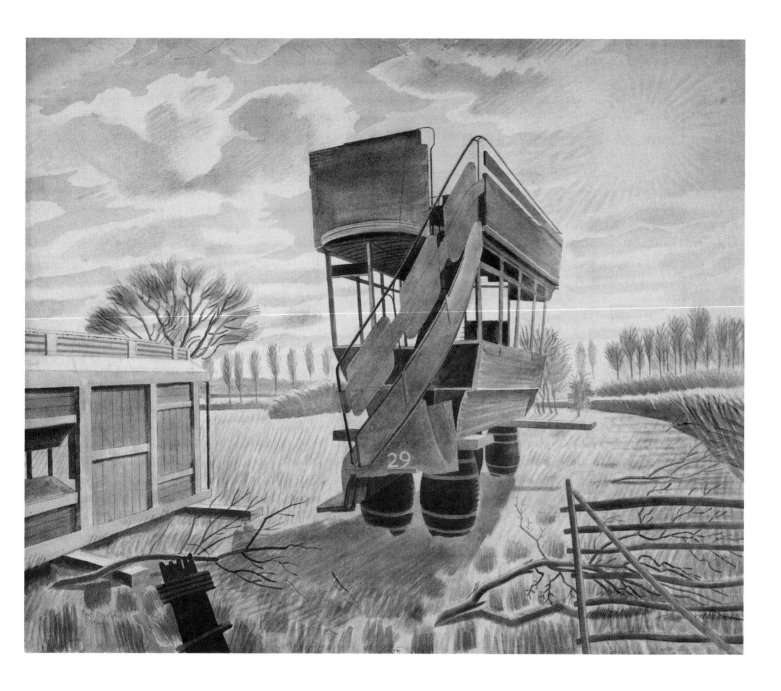

NO. 29 BUS

1934, watercolour and pencil on paper, 45.7 × 55.9 cm, Towner, Eastbourne.

Ravilious and Bawden shared a fondness for quirky subjects and unusual perspectives, and both 'painted pictures with the sun shining directly at them'.[33] Tirzah suggested that they did this out of a perverse desire to outdo each other in enduring discomforts, but as admirers of Samuel Palmer and Van Gogh they were probably interested in the effects of sunlight viewed in this way.

Here, the sun is a pale explosion, the treatment similar to the related wood engraving 'The Hansom Cab and the Pigeons' (p. 4), though less boldly stylized. In the artist's later work the light itself would become a major preoccupation, but for now the lighting serves to increase the strangeness of a scene in which a derelict bus seems to be heading off across the fields. A subtle play of angles between the bus and the neighbouring shed gives the old vehicle a sense of momentum – even though it cannot move.

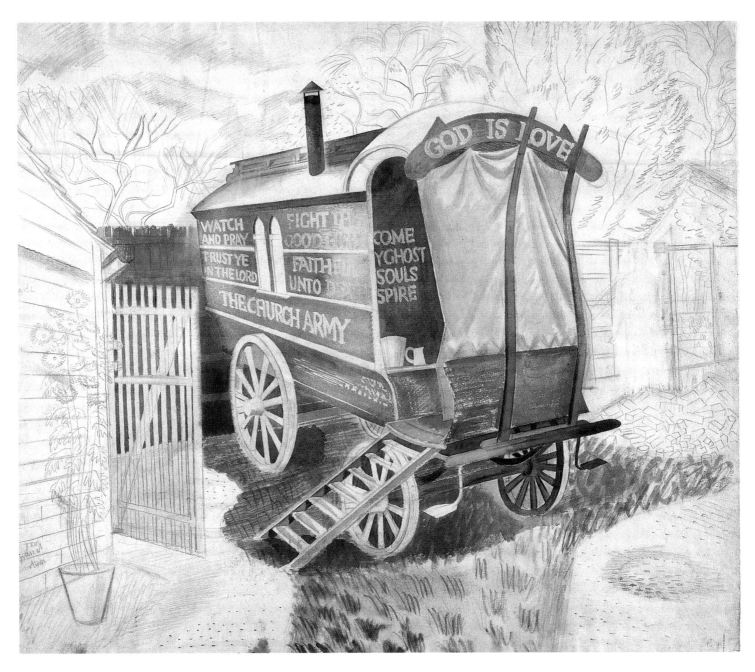

CHURCH ARMY CARAVAN

1935, watercolour and pencil on paper, 48.2 × 55.5 cm, private collection.

'You won't get a letter from me now,' wrote Ravilious to Helen Binyon one November morning in 1935, 'because a Church Army Van, plastered with texts, has taken up a position in the village and I want to make a drawing before it goes on its way. It is a beautiful object, dark green with white lettering all over it.'[34]

Although he never finished the painting he lavished considerable attention on the vehicle itself. Are we to suppose, then, that the 32-year-old Ravilious remembered his Nonconformist upbringing with equanimity – even warmth? Or that he saw the words simply as decoration, irrespective of their meaning?

He certainly had a soft spot for old wooden vehicles – a legacy perhaps of his family's involvement in coachbuilding. In Sussex he discovered a pair of abandoned Boer War fever wagons, and had them towed up the lane to Furlongs. 'We got a man to mend them inside,' reported Tirzah, 'and fit up one for a bedroom and the other for a living room and I nailed new canvas over the top of them and painted them green with red wheels.'[35]

CARAVANS

1936, watercolour and pencil on paper, 45 × 56 cm, The Fry Art Gallery. Purchased with the assistance of the Art Fund in 2010.

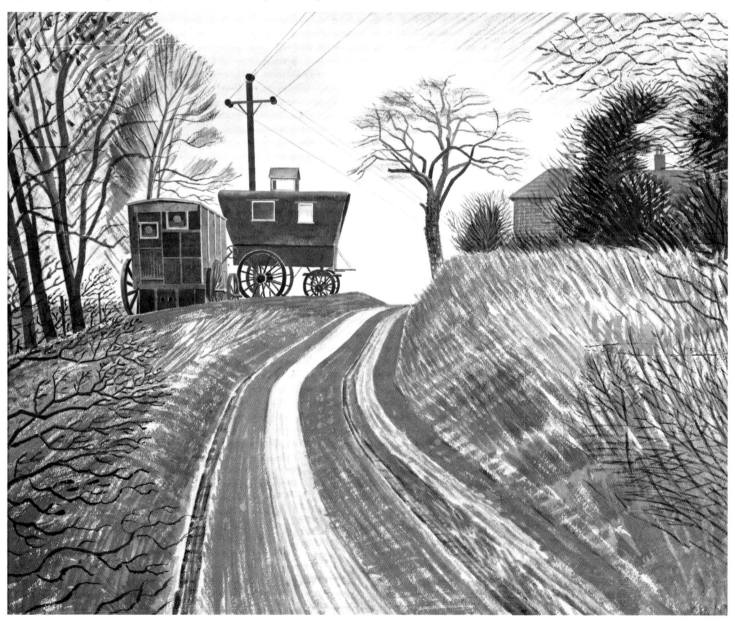

THE WATERWHEEL

1938, watercolour and pencil on paper, 41.5 × 50 cm, Brecknock Museum, with support from the Art Fund, the V&A Purchase Fund, Brecknock Art Trust, Brecknock Society, Usk Valley Trust.

When Ravilious visited the Welsh hamlet of Capel-y-ffin, he stayed with a family of English farmers. It was they who built this remarkable turbine 'out of chunks of wood and the bottoms of petrol cans',[36] and used it to power a grindstone for knife-sharpening. The knives were used on an unfortunate pig, which provided breakfast, lunch and dinner for weeks afterwards.

Often in his career Ravilious set a man-made structure in landscape, but here it is clearly the waterwheel that is the subject, while the landscape is sketched in behind with a freedom that he had rarely shown before and the trees drawn in with deft strokes. Ravilious himself described this watercolour as 'a bit Chinese', a topical remark given that the first London exhibition of paintings from that country had been curated only a couple of years earlier by Laurence Binyon.

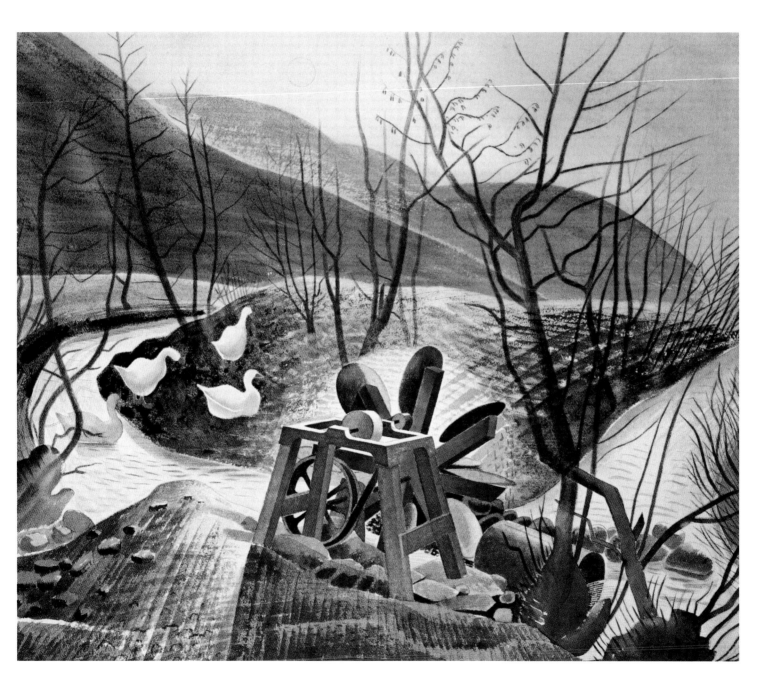

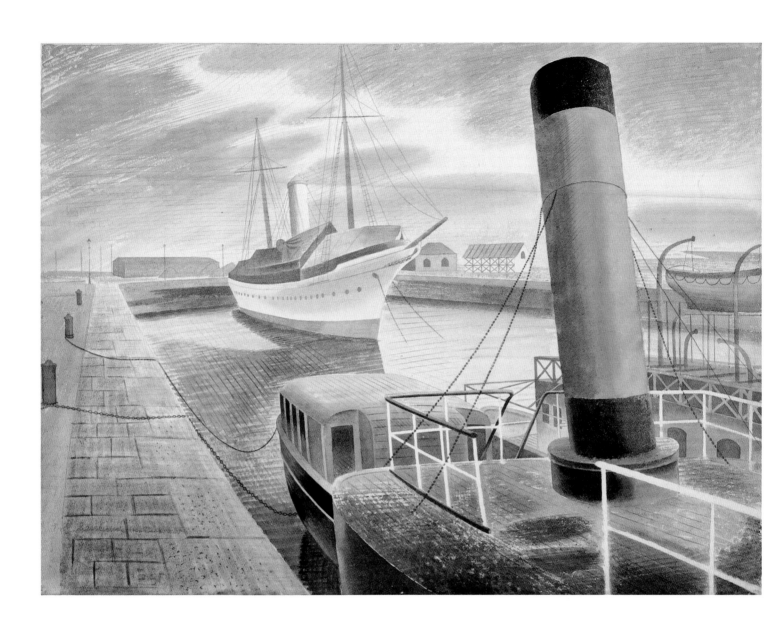

YELLOW FUNNEL

1938, watercolour and pencil on paper, 56 × 72 cm, Grundy Art Gallery, Blackpool.

The weather was so cold when Ravilious visited Le Havre in March 1939 that he could only stay outside for short periods, retreating regularly to his hotel on the Quai King George V. Of the café he wrote admiringly: 'Powerful and voluble dockers, rivetters and fitters fill it at lunch. I love them – they are magnificent, they wear such nice clothes and blue trousers and berets, and throw bread about and laugh out loud.'[37]

Outside, he was particularly taken with a steam yacht owned by the Rothschild family, describing it as 'a beauty; the most elegant boat I ever saw, all white and a white funnel with a figurehead in front elaborately carved'.[38]

You can just make out the figurehead in this painting, but the celebrated vessel is a rather ghostly presence here, certainly in comparison with the splendid yellow funnel. This may be little more than a cylinder striped with black at each end, yet something about it attracts one's attention. It is so clearly defined against the hazy grey sky, so adroitly angled in comparison with the bow of the steam yacht, and so wonderfully coloured.

Perhaps some of the artist's warm feelings towards the local populace found their expression in this painting of a simple man-made object, as American poet William Carlos Williams communicated his feelings about another place and its people through his evocation of a red wheelbarrow. An ocean and a generation apart, the two men may have known nothing about each other, but both understood the emotive power of inanimate things.

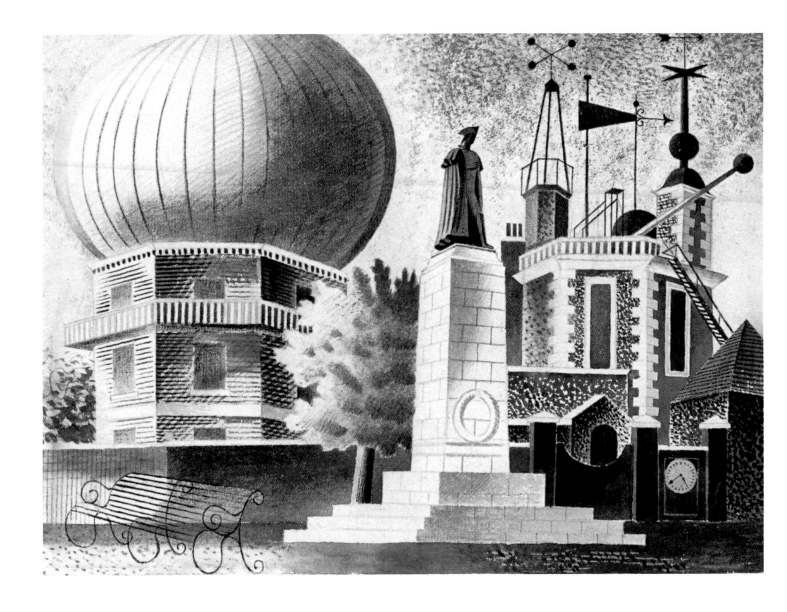

GREENWICH OBSERVATORY

c. 1937, watercolour and pastel on paper, 19 × 29.5 cm, London Transport Museum.

Ravilious's interest in idiosyncratic objects transcended limits of location, context and scale. The arcane scientific instruments and signalling devices of *Greenwich Observatory* offer the same kind of pleasure to the curious eye as the tools hastily assembled by the naval personnel tasked with defusing mines in the first months of World War II. 'R.M.S.' here is an abbreviation of 'Rendering Mines Safe', a breezy description of a dangerous job.

The composition of *Bomb Defusing Equipment* involves subtle contrasts of light and dark, curves and straight lines, with the various objects presented clearly and precisely. Only the previous year Ravilious had produced an equally stylish composition based around a very different group of objects, and in a gentler mood. The design for embroidery he made for Dunbar Hay just before the war uses similar contrasts of tone and shape, and shows the same clear eye at work. That design, though, is wonderfully light-hearted.

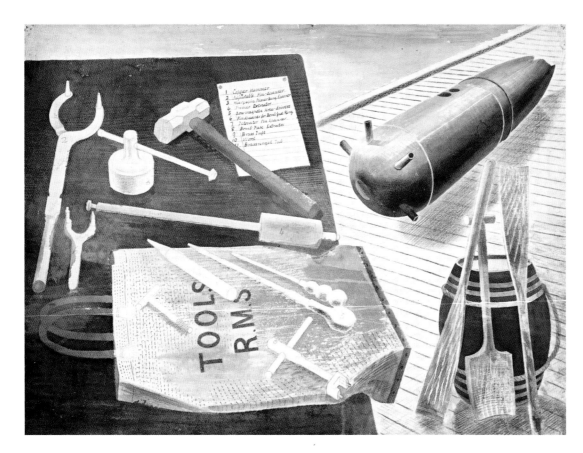

BOMB DEFUSING EQUIPMENT

c. 1940, watercolour, pencil and colour pencil on paper, 43.1 × 58.4 cm, private collection, courtesy of Towner, Eastbourne.

DESIGN FOR DUNBAR HAY EMBROIDERY

1939, watercolour and pencil on paper, 39.5 × 52 cm, private collection.

DESIGN FOR WEDGWOOD ALPHABET MUG

1937, watercolour and pencil on paper, 26 × 43 cm, private collection, courtesy of Towner, Eastbourne.

Here are two collections of objects – relics and curiosities on a small scale – that offer intriguing insights into the creative interests and working methods of an artist who appreciated that inanimate things have their own kind of life.

The Alphabet design is perhaps Ravilious's best-known creation, produced in 1937 to decorate a Wedgwood nursery service. Of the twenty-four miniatures some were borrowed from previous projects; if you look closely at the design for the Morley College murals you might spot an earlier version of the Palm, while the Eggs take us back to *Boy Birdnesting*. Whether you see the Alphabet design as a kind of coded self-portrait or simply a random collection of images, it is unusually intriguing.

Created several years later, during a break from his duties as a war artist, the design for a child's handkerchief is less controlled but equally eccentric. Who but Ravilious would choose to illustrate the number 4 with a weathervane that has the points of the compass reversed? The boots bring us down to earth, but at the same time they are so vividly realized that they reinforce the main lesson of this and the Alphabet design: that Ravilious saw wonders everywhere.

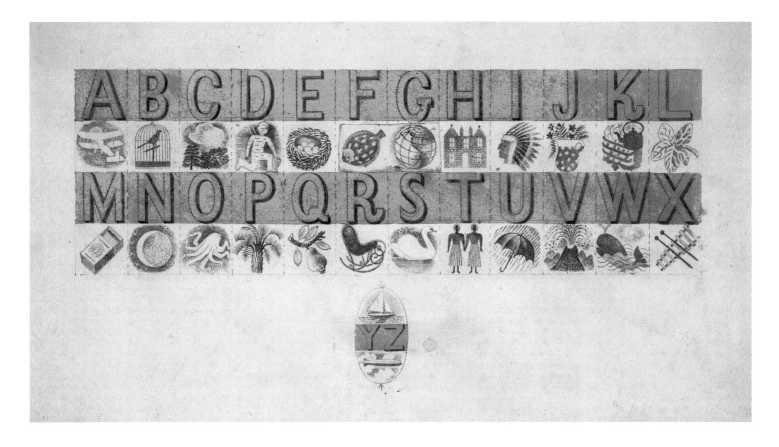

DESIGN FOR HANDKERCHIEF

1941, lithograph, 44 × 56 cm, private collection.

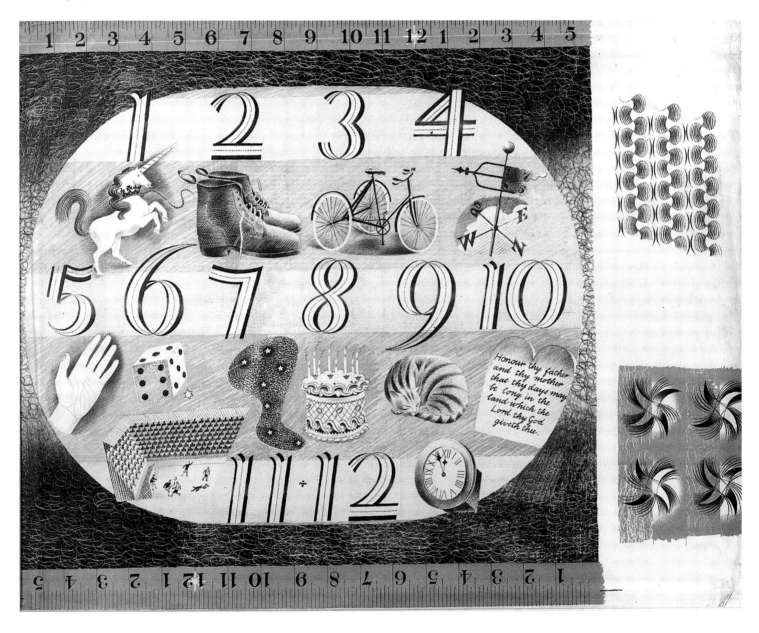

ANCHOR AND BOATS

1938, watercolour and pencil on paper, 44 × 52 cm, private collection.

In the summer of 1938 Ravilious revisited his 'abandoned machinery' series in this painting of junk-strewn shingle, and one can see how his technique had evolved over the intervening years. The beach is delicately and warmly represented with areas of lightly stippled paint, providing an undulating background to a range of distinctive forms. While the Rye Harbour lighthouse with its tapering sides and pyramidal roof has all the substance of a dream, the chain tied to the bow of the largest boat seems almost alive. Light against dark initially, then dark against light, the chain pulls the picture together without appearing to have any purpose.

This kind of coastal still life was in vogue during the 1930s, with artists like Edward Wadsworth and Tristram Hillier exploiting the oddities of maritime culture to create surreal – and in Hillier's case overtly Surrealist – paintings. Paul Nash had a similar fascination for the flotsam of Swanage, which presented him with many an *objet trouvé*, but no arcane meaning is suggested for this assemblage of curiosities. Instead the artist's careful selection and arrangement encourage us to look, and look again.

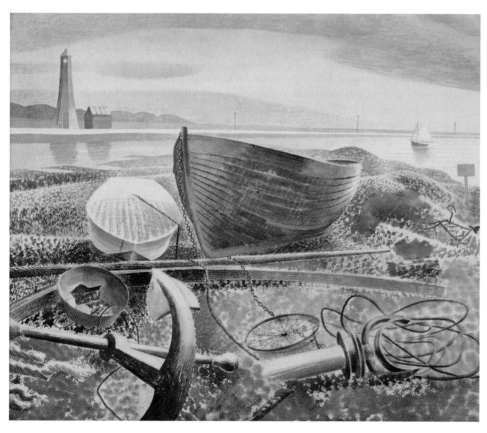

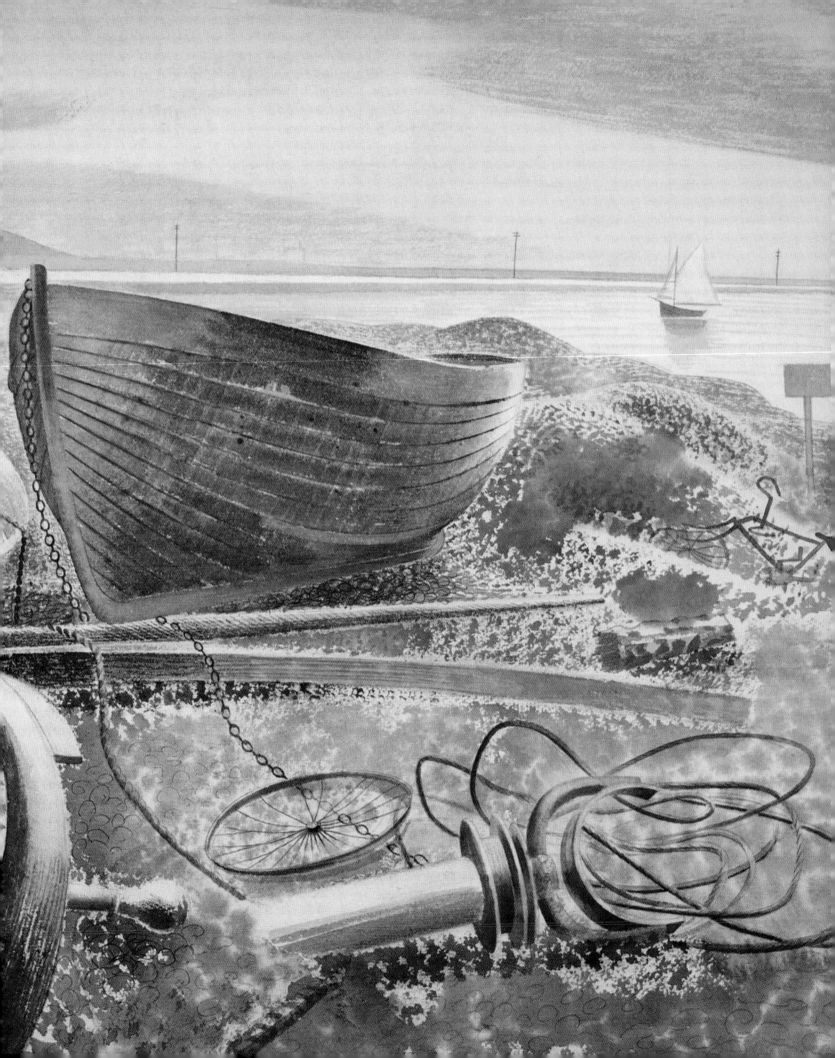

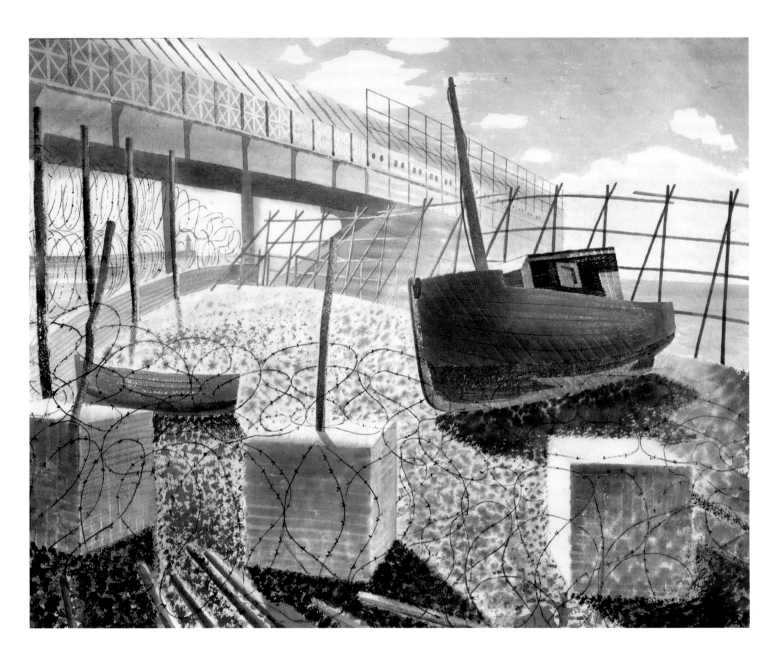

SOUTH COAST BEACH

1939–42, watercolour and pencil on paper, 43 × 54.5 cm, Aberdeen Art Gallery & Museums Collections.

There can't have been many people in wartime Britain who viewed the concrete blocks and barbed wire of coastal defence as things of beauty, but Ravilious found decorative motifs in the most unpromising material. The wire in particular loops and twists in an exuberant dance, while the three blocks palely reflect the sun. In the context of wartime invasion fears the coils of wire and fencing and the enclosed pier beyond may have seemed reassuring, the boats surrounded and protected, although one could equally say that the brightly painted craft are trapped, prevented from taking to the water as the British public were for the duration of the conflict.

Having painted beach huts and boats with such enthusiasm before the war, Ravilious perhaps saw this irony. He might have added something about defence to the title, but instead left the word 'beach' hanging, with all its pre-war connotations of pleasure and relaxation.

SHIP'S SCREW ON A RAILWAY TRUCK

1940, watercolour and pencil on paper, 42.7 × 54 cm, Ashmolean Museum, Oxford. Present by H.M. Government (War Artists' Advisory Committee).

After being appointed an official war artist in early 1940, Ravilious was given the rank of Captain in the Royal Marines and sent off to the dockyard at Chatham, where he enjoyed the camaraderie of life in the armed forces while struggling with the niceties of naval etiquette. He had never liked painting in front of a crowd, and so went off to the remotest corners of the dockyard in search of subjects and the peace in which to paint them.

A central tenet of the war artists' scheme was that each artist should be allowed to work in their own way, and here Ravilious found the kind of subject he would have enjoyed at any time. Newly forged at one of the foundries nearby, and waiting to be fitted, the propeller is at once massive and delicate. It glows in the winter dark as if lit from within, colour faintly scattering like pollen from its blades. Yet how much less of a painting it would be without the curving tyre tracks to pull the composition together, or the footprints, not yet covered by the falling snow, to remind us of the men who created this utilitarian work of art.

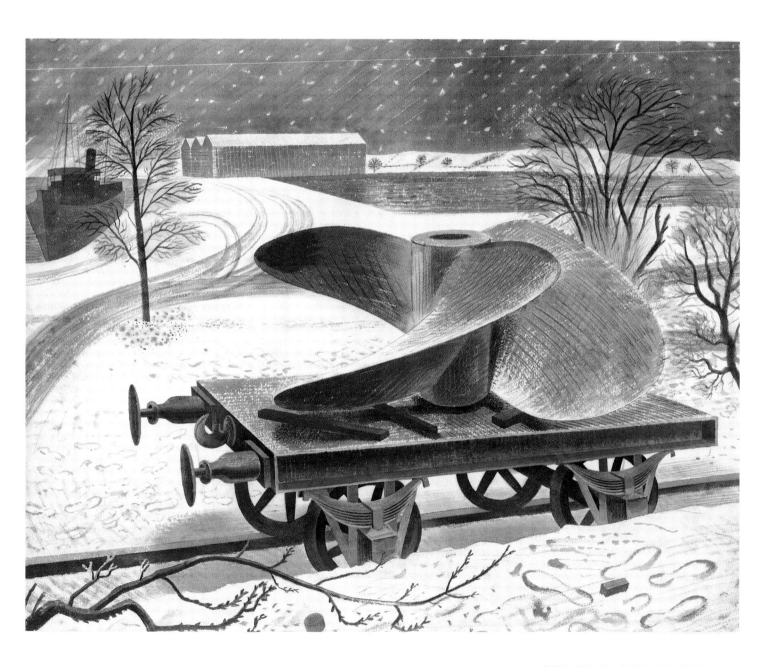

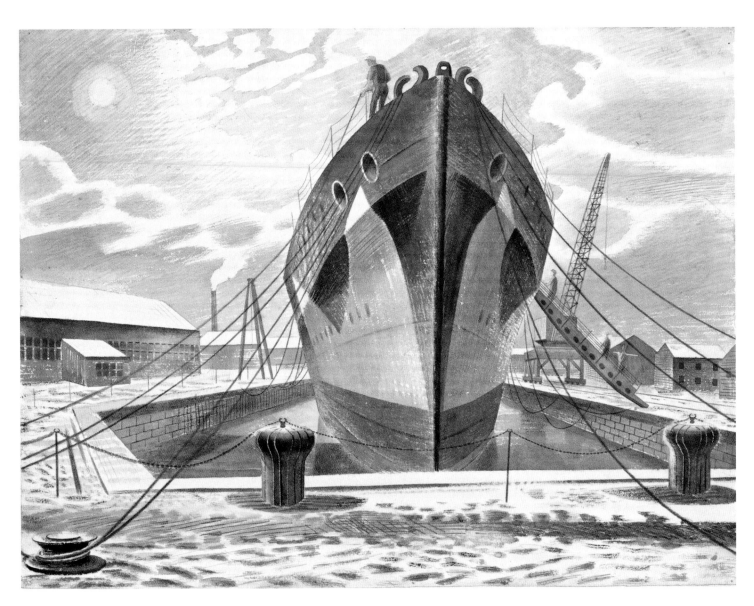

A WARSHIP IN DOCK

1940, watercolour and pencil on paper, 44.1 × 58.7 cm, Imperial War Museum.

SUBMARINES IN DRY DOCK

1940, watercolour, crayon and pastel on paper, 43.2 × 57.1 cm, Tate. Presented by the War Artists Advisory Committee.

In peacetime Ravilious was free to choose his painting subjects, but as a war artist the range of options was limited; his request to paint an Admiral's bicycle at Chatham was turned down in no uncertain terms, and he dared not ask to draw the splendid statue of a marine that stood outside the barracks.

Having little or no interest in military might, he chose instead to study naval vessels in his own way, approaching them from unusual angles to create the kind of interesting shapes he needed. Thus submarines in a dry dock are all curved propeller and rounded flank, while the bow of a warship, seen from below, resembles some great toothed creature, shackled and at bay.

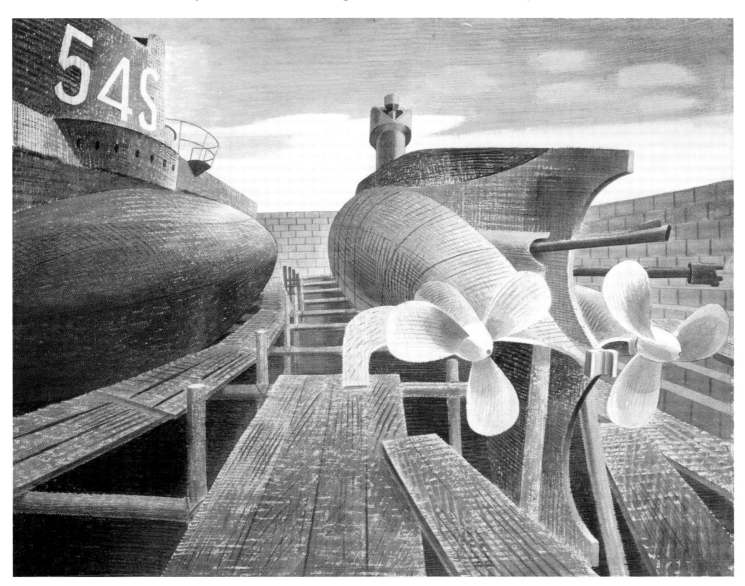

TIGER MOTH

1942, watercolour and graphite on paper, 45.7 × 55.9 cm, Tate, presented by the War Artists Advisory Committee.

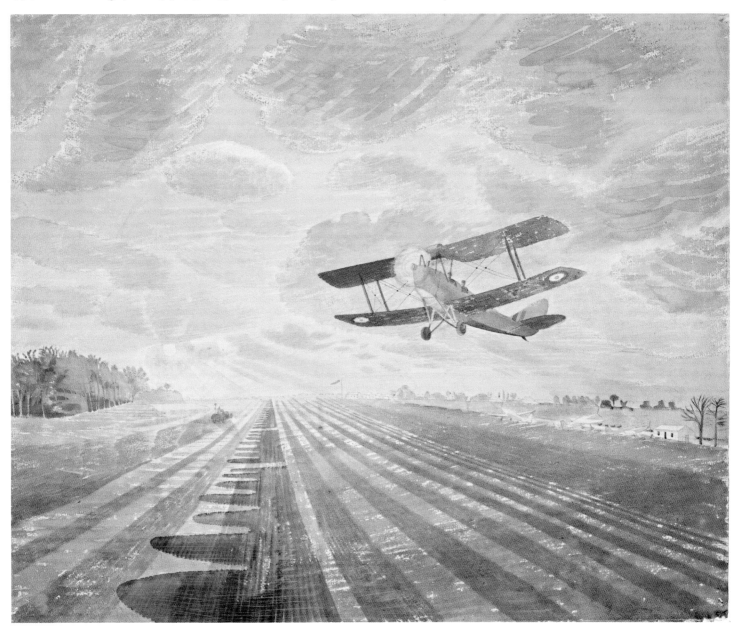

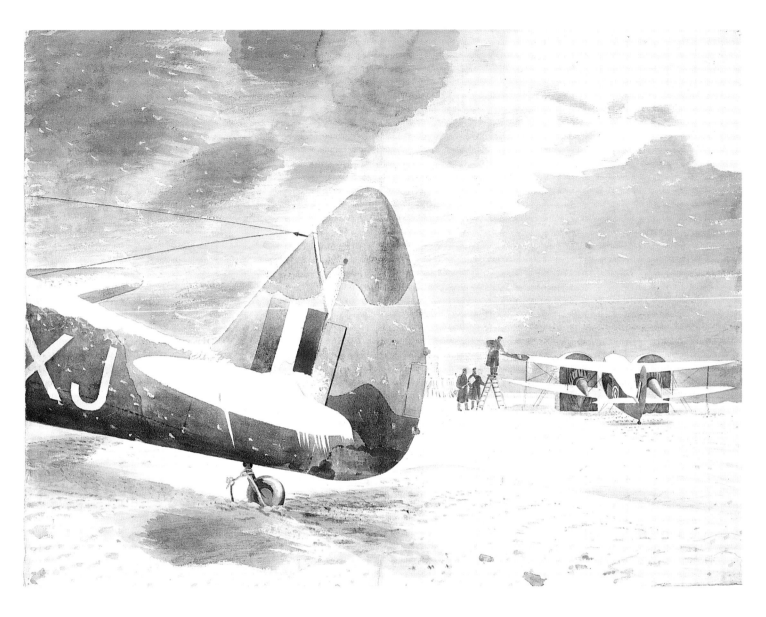

DE-ICING AIRCRAFT

1941, watercolour and pencil on paper, 45.7 × 60.9 cm, Imperial War Museum.

Tasked with painting military aircraft, Ravilious shied away from bombers ('such repellent things'[39]) and wrote on one occasion, 'if only aeroplanes weren't all so alike and so edgy and tinny'.[40] He yearned to be sent to Russia, in part because planes were fitted with skis there, but found closer to home that Walrus seaplanes offered interesting subject matter. They were, moreover, 'comic things with a strong personality like a duck',[41] and their main role was in air-sea rescue rather than combat.

A trip to York in March offered the dual excitement of polar conditions and unusual aeroplanes, such as the twin-engine biplane shown in *De-Icing Aircraft*. However, a more compelling subject is provided by the Tiger Moth, a slow-moving training aircraft which Ravilious described as 'the perfect plane for drawing'.[42] This was actually a new model of aircraft, but here it seems to have drifted out of the distant past, a delicate form against an expanse of sky.

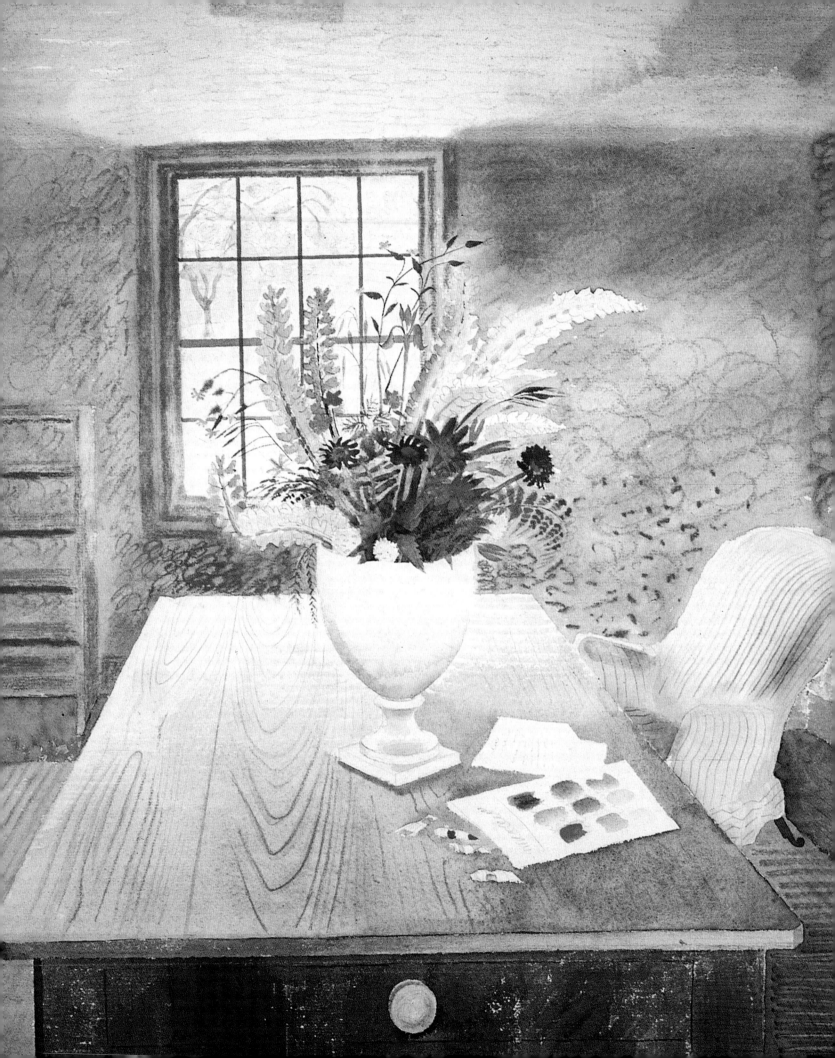

FIGURES & FORMS

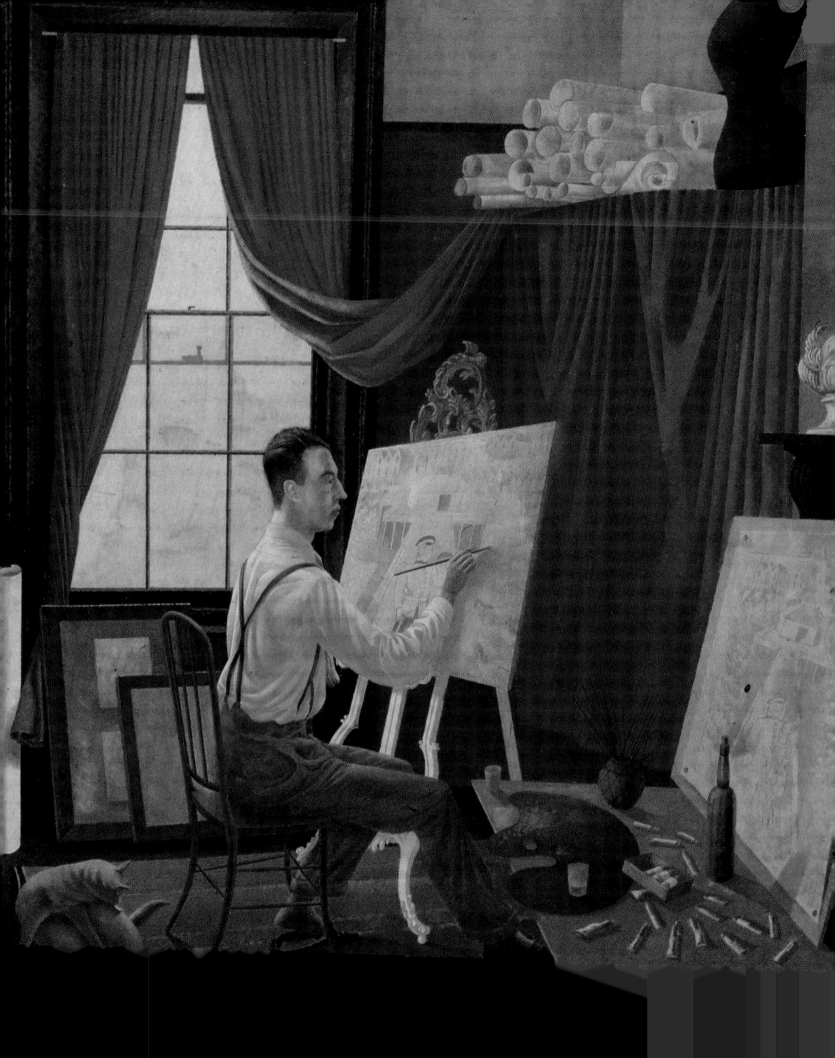

EDWARD BAWDEN WORKING
IN HIS STUDIO

1930, Tempera on board, 79 x 92 cm, Royal College of Art Collection.

This delightful painting is a rarity for Ravilious: a portrait painted in tempera. As a watercolourist he was just beginning to find his way at this stage in his career, and it is unclear why he abandoned a medium that he used here to such good effect. In this highly finished painting we have his close friend Edward Bawden, working on a painting of Clacton Pier in his back room in Redcliffe Road, Chelsea; the rolls of paper in the corner are studies for the Morley College murals, testament to the amount of work the artists put into the project.

While certainly a portrait, this is a painting as much of Bawden's aesthetic world as it is of him in person. Though excessively hard-working and painfully shy, the boy from Braintree was a trendsetter, particularly in his admiration for Victoriana – note the rococo mirror and easel; the bust of Queen Alexandra on the mantelpiece. The guardsman's jacket on the floor could have been carelessly dropped by a visiting Beatle; we might remember that Bawden was an influential teacher at the RCA when Peter Blake and his contemporaries studied there after World War II.

There is something curiously animated about the jacket, and with the curtained corner and the tailor's bust the overall picture has an understated strangeness that presages the mood of Ravilious's later watercolours.

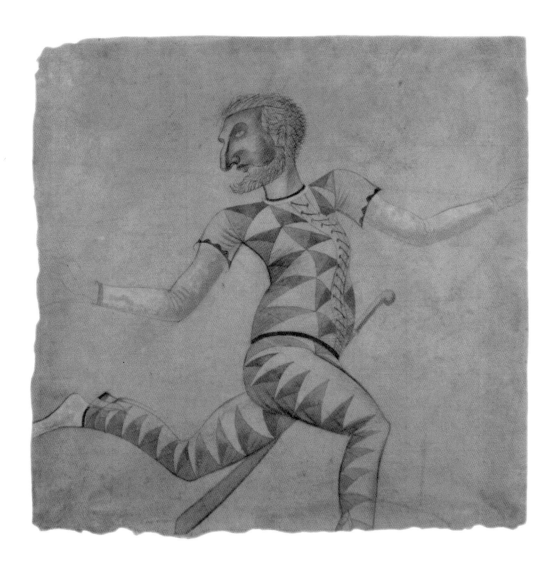

HARLEQUIN

1928, watercolour and pencil on paper with board support, 52 × 50 cm, The Fry Art Gallery. Purchased with the assistance of the Art Fund and the Essex Heritage Trust.

This figure, drawn in preparation for Morley College, stands out as one of the artist's more extraordinary creations. A stock character of the Italian *Commedia dell'Arte*, Harlequin became established as a British theatrical institution during the eighteenth century; the Harlequinade was widely performed until well into Victoria's reign. Here we see the character with traditional tight-fitting patterned costume, black *Commedia* mask and *batte*, or 'slapstick', which he used to bash flaps and levers placed strategically around the stage, to change the scenery and so the location.

As a stock character Harlequin was as reliable in his behaviour as Mr Punch. His role was to make off with Columbine, beautiful daughter of Pantaloon, and the Harlequinade involved a lengthy chase with plenty of laughs. As we see here, Harlequin was energetic and high-spirited. He was also sly, mischievous and, as the goatish beard suggests, possessed of a satyr's sensuality.

STUDY FOR MORLEY COLLEGE MURALS

1928–30, watercolour and pencil on paper (extensively annotated), 47 × 81 cm, private collection.

This and other studies are all that remain of the splendid murals painted by Ravilious and Bawden in the refectory of Morley College, the paintings themselves having been destroyed in the Blitz. At different times the friends had each visited Tuscany, but while the improbable pavilions and disregard for conventional rules of perspective suggest the influence of Masolino and his peers, the subject matter pays exuberant homage to seventeenth-century English theatre.

While Bawden tackled Shakespeare, Ravilious took on Marlowe, George Peel and Ben Jonson, clothing their characters in fabulous costumes, and giving their revels a backdrop of Sussex downland. Overhead float winged figures reminiscent of Pompeiian frescoes (which Ravilious saw in postcard form) and modelled on the Morley College mistresses.

Opening the murals, Stanley Baldwin suggested 'that the works were conceived in happiness and joy, and the execution gave real pleasure to the artists'. He was certain that 'those who lived in these rooms where the pictures were would derive pleasure from them for a long time to come'.[43]

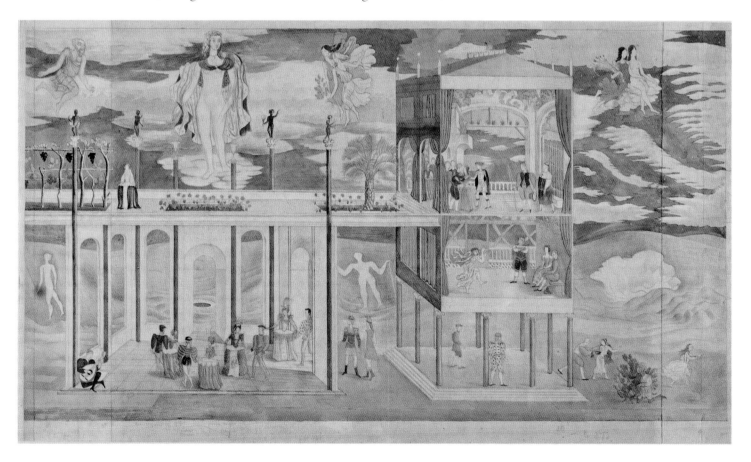

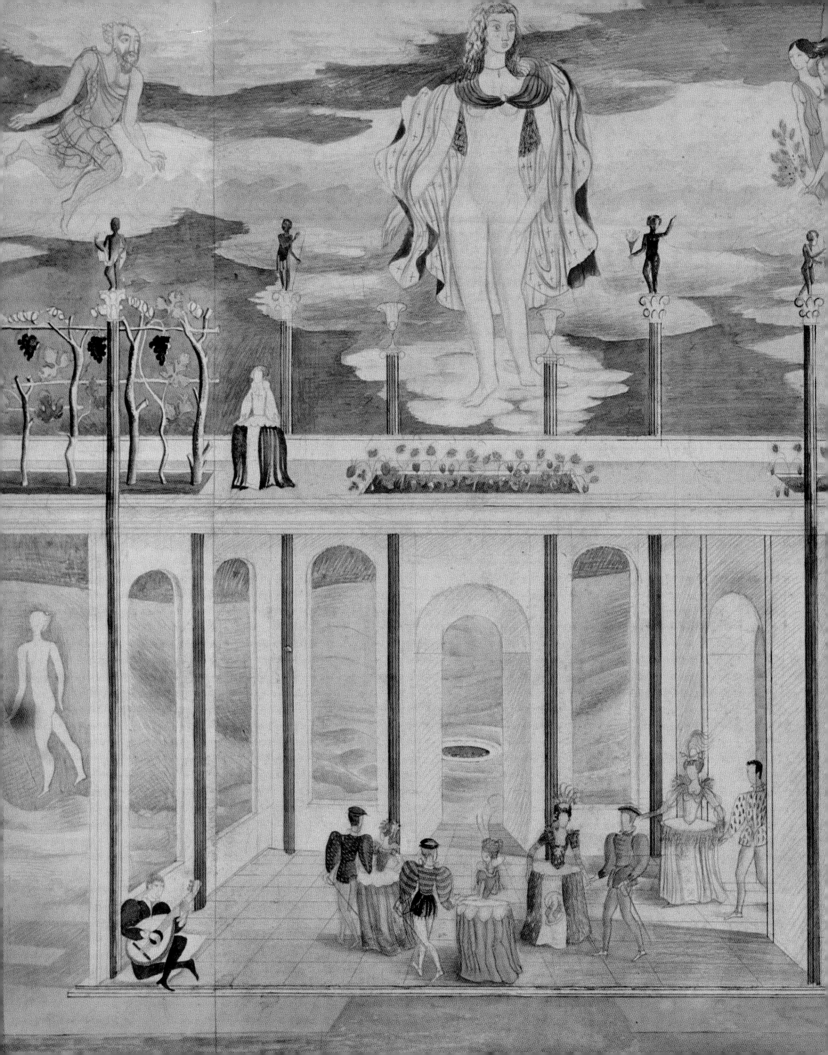

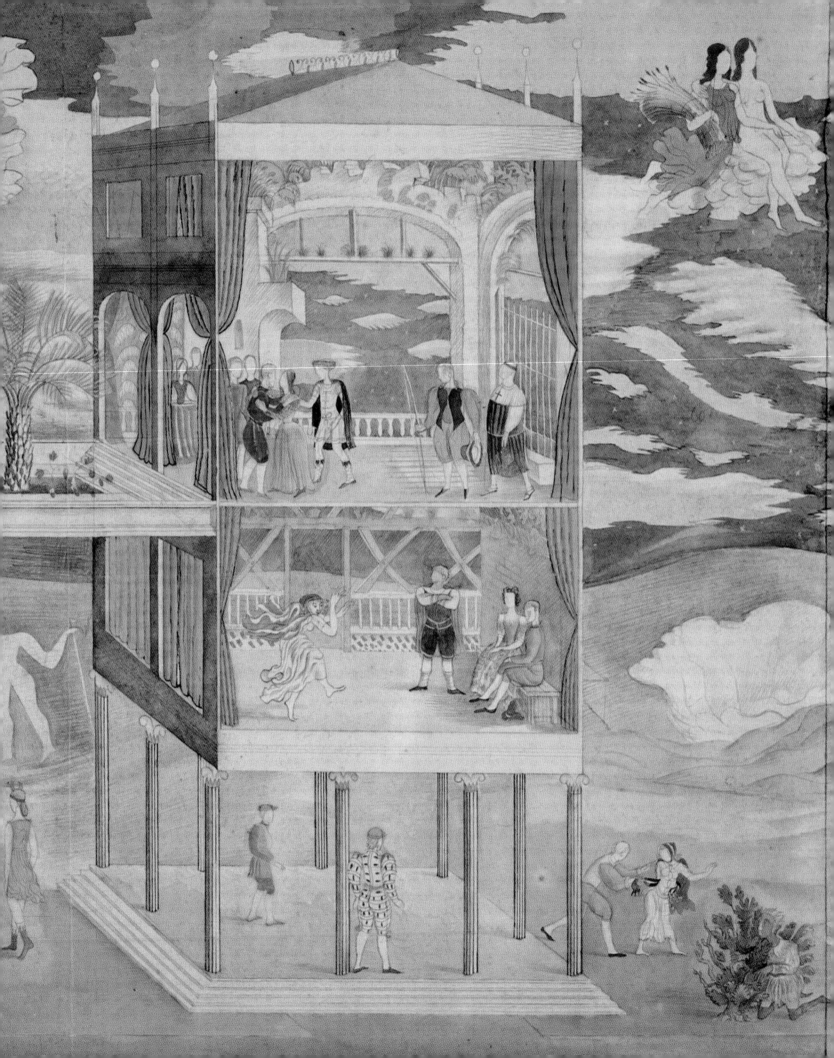

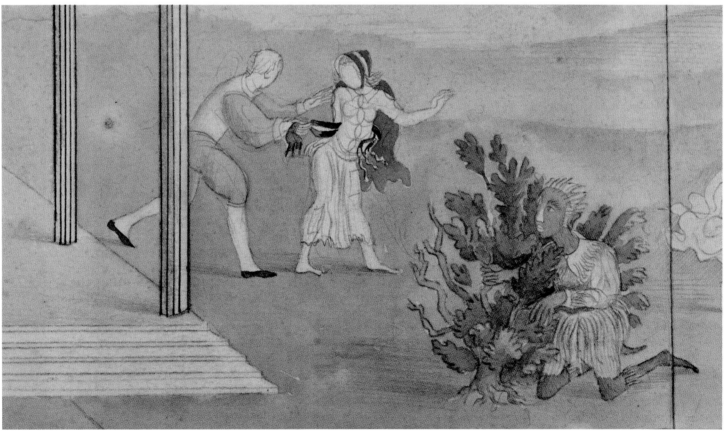

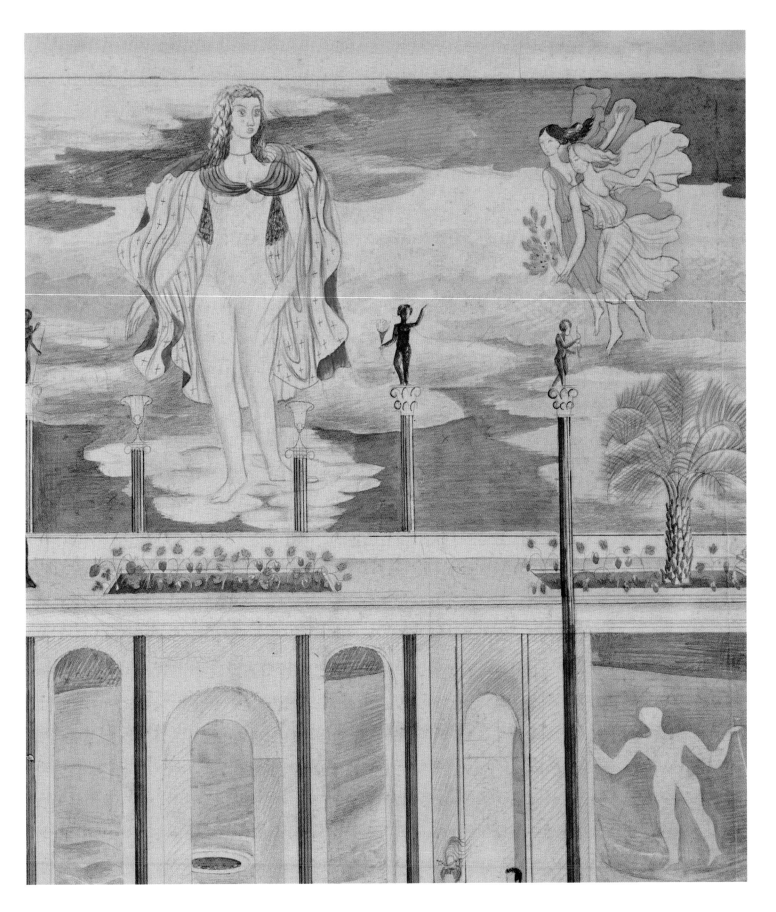

PROSPECT FROM AN ATTIC

1932, watercolour, pencil and pen on paper, 47.4 × 63 cm, Scarborough Museums Trust.

When Bawden married Charlotte Epton, his father bought Brick House in Great Bardfield for the couple, and much-needed renovation works began with ladders being put up to the roof. Since Eric and Tirzah were living there part-time, the two men took advantage of this access route to paint views from the roof. 'They used to get up very early in the morning and were interested to find how powerful kipper smoke was when it was coming out of the chimney',[44] Tirzah later recalled.

Bawden went on to paint this view, usually from the attic or an upstairs window, many times, and often included Charlotte in the composition. Here Ravilious has drawn her in a typically Bawdenish way, beating a rug, while beyond the garden wall the trees are so full of early morning brio they seem to be dancing.

In a different way trees also dominate the earlier painting *Hampden Park*, which commemorates the suburban landscape of the artist's childhood. The figure on the bench is probably Tirzah.

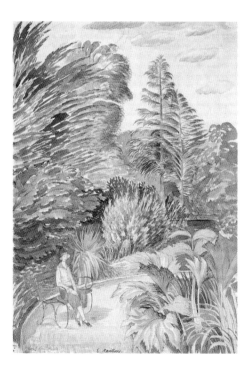

HAMPDEN PARK

c. 1928, watercolour, pencil and pen on paper, 39.5 × 28 cm, private collection, courtesy of Towner, Eastbourne.

THE BUTCHER'S SHOP

*c.*1937, design for *High Street*, watercolour and pencil on paper, 48 × 58.5 cm, Towner, Eastbourne.

Although the Essex landscape did not inspire Ravilious as it did Bawden, everyday life in the Hedinghams provided him with numerous subjects. One November he spent several days among the feathers and sawdust of a local butcher's shop, the exterior eventually finding its way into the pages of *High Street*. With that pig's head and sheets of paper for wrapping meat, this is a scene far removed from the sanitized butcher's shops of today.

Likewise, *The Vicarage* recalls the days when bread was delivered door-to-door by handcart. Working in the bay window of Bank House, Ravilious would watch for the baker's boy, whose round was as regular as the postman's.

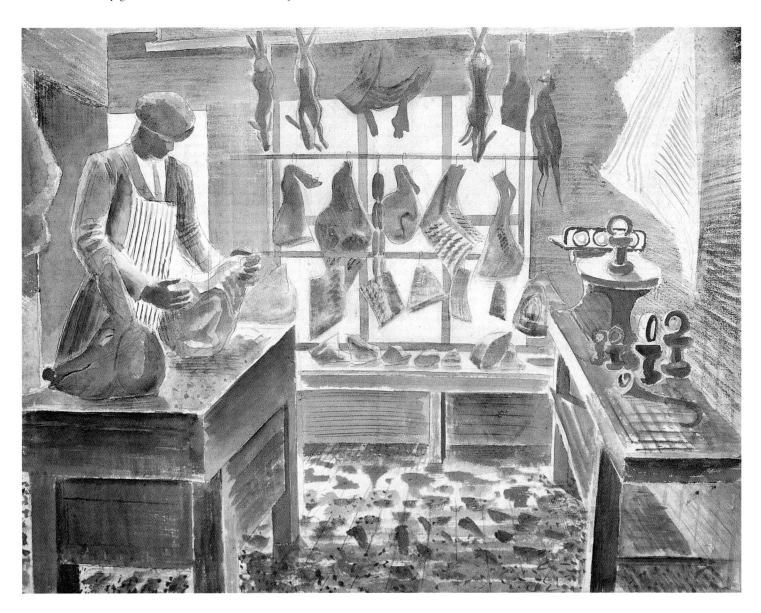

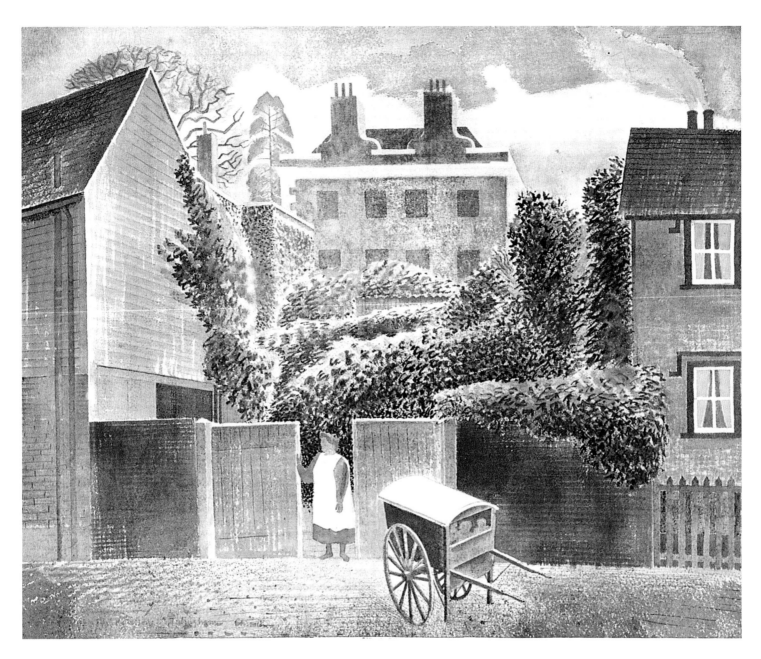

THE VICARAGE

1935, watercolour and pencil on paper, 45.8 × 57.2 cm, collection of David Hepher.

PORTRAIT OF A GIRL

1927, pencil on paper, 32.25 × 25.25 cm, private collection.

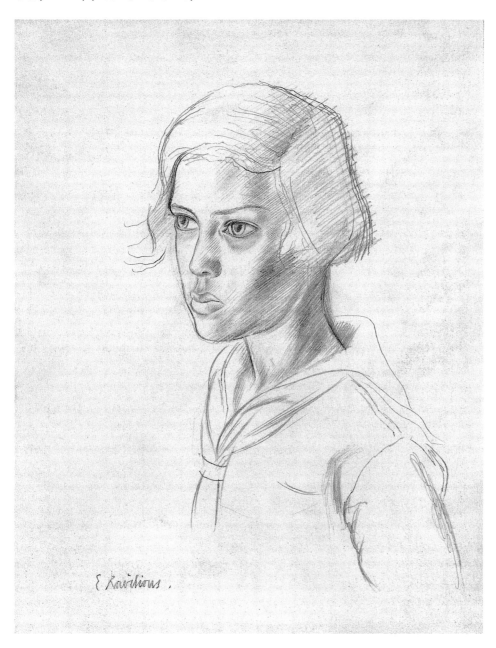

STUDY FOR SUBMARINES SERIES 2

c. 1940–41, watercolour and pencil on paper, 56.2 × 44.1 cm, Towner, Eastbourne.

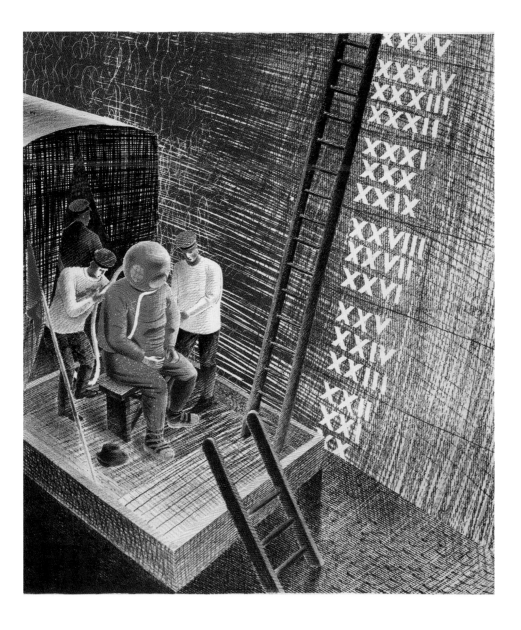

THE DIVER

1941, 32 × 28 cm, lithograph for 'Submarine Series', 1941, Imperial War Museum.

In July 1940, having recently returned from Norway, Ravilious took on one of the biggest challenges of his life. For several weeks he travelled aboard a naval submarine, 'trying to draw interiors. Some of them may be successful, I hope,' he continued, 'but conditions are difficult for work. It is awfully hot below when submarines dive and every compartment small and full of people at work.'[45]

Initially he tried to paint watercolours of the submarine interiors, but when he worked on the paintings at home in Essex he found that they were too gloomy and so embarked instead on a series of lithographs. While he had drawn sensitive portraits in the past, he faced a considerable challenge in trying to portray the human forms of the submariners in the context of a radically simplified, distorted design. From numerous detailed preparatory studies he created a remarkable set of prints.

Pick of the bunch is perhaps *The Diver*, which was based on drawings and photographs from Grimsby Docks. The central figure is like a visitor from another world, and the setting is equally strange – a space between ascending and descending ladders, marked out with Roman numerals. Meanwhile the lithographs of the actual submarine interiors suggest more the fantasy world of Jules Verne's Nautilus than the realities of life aboard a submarine in the 1940s. Today the Submarine Series stands out as a masterpiece of twentieth-century printmaking.

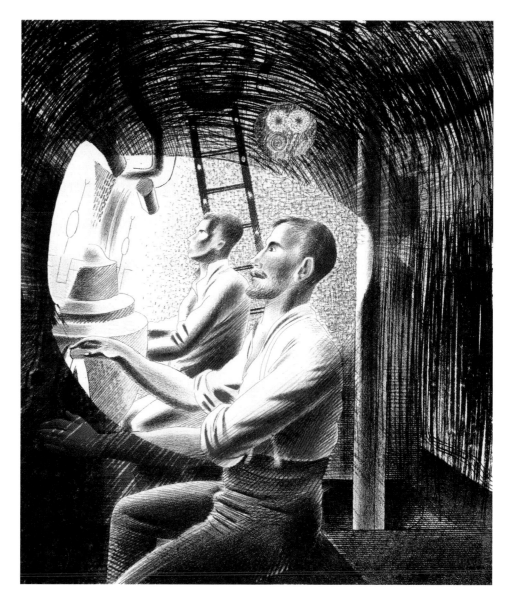

DIVING CONTROLS
(2)

1941, 34.9 × 28.5 cm, lithograph for
'Submarine Series', Imperial War Museum.

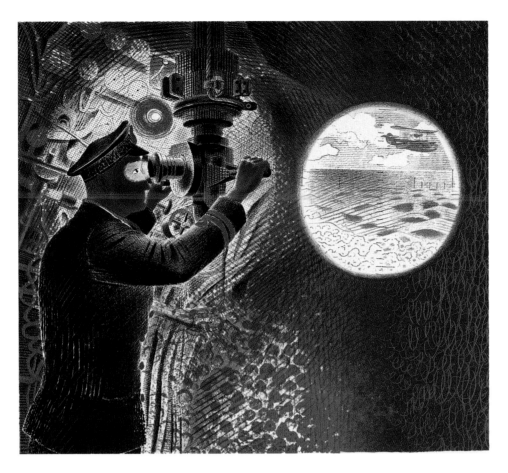

COMMANDER OF SUBMARINE LOOKING THROUGH A PERISCOPE

1941, 28 × 31.9 cm, lithograph for
'Submarine Series', 1941, Imperial War Museum.

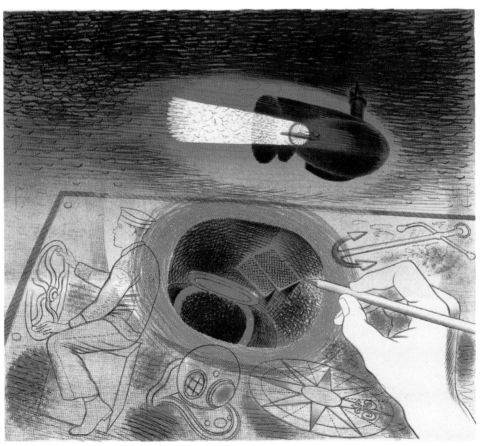

INTRODUCTORY LITHOGRAPH

1941, 27.8 × 32 cm, lithograph for
'Submarine Series', 1941, Imperial War Museum.

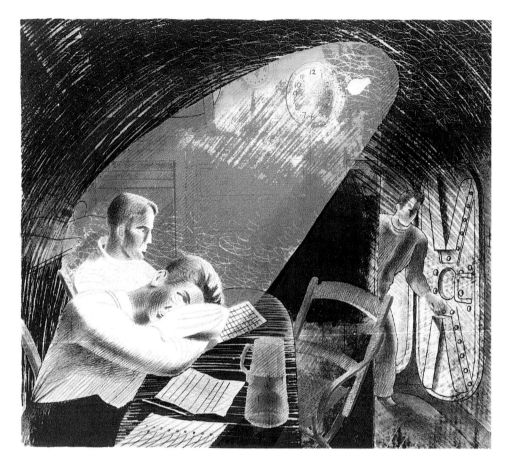

THE WARD
ROOM (1)

1941, 28 × 32 cm, lithograph for
'Submarine Series', 1941, Imperial War Museum.

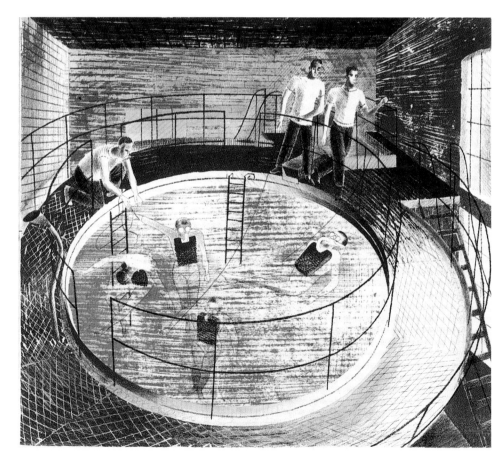

TESTING DAVIS
APPARATUS

1941, 28 × 31.9 cm, lithograph for
'Submarine Series', 1941, Imperial War Museum.

DRAWING OF A SUNFLOWER

c.1930s, pencil on paper, 53 × 43 cm, private collection.

In 1924 the National Gallery acquired one of Van Gogh's four paintings of sunflowers. Reproduced widely in the form of prints and postcards, it rapidly became one of the most popular images of the day, joining Underground posters on the walls of youthful art lovers. Perhaps inspired by Van Gogh, Eric and Tirzah grew sunflowers in their tiny garden in Hammersmith when they were first married, but they were outdone by the green-fingered Edward Bawden.

At Brick House, so Tirzah recalled, 'There was a row along the wall by the lavatory and half way up the garden, the cream of the collection, a monstrous double sunflower grew to huge maturity. So large and so splendid was it that looking up to its vast centre I felt that I should never be satisfied with any future sunflower I might grow, this was the limit.'[46]

Ravilious drew plants more often than he did people, perhaps because the shapes of flowers and leaves could be distorted without their essence being lost. This may only be a pencil drawing, but the sunflowers blaze.

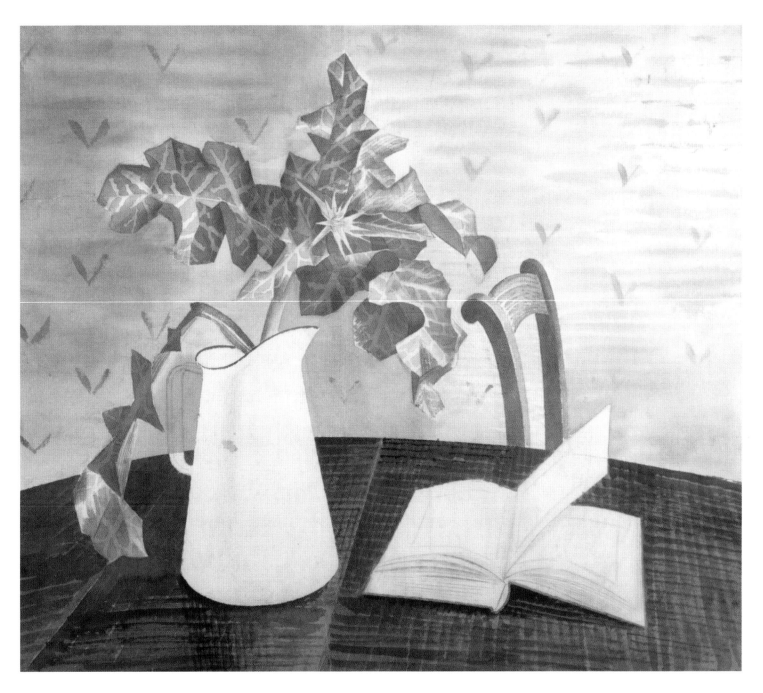

STILL LIFE WITH ACANTHUS LEAVES

1938–39, watercolour and pencil on paper, 45.8 × 53.4 cm, private collection, on long-term loan to The Fry Art Gallery.

The spiny leaves of the acanthus plant have a long and noble history in Western art and architecture. Ancient Greek and Roman architects used them to decorate the capitals of Corinthian columns, and they remained an important decorative feature of Byzantine and Gothic stonework. William Morris returned to the tradition in 1875 with his Acanthus wallpaper, a flowing, layered design based around scrolling, intertwining leaves, which bears almost no relation to the plant as depicted by Ravilious.

Given Bawden's fascination for wallpaper and admiration for Morris's block-printing technique, it is likely that Ravilious saw this pattern, and he would certainly have been aware of the plant's long history as a decorative motif. What he has given us is something quite different. These leaves (of a variegated variety) are angular, crumpled, twisted; they could be made of the same metal as the jug.

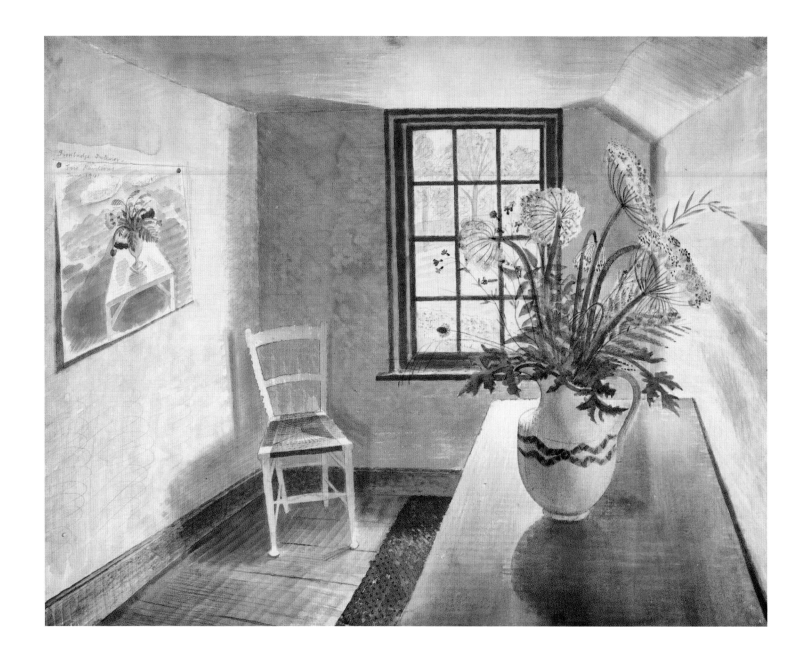

IRONBRIDGE INTERIOR

1941, watercolour and pencil on paper, 46 × 57.7 cm, private collection, courtesy of Towner, Eastbourne.

The move to Ironbridge Farm in 1941 had one notable effect on Ravilious's career. The property was considerably grander than their previous house in Castle Hedingham, and the rent was too high for their wartime income. So their landlord, the eminent left-wing author and politician John Strachey, agreed to take half in cash and half in paintings, and whenever the artist came home on leave he painted a watercolour or two.

Perhaps he saw this work as a chore, but the best of these watercolours show him painting with a new freedom and lightness. After all, these pictures were not destined for public display or critical scrutiny. They were for the eyes of his landlord's family only, and so Ravilious painted flowers with unconstrained delight.

FLOWERS ON A COTTAGE TABLE

1942, watercolour and pencil on paper, 51 × 56 cm, private collection.

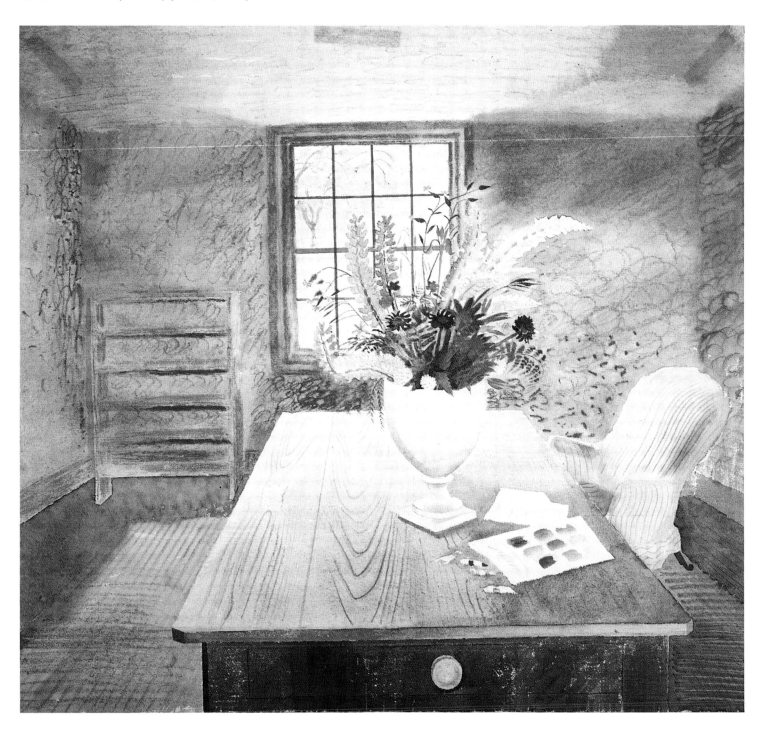

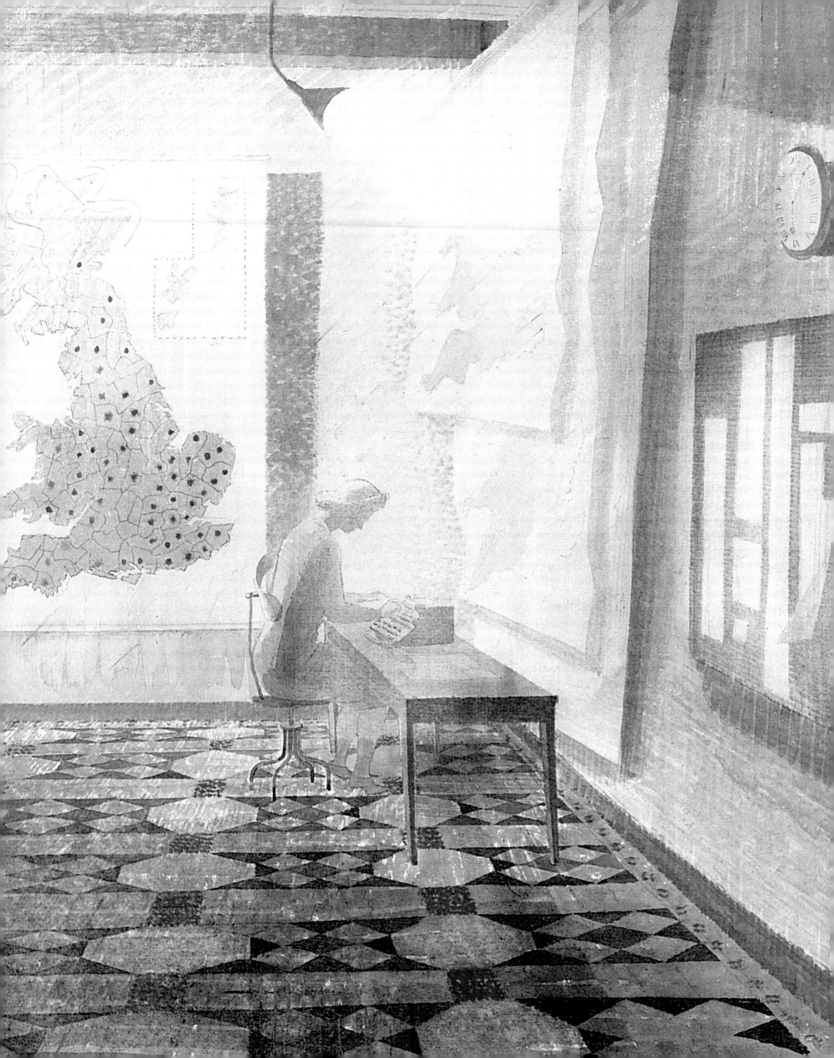

INTERIORS

THE GREENHOUSE, CYCLAMEN AND TOMATOES

1935, watercolour and graphite on paper, 47 × 59.7 cm, Tate: presented by Sir Geoffrey and the Hon. Lady Fry in memory of the artist 1943.

Focus on the shapes in this painting and we perceive a gradually diminishing progression of rectangles and triangles, so carefully arranged that we could trace these geometric shapes and make an abstract composition. Look again, and we are once more in a greenhouse, with bunches of yellow tomatoes hanging overhead and the smell of warm, damp compost.

That year, 1935, saw a minor revolution take place in the London art world. Since the end of the Great War a group of painters and sculptors had shown together every year as The Seven and Five Society. Ravilious had never done so, but Bawden's work had been exhibited alongside paintings by Ivon Hitchens, Christopher Wood, Frances Hodgkins, Ben and Winifred Nicholson, David Jones and John Aldridge at the Leicester Galleries in 1932, 1933 and 1934. Not, however, in 1935.

That was the year when Ben Nicholson and John Piper staged a coup, renaming the society The Seven and Five Abstract Group, and permitting only abstract art to be included at their Zwemmer Gallery exhibition.

This was the first purely abstract art exhibition in Britain, and a sign of things to come. But perhaps it was simply coincidence that Ravilious at this time began to brace his paintings with such taut design.

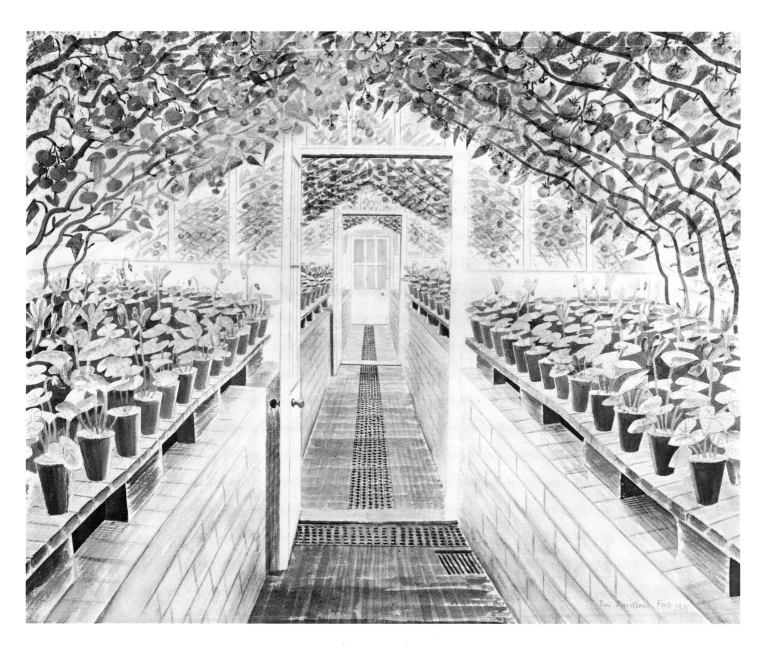

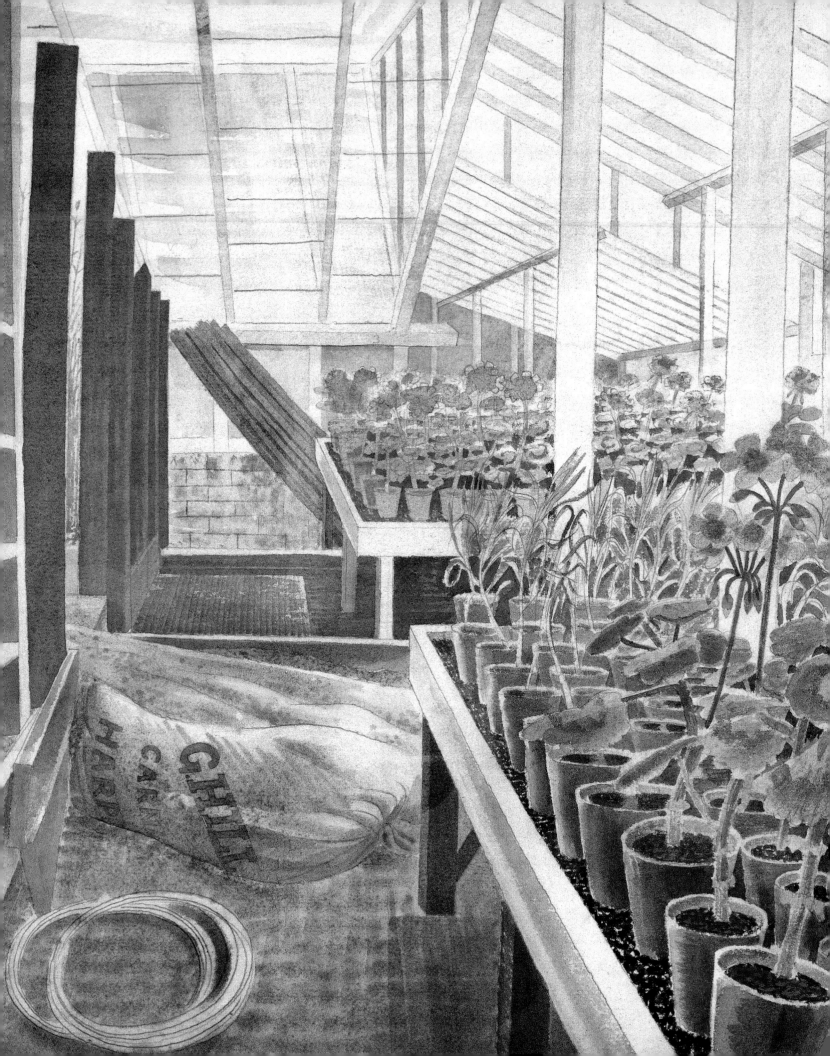

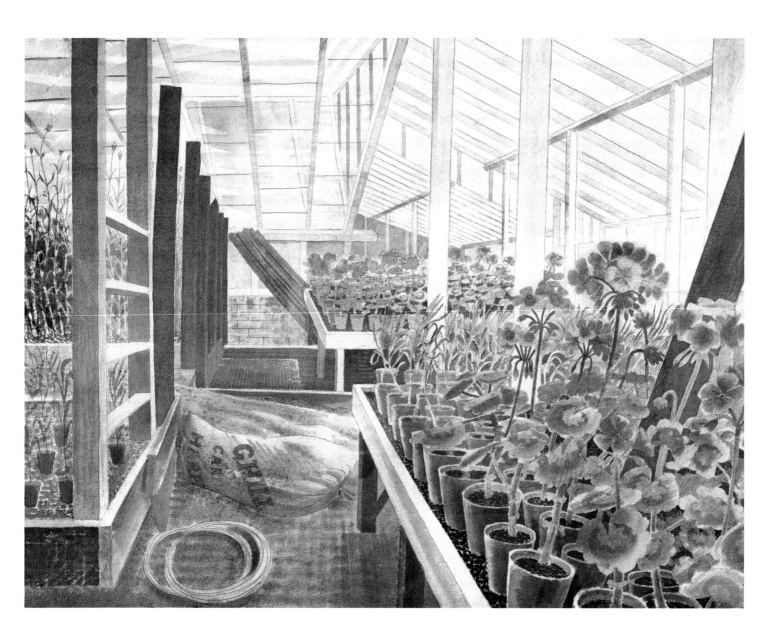

GERANIUMS AND CARNATIONS

1938, watercolour and pencil on paper, 39.4 × 52.1 cm, private collection, on long-term loan to The Fry Art Gallery.

Is something mysterious going on here – sinister even? Ravilious rarely painted simply what he saw, although he did generally use a real place as the starting point for a composition, and this greenhouse might still be standing in or close to Wittersham, north of Rye in Sussex. He stayed in the village in 1938, hoping for inspiration in countryside that Paul Nash had found so fruitful a decade earlier, but struggling with the open spaces of Rye Marshes. So instead he found this greenhouse and made a quite beautiful study of geraniums – so striking in colour and poise that you can almost smell their scent – against the geometric wooden structure.

But he also included a coil of wire, and a sack bearing the name G.HILL and CARN (perhaps CARNATION). These objects are in the way. We feel that the head gardener would have them shifted in a jiffy. And partly perhaps because they shouldn't be there we are drawn to that coil of wire and that sack, lying on its side, full of … what? A shipment of compost, perhaps. We don't know. All we do know is that everything in the greenhouse is on display except for the contents of the sack. It is difficult not to wonder.

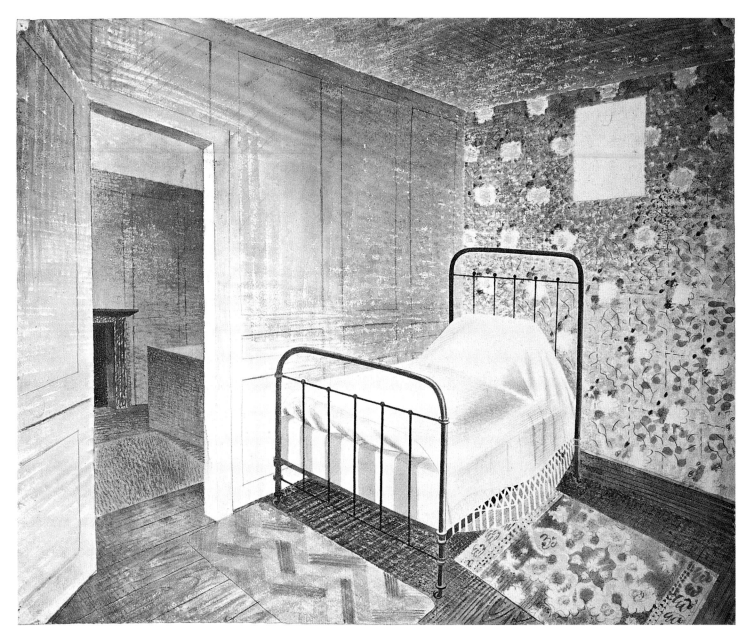

THE BEDSTEAD

c. 1939, watercolour and pencil on paper, 44.1 × 54.4 cm, Towner, Eastbourne.

Visiting Le Havre during a cold snap, Ravilious was forced to retreat indoors regularly, and as with *A Farmhouse Bedroom* he took the opportunity to paint a decorative but unsettling interior.

Here, the bedroom itself is a curious mixture of institutional efficiency (a bed on casters) and decorative exuberance, but the drama of the piece lies in the open doorway and the fireplace beyond.

Whenever we look at the bedstead and the cheerful rugs our eye is pulled sideways through the doorway into the room beyond and that dark opening. Perhaps this was simply the most interesting way to compose the painting, with contrasts of light and dark that would make the viewer look twice. Outside, the French newspapers were full of the coming war, but nobody could have predicted that this room, the hotel and most of the surrounding port would be destroyed.

A FARMHOUSE BEDROOM

1930s, watercolour and pencil on paper, 45.1 × 54 cm, Victoria & Albert Museum.

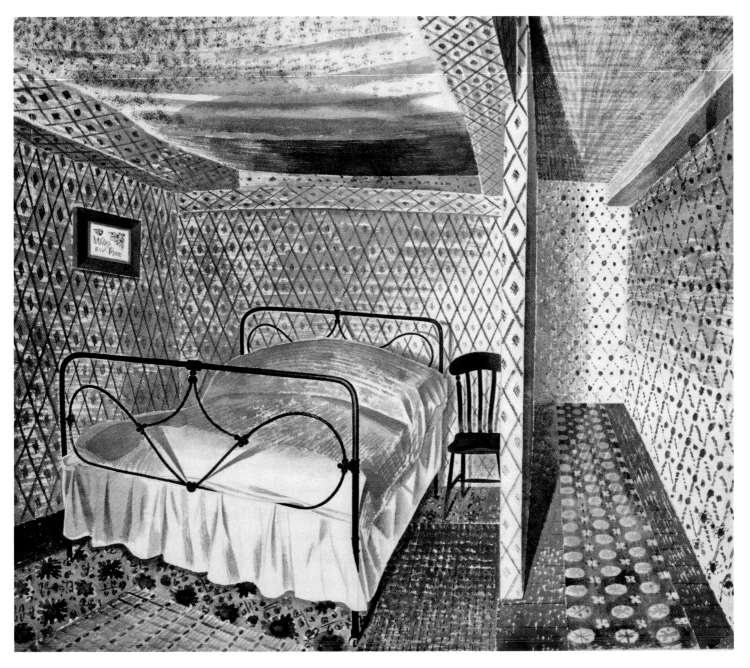

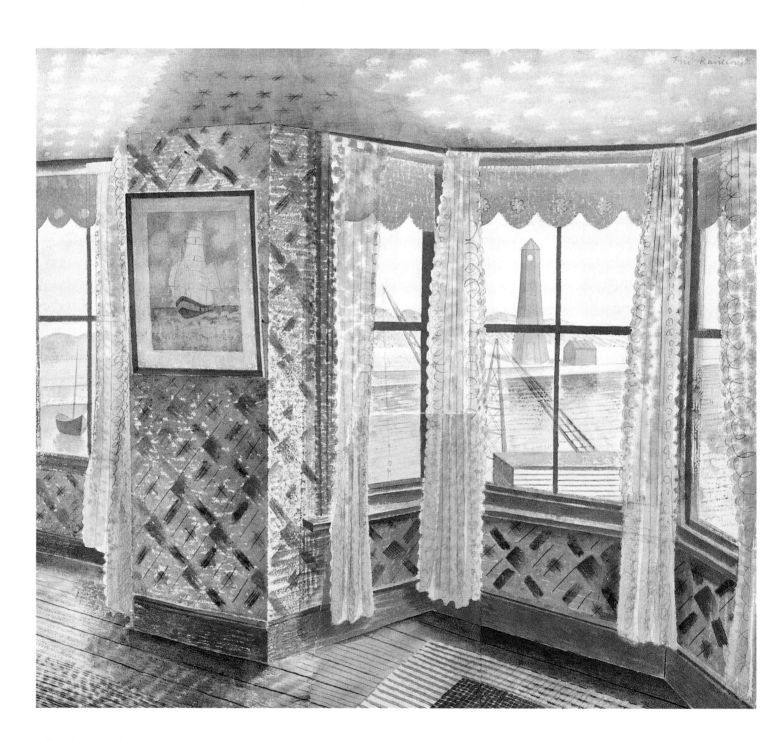

ROOM AT THE WILLIAM THE CONQUEROR

1938, watercolour and pencil on paper, 45.8 × 54.4 cm, private collection.

Ravilious was unusual in that he rarely made preparatory drawings for his watercolours, preferring to work through every stage of the painting on the same sheet of paper. The main drawback with this approach was that he was forced to destroy two-thirds or more of the paintings he began. Indeed, he was brutally self-critical, but apparently saw nothing amiss in leaving colour notes on the finished painting. Look carefully at his paintings and you will sometimes see these pencilled words, barely concealed beneath the translucent pigment.

So he saw no need to erase his notes, and neither did he worry about leaving the odd detail unfinished, or occasionally patching a painting, as he did here. Initially he included a chair in the middle of the foreground, in front of the window, but changed his mind and removed it. Whatever his reasons for doing so, we are left with a work in which the contrasting worlds of exterior and interior are delicately balanced, and where we can enjoy, with uninterrupted pleasure, that outrageous wallpaper.

INTERIOR AT FURLONGS

1939, watercolour and pencil on paper, 45.8 × 54.4 cm, private collection, courtesy of Towner, Eastbourne.

One of the group of exceptional paintings executed during the summer and autumn of 1939, *Interior at Furlongs* shows the artist matching design and subject in a way that appears effortlessly right. On the face of it, this is a simple cottage interior bathed in pale sunlight, with the bright summer landscape visible through the open door. The scene is empty and still, but at the same time curiously charged. Yes, there is a coat behind the door and a chair in front of the window, but these things are not in themselves enough to create the strange, energized atmosphere of the piece.

Perhaps we are deceived when we think of this as a place. It isn't the interior of Furlongs, after all, but a composition based on the interior, and in a subtle way it is a composition as strange as a Van Gogh. Look, for instance, at the chair. If the light is falling from the doorway, then the shadow is in the wrong place. And what if we were to close the door – would it fit in the frame? As we look more closely, we begin to realize that everything in the painting is slightly distorted. That chair really is an odd shape, when you think about it, but within the altered geometry of the painting it works.

It is not easy to describe in words the complex shapes and angles that lend such energy to so quiet a scene. Besides, to do so would not solve the mystery of this fascinating painting. As with a poem, we can appreciate how *Interior at Furlongs* was made, but something at the heart of it eludes us.

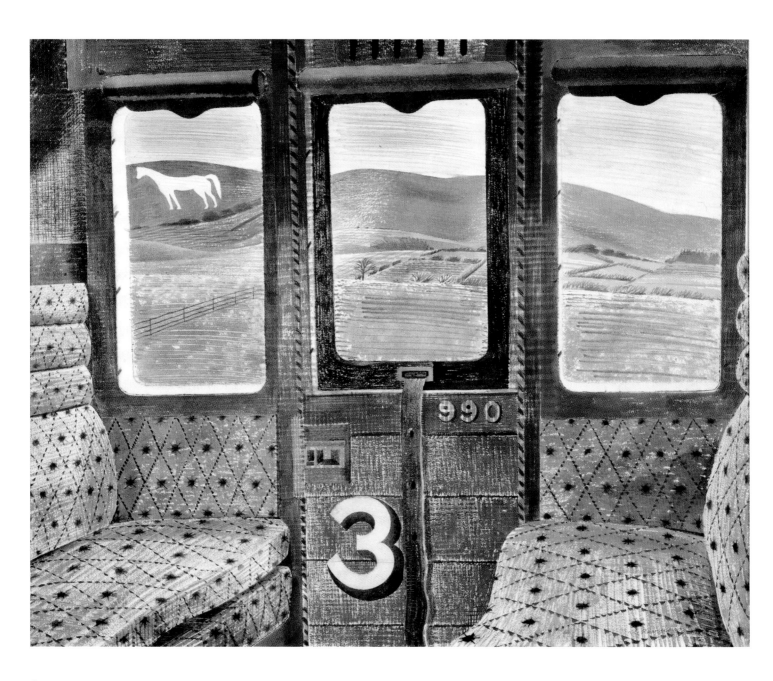

TRAIN
LANDSCAPE

1940, watercolour and pencil on paper with collaged sections, 44.1 × 54.8 cm, Aberdeen Art Gallery & Museums Collections.

Look at the detail in this painting: the upholstery so carefully and sensitively realized; the window strap that is clearly made of leather and not some artificial material; the window fittings and the striped draught strips. The interior of the railway compartment is so beautifully drawn, with such clarity, that it is not difficult to imagine leaning back on that not-very-comfortable seat or tugging at the stubborn window strap. And yet all this precise description would not come to life on the paper were it not for an overarching imprecision. Put crudely, the picture is crooked. On the right-hand side the seat cushions intrude awkwardly. The top edge of the painting cuts across a vent. With so much window available, the white horse has barely made it into the frame at all.

It's as if someone noticed the chalk figure, grabbed their camera and – as the landmark slid by amid anguished cries of 'Hurry up! You'll miss it!' – focused briefly and pressed the shutter. The effect is spontaneous; the moment lives.

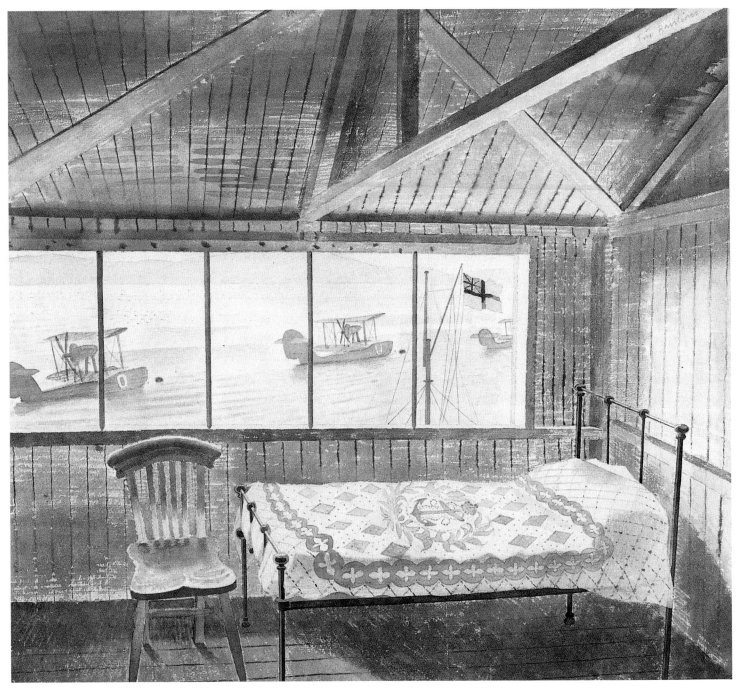

RNAS SICK BAY, DUNDEE

1941, watercolour and pencil on paper, 48.8 × 54.2 cm, Imperial War Museum.

In Ravilious's peacetime paintings of bedrooms the beds tend to be inviting, voluptuous even, but beneath its decorated counterpane this one is hard and narrow. This is an austere room in a Presbyterian land, and the Walrus seaplanes moored outside the window remind us that the times too are serious.

Not that the artist objected to basic living conditions. This room is a precursor to the even more austere world of RAF Sawbridgeworth, where he felt right at home. Aside from the lack of female company, which he always lamented, he enjoyed life at the air base, with its 'lovely wooden huts all yellow and green with latrines among the trees, a very hard bed with calico sheets almost like canvas, no pillow, table, chair or looking glass for shaving'.[47]

The Operations Room shows such a hut, although this one does at least have a chair. A map of Britain dominates the scene, while a large white arrow outside the window adds a surreal touch. Where it is pointing, and what one might see if we sat in the empty chair, we can only imagine.

THE OPERATIONS ROOM

1942, watercolour and pencil on paper, 49.7 × 55.7 cm, The Syndics of the Fitzwilliam Museum.

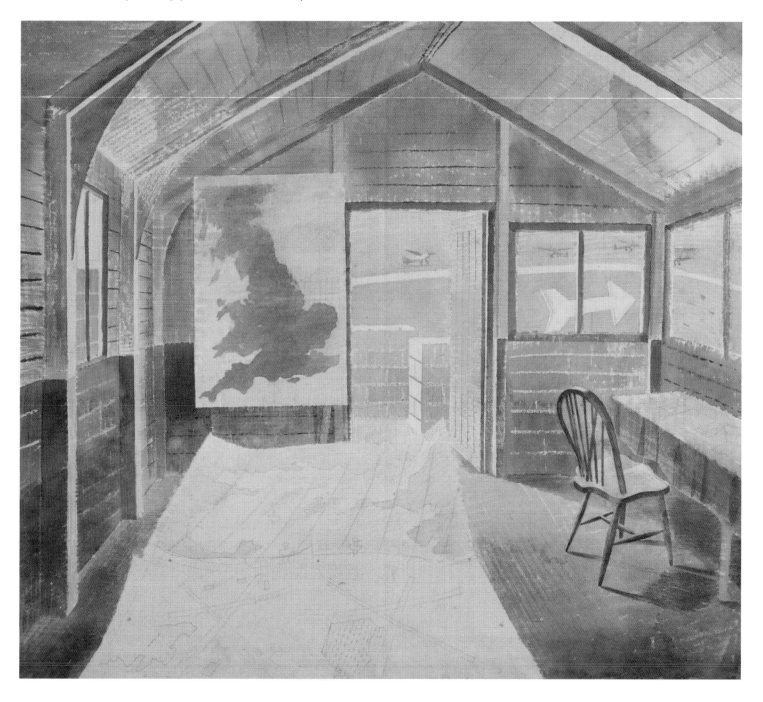

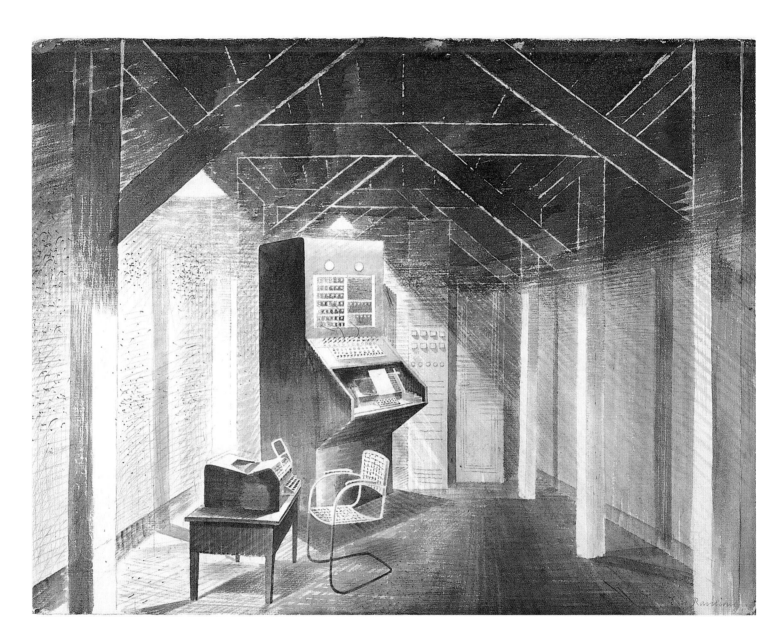

THE TELEPRINTER ROOM

1941, watercolour and pencil on paper, 39.3 × 51.7 cm, Imperial War Museum.

NO. 1 MAP CORRIDOR

1940, watercolour and pencil on paper, 39.4 × 56.5 cm, Leeds Museums and Galleries (Leeds Art Gallery).

In the spring of 1941 Ravilious was invited by Commander Aylmer Firebrace, Chief of Fire Staff, to visit the newly built Home Security Control Room, buried deep beneath Whitehall. He must have spent a considerable time there because he produced a whole set of accomplished watercolours, but there is little record of his activities. We do know that Commander Firebrace approved of the paintings, while the official censor was less enthusiastic.

Having spent the winter working intently on his submarine lithographs,

Ravilious seems to have relished the opportunity presented by interiors that rivalled submarines for strangeness but not for discomfort. People retire into the background, and his eye for the incongruous lights on exotic new machines as it had on abandoned vehicles. While *The Teleprinter Room* is a study of wartime communications technology, with a marvellous modern chair thrown in, *No. 1 Map Corridor* resembles a scene from a Cold War thriller, complete with a shadowy figure in a distant doorway.

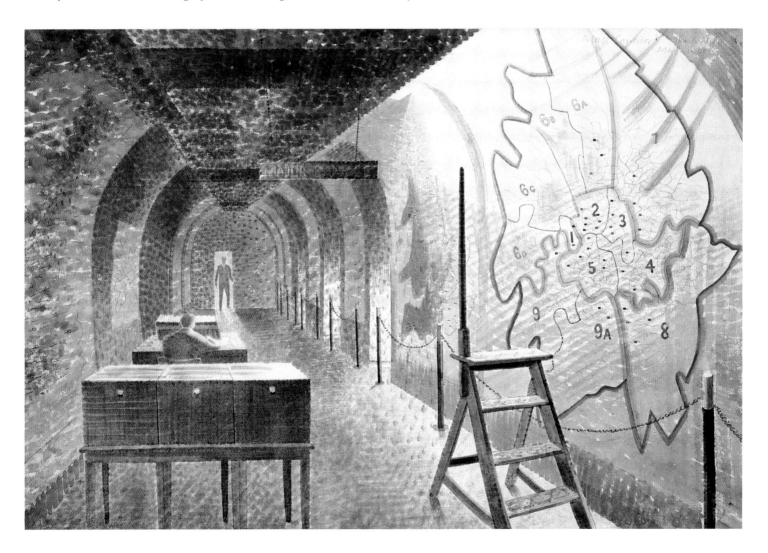

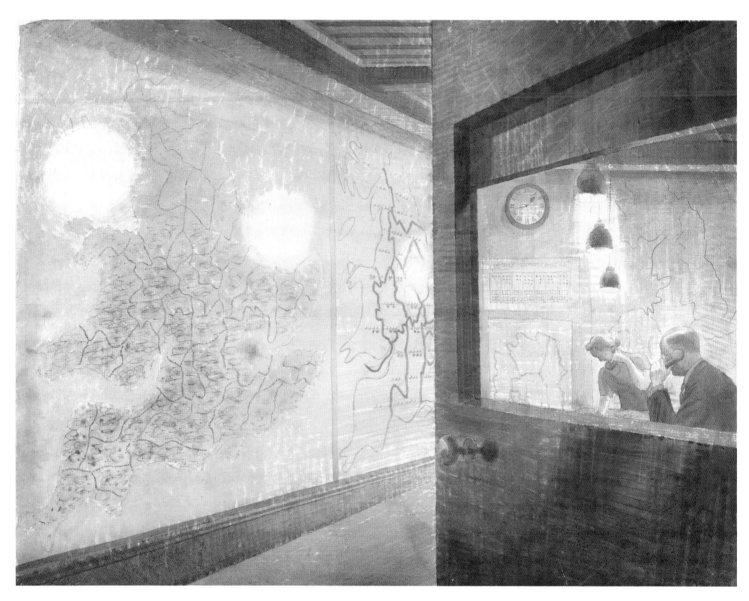

WALL MAPS

1941, watercolour and pencil on paper,
38.7 × 50.8 cm, Imperial War Museum.

ROOM 29, HOME SECURITY CONTROL ROOM

1941, watercolour and pencil on paper, 40.6 × 57.1 cm, Imperial War Museum.

One of the difficulties of looking at a watercolour that is more than seventy years old is not knowing how it might have altered over time. Have certain pigments been affected by sunlight? Has it suffered from damp, or cigarette smoke, or poor restoration? Far more than with oil paintings we are often looking at something subtly different from the picture as originally laid down.

Here we are faced with a compellingly beautiful image that has at its focal point a woman – typist, telegrapher or code-breaker – who might be a ghost. Compared to the floor with its striking pattern she is almost substanceless, and given the artist's fondness for empty chairs and empty beds it is tempting to see her as a deliberate contrivance, a figure hovering between being and nothingness. She might be a representation of anonymous wartime womanhood, one of those countless women without whose contribution the oft-photographed fighter pilots and generals would have been powerless to act …
or she might simply have faded over time.

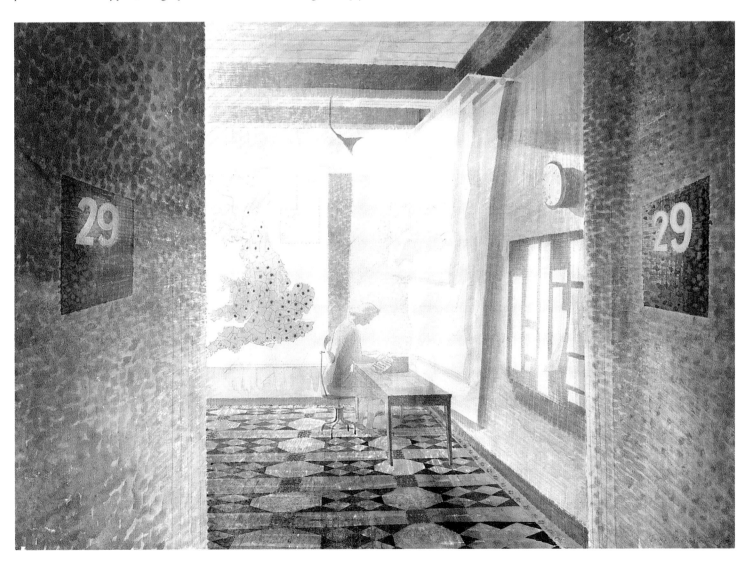

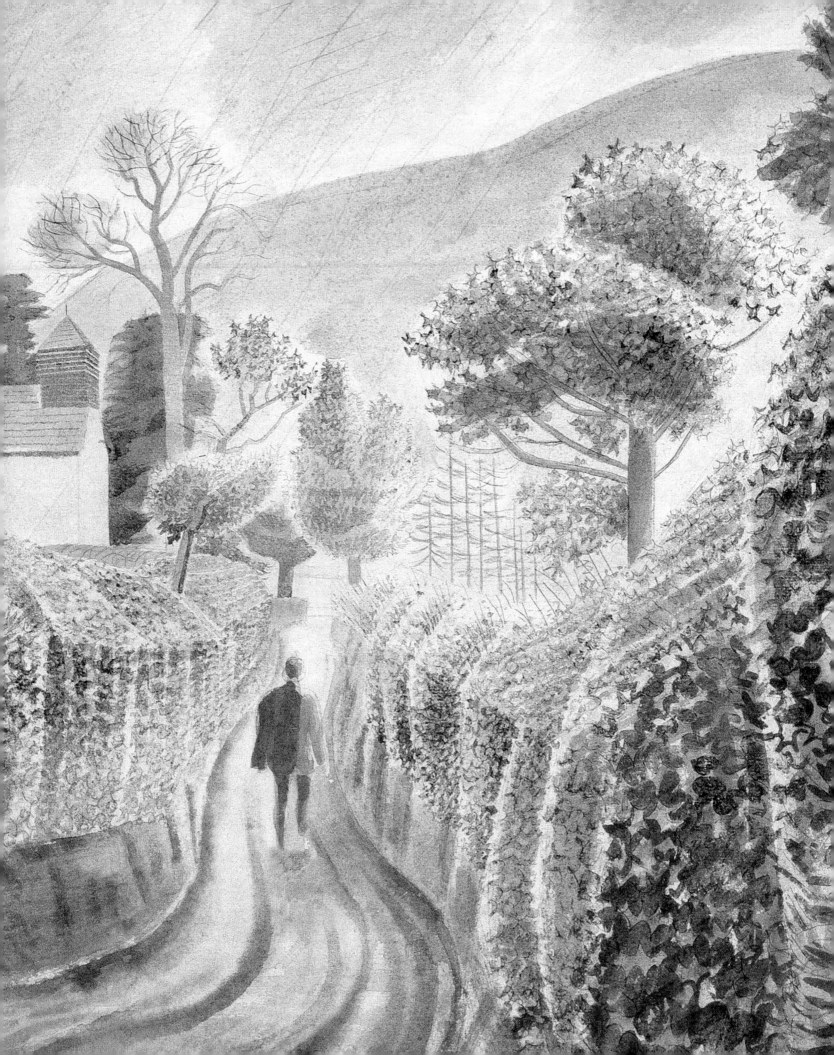

PLACE & SEASON

RIVER THAMES AT HAMMERSMITH

1933, watercolour, ink and pencil on paper 36 × 51.5 cm, private collection,
courtesy of Towner, Eastbourne.

We think of Ravilious as an artist of
place, but how often are his paintings like
snapshots of a particular moment? Later
in his career he became adept at handling
time in a way that was more theatrical
than documentary, so that in *Geraniums and
Carnations* or *Interior at Furlongs* we sense
that a moment has been captured without it
being necessarily July 1938 or August 1939.
This, by contrast, is a history painting.

The car belongs to a particular time,
and so do the osier beds on Chiswick Eyot,
since the harvesting of willow for basket-
making ended only a few years after this
watercolour was painted. The workman
is not engaged in some generic task but in
the building of a new slipway, which is still
there today. In fact you could probably date
this painting from the various activities
shown, which leads to a tantalizing
question. Did the artist simply paint what
he saw going on that day on Chiswick Mall,
or did he include all these historical details
deliberately?

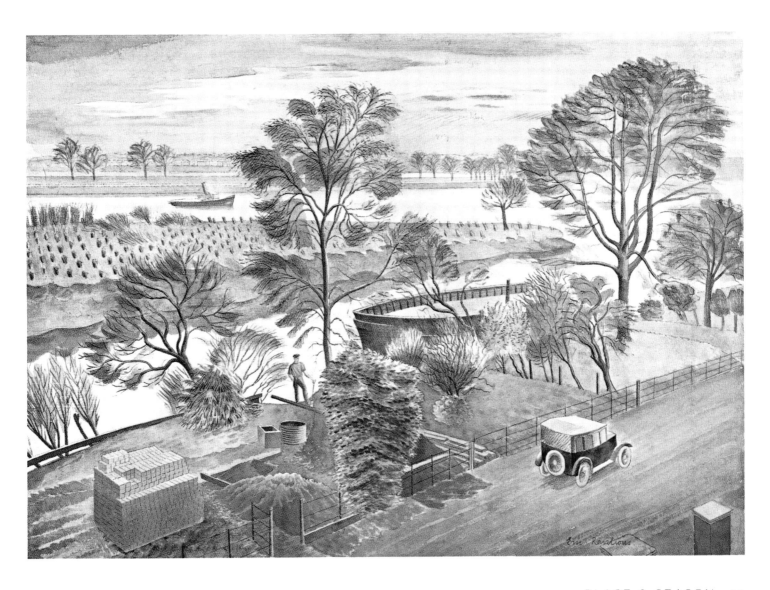

FIRLE BEACON

1927, watercolour, pen and pencil on paper, 40 × 49.5 cm, National Museum of Wales.

Based on a view of the Sussex Downs not far from Eastbourne, the breezy painting *Firle Beacon* is busier than later works but successfully draws our eye towards the distant landmark, then back to the fence in the foreground. So often in a Ravilious watercolour we find our gaze pulled between competing points of interest, and he seems to have realized early on the importance of keeping the viewer engaged in this way. Most compelling though is the fence, and particularly the play of contrasts that makes it light against dark in one place, dark against light in another.

Litlington, Sussex has something of the haunting atmosphere of the artist's later watercolours and evokes the place beautifully, but *Firle Beacon* grasps and holds the attention.

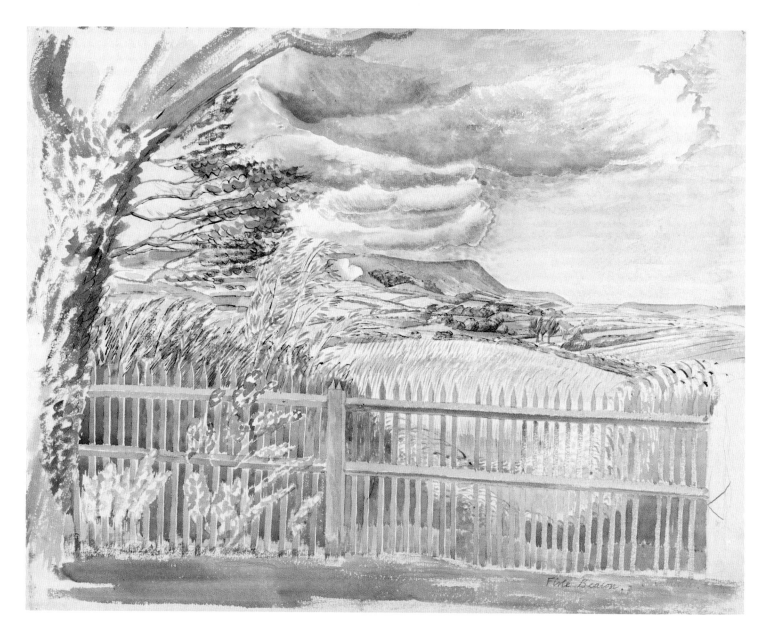

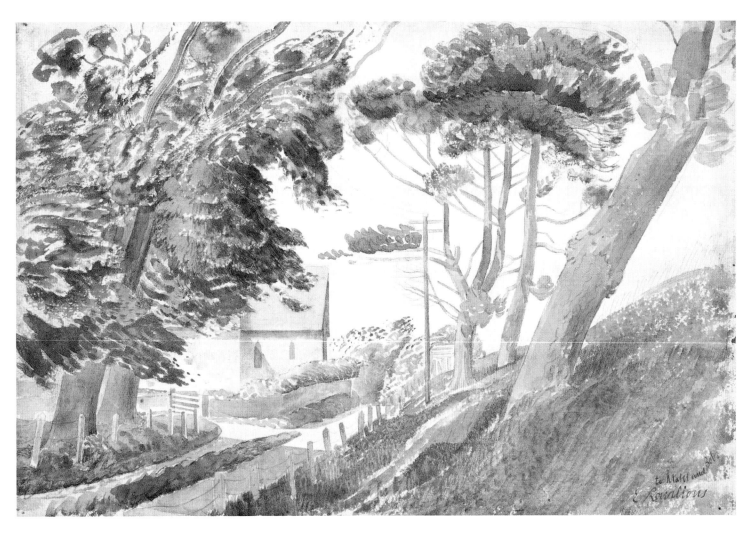

LITLINGTON, SUSSEX

c. 1920, watercolour, ink and pencil on paper, 25.2 × 36.7 cm, Towner, Eastbourne.

MOUNT CABURN

1935, watercolour, pen and pencil on paper, 47 × 58.2 cm, private collection, courtesy of Towner, Eastbourne.

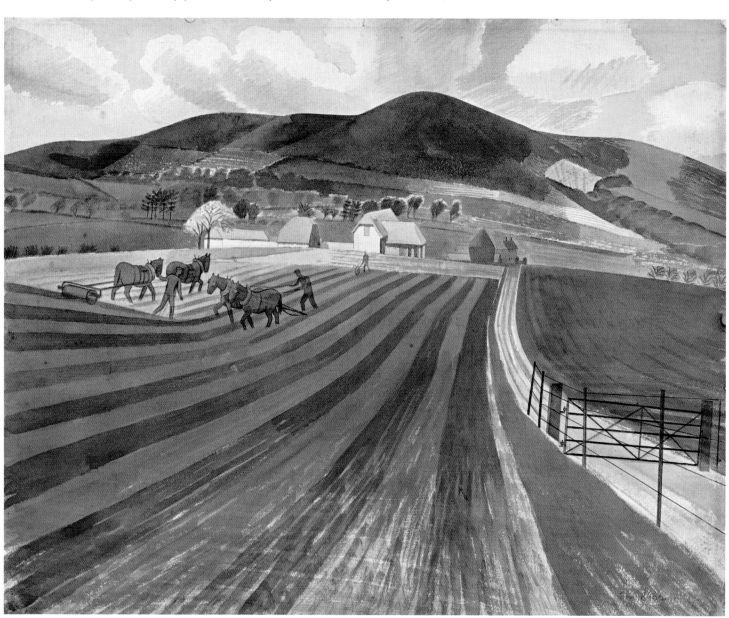

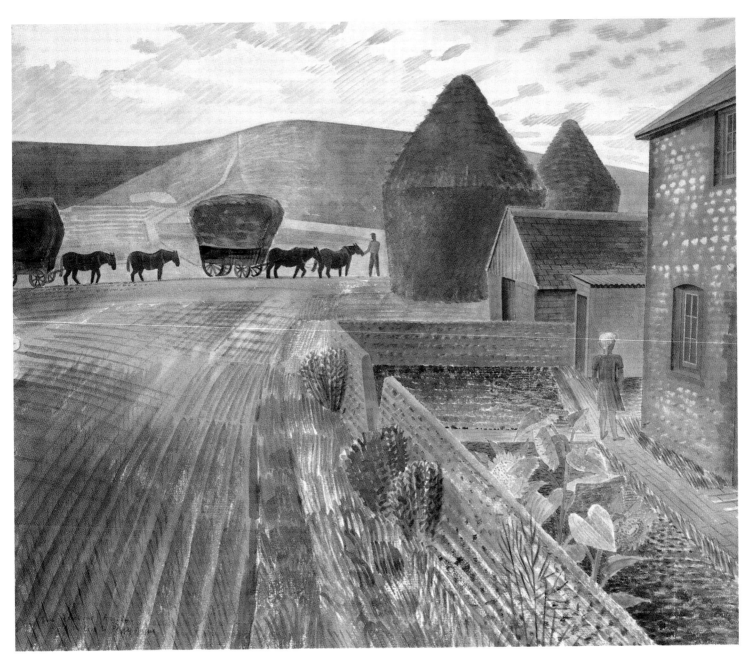

FURLONGS

1935, watercolour and pencil on paper, 43.2 × 50.8 cm, private collection.

After Ravilious left Eastbourne for London, Peggy Angus took up a post at the Art School and fell in love with the Sussex Downs. In 1933 it was her turn to leave, and she determined to find a cottage with a spare room to let for holidays; she walked purposefully from Alfriston to Beddingham, making enquiries as she went, until she found Furlongs, a shepherd's cottage belonging to tenant farmer Dick Freeman. Although the cottage next door was occupied by the ploughman (seen working in these paintings during different seasons), this one was empty and, after a lengthy campaign, Dick agreed to let the place to Peggy. When Ravilious visited the following spring, his life and art both changed.

Peggy was still living part-time at the cottage in 1987 (and paying the same rent), when *Furlongs* was included in the exhibition 'Furlongs: Peggy Angus and Friends' at the Towner Art Gallery. Alongside this painting and Angus's own work were paintings, drawings and photographs by an array of artists who had stayed at the cottage over the years, including John Piper, Percy Horton, Edwin Smith, Kenneth Rowntree and Philippa Threlfall.

THE CEMENT PIT

1934, watercolour and pencil on paper, 44.4 × 55.8 cm, private collection.

Describing Furlongs and its environs, Tirzah wrote: 'There were two cement works nearby, one called Greta and the other Garbo, and Eric was delighted with them and the funny little engines which drove the trucks. He was very happy there and did a series of cement works pictures.'[48]

Until he stayed at RAF Sawbridgeworth during the war, there were few places Ravilious found so inspiring, and none where he was more productive. But what was it about these works, which many people considered an eyesore, that inspired him so much? Was it the strangeness of the scene, covered as it was by a layer of white dust? Or the incongruity of the dolly engines and their tracks? Part of the attraction, perhaps, lay in the scale.

When Ravilious wrote to John Rothenstein in 1937, enquiring about the possibilities of painting in a New England town, he commented, 'I hope the scene is small in scale but it most likely isn't.'[49] In the cement works he had found perhaps his ideal scale, a miniature landscape complete with dramatic cliffs and deep gorges: a kind of modern, industrial – and in a strange way domesticated – version of the Romantic landscapes painted by Cozens and Towne.

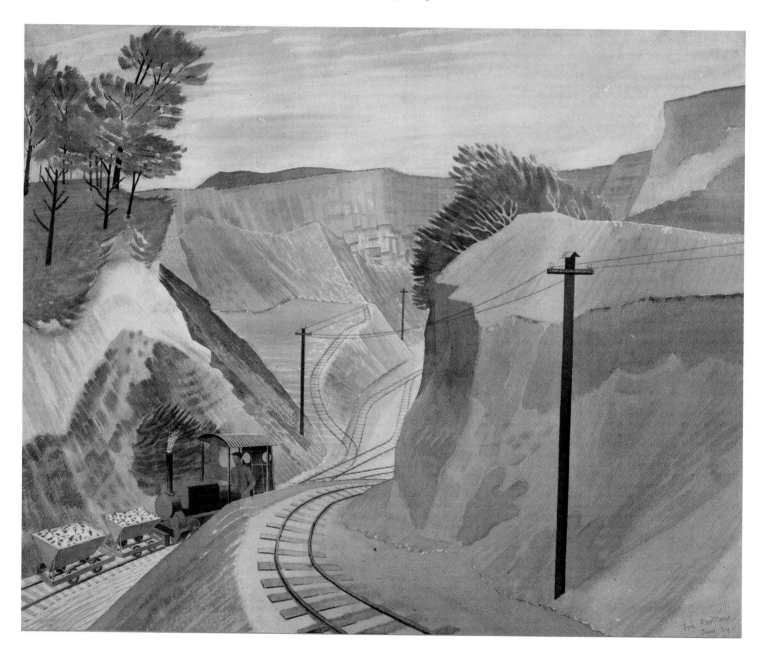

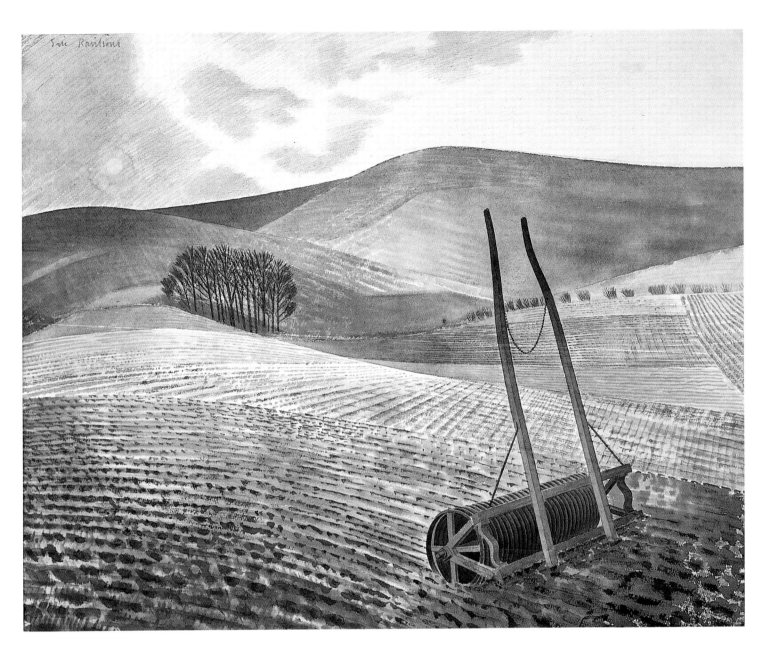

DOWNS IN WINTER

1934, watercolour and pencil on paper, 44.5 × 55.5 cm, Towner, Eastbourne.

A roller stands in barren winter fields, the furrows and folds of which are represented with the kind of economical mark-making pioneered by J.R. Cozens and visible too in Palmer's work. What makes this painting so strikingly modern is the inclusion of the roller, a meticulously drawn artefact surrounded by landscape that is suggested rather than drawn.

Is this a 'character' or 'personage', to use Paul Nash's splendid term for objects that stood in for people? Nash's painting *Event on the Downs* (p. 11) has a similar setting to this watercolour, and it is staged to suggest some mysterious happening. For a time Nash considered himself a Surrealist and urged his former student to declare an allegiance to the burgeoning movement, but without success. So we are left with the feeling that there is more to this painting than simply a roller in a winter field, but that is all.

TEA AT FURLONGS

1939, watercolour and pencil on paper, 35 × 43 cm, The Fry Art Gallery. Presented to The Fry Art Gallery by Jane Tuely.

In November 1939 Ravilious wrote to his friend Cecilia Dunbar-Kilburn, urging her to sell boules sets at her London design store Dunbar Hay. 'I played just before the war,' he told her, 'in Chermayeff's garden on a fine Sunday evening.'[50] World War II had only just begun, yet he wrote as if looking back from a great distance. The 1930s had not been easy, but he appreciated what 'before the war' already meant.

He had spent that golden late August with Peggy Angus at Furlongs (and visited architect Serge Chermayeff at nearby Bentley Wood one Sunday). This was one of the resulting paintings, but did he finish it then and there or was he working on it in November, when he was so charged with the memory of peace?

This is certainly a scene of tranquillity. The table is laid for tea, and someone has already brought out the bread and butter. Beyond the garden wall the wheat is almost ready to harvest, and Beddingham Hill rises to meet a sky as yet untroubled by hostile squadrons. With the mismatched crockery and chairs this is evidently no grand affair. It is, simply, a particular moment in a particular place: tea at Furlongs. Yet the chairs are impossibly slender and the table is brightly illuminated without any obvious light source. The garden wall fails to observe the laws of perspective and the umbrella gives no shade. The more you look, the more you might think that this scene is designed to be remembered – not any old tea at Furlongs but the last, the tea that must be preserved against all eventualities.

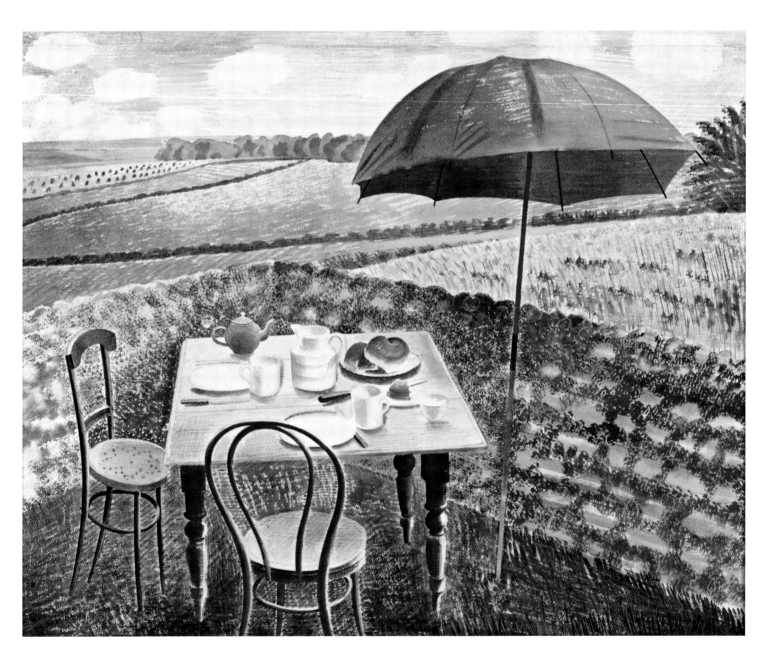

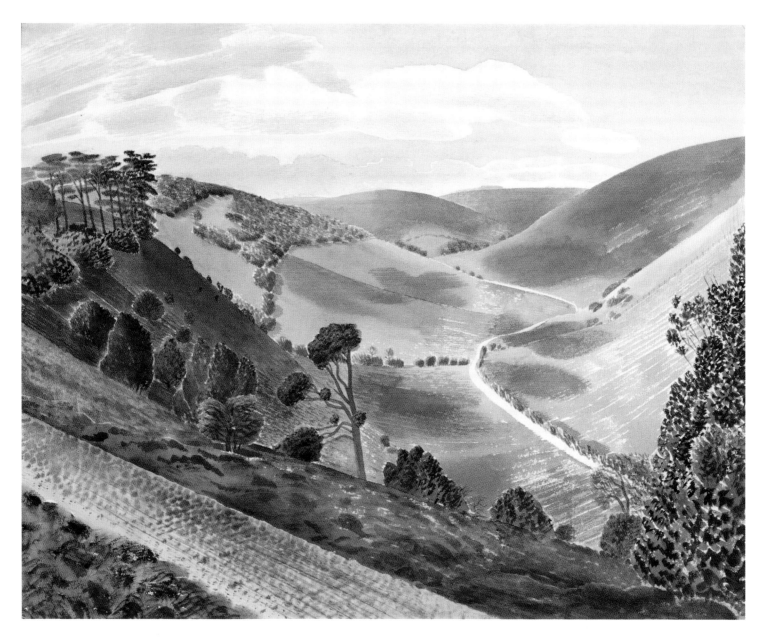

THE CAUSEWAY, WILTSHIRE DOWNS

1937, watercolour drawings, 44.2 × 54.8 cm, Victoria & Albert Museum. Given by the Contemporary Art Society.

WILTSHIRE LANDSCAPE

1937, watercolour and pencil on paper, 42 × 54 cm, private collection.

A trip to Wiltshire in the spring of 1937 produced two paintings that contrast in style but share a sense of longing.

While *The Causeway, Wiltshire Downs* presents undulating hills in a charming and unusually straightforward way, with simple washes of green and little sign of human presence other than the road in the foreground, *Wiltshire Landscape* employs the kind of pattern-making seen in earlier paintings of the downland. This painting is carefully composed, with a row of telegraph poles enhancing the sense of distance and, at the same time, adding structure to the rolling hills. The design is as taut as an aeroplane's wing, yet we still sense the bleakness and beauty of the place. Perhaps Ravilious felt the painting was too melancholy, as he later added the red van – a toy, almost – from a photo in his scrapbook.

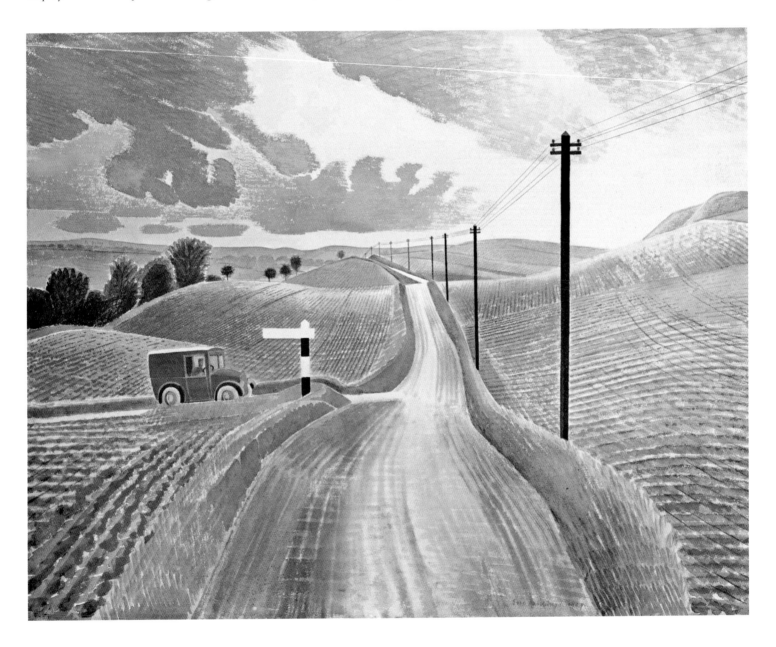

VICARAGE IN WINTER

1935, watercolour, pen and pencil on paper, 72 × 85 cm, collection of David Hepher.

On 15 January 1935 Ravilious wrote to Helen Binyon, 'The snow picture is finished and not bad – rather pretty but so was the thing, like a Christmas card.'[51] The previous winter he had painted a snow scene in oils – one of only two paintings in this medium that have survived – but this was his first successful watercolour of the subject. It is clearly dated, 9 January 1935, a day when Tirzah recorded in her diary that his paint had frozen on the brush.

With its model buildings framed by an ivy-covered tree, this view of the Castle Hedingham vicarage is 'rather pretty', but the sky shows a more sophisticated mind at work. Faced with the problem of how to represent the peculiar radiance of the winter sky he has invented a pattern: a loose, delicate, airy version of the cross-hatching he used to create texture in wood engraving.

He had begun experimenting with pattern in his watercolours the previous year, but this is something of a breakthrough, and a prelude to the bold studies of dawn skies he would make later in his career.

WET AFTERNOON

1938, watercolour and pencil on paper, 43.2 × 50.8 cm, private collection.

DUKE OF HEREFORD'S KNOB

c. 1938, watercolour and pencil on paper, 44.6 × 53.2 cm, private collection.

Among the living painters Ravilious admired was Anglo-Welsh artist and poet David Jones, a watercolourist who spent the mid-1920s living with Eric Gill in Capel-y-ffin. He often painted the hill shown above, which he knew as Y Twmpa. Having noticed, when he arrived in the village years later, that the surrounding slopes were covered in 'flocks of David Jones's sheep',[52] Ravilious included plump cattle in

his painting of the hill, which he called by its English name. With the Baptist chapel in the foreground this is a picture of serenity, in which death coexists with life.

The scene remains much the same today, as do the holly hedges and boxy church of St Mary shown in *Wet Afternoon*. Inevitably our eyes are drawn to the figure striding down the hill away from us. Is he simply a passer-by? Or a kind of self-portrait of the

artist-as-solitary-walker? Or an invention? Ravilious had read Edward Thomas and W.H. Hudson, and Gilbert White was one of his favourite writers. He illustrated *The Natural History of Selborne* with wood engravings and had a lot in common with the ever-curious antiquarian and naturalist. So perhaps we should think of this rambler as a curious explorer of the byways, in search of everyday wonders.

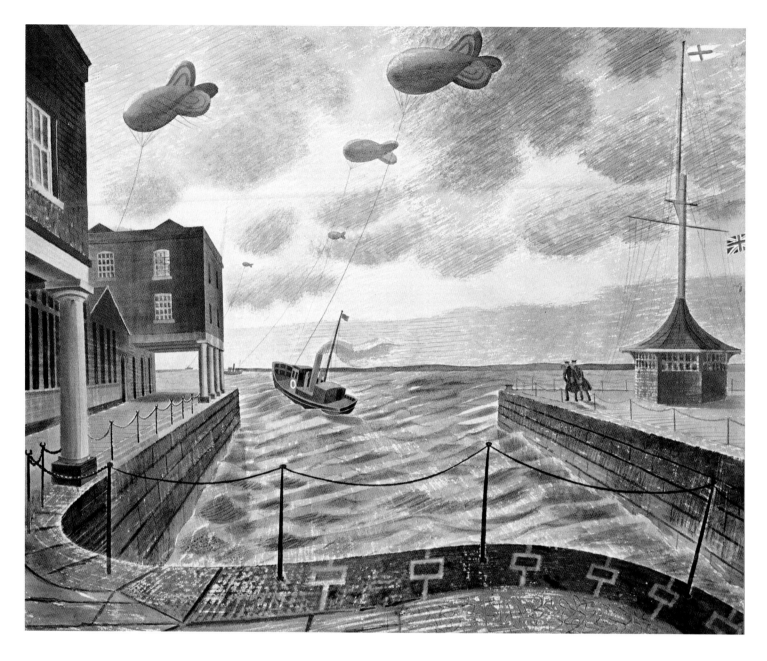

BARRAGE BALLOONS
OUTSIDE A BRITISH PORT

1940, watercolour and pencil on paper, 64.5 × 74.5 cm, Leeds Museums and Galleries
(Leeds Art Gallery).

Leaving the naval dockyard at Chatham
in search of good subjects, Ravilious
discovered this nearby port, writing
'Sheerness, itself, that is to say the docks – is
good – and lovely Regency buildings, almost
Venetian in parts, and oh, the still-life of
buoys, anchors, chains and wreckage! I must
try to remember what I am here for.'[53]

With its flags and slender flagpole the
painting carries echoes of the delightful
seaside mural Eric and Tirzah had painted
together in 1933 at the Midland Hotel,
Morecambe. The colours are more sombre,
but the flags snap tight in a stiff breeze that
fills the scene with life.

LEAVING SCAPA FLOW

c. 1940, watercolour and pencil on paper, 44.4 × 57.2 cm, Bradford Art Galleries and Museums.

This is really a painting of two very different but complementary places: the deck of a World War II destroyer and the sheltered anchorage of Scapa Flow, Orkney. To the left is the iron superstructure of the destroyer, painted with random geometric shapes to camouflage its distinctive silhouette and so foil enemy submariners, and to the right the misty, mysterious hills of Hoy.

There is a functional beauty in the ship's architecture, and the lifeboat is lovingly drawn; likewise the hills are just warm enough to be considered home. But both environments are uncompromising, and the figure on the deck strikes a melancholy note. Whether or not this is a self-portrait of the artist, who travelled from Scapa Flow in May 1940 aboard HMS *Highlander*, en route for Norway, one senses that this is a man who finds himself far from home, in a beautiful but lonely place.

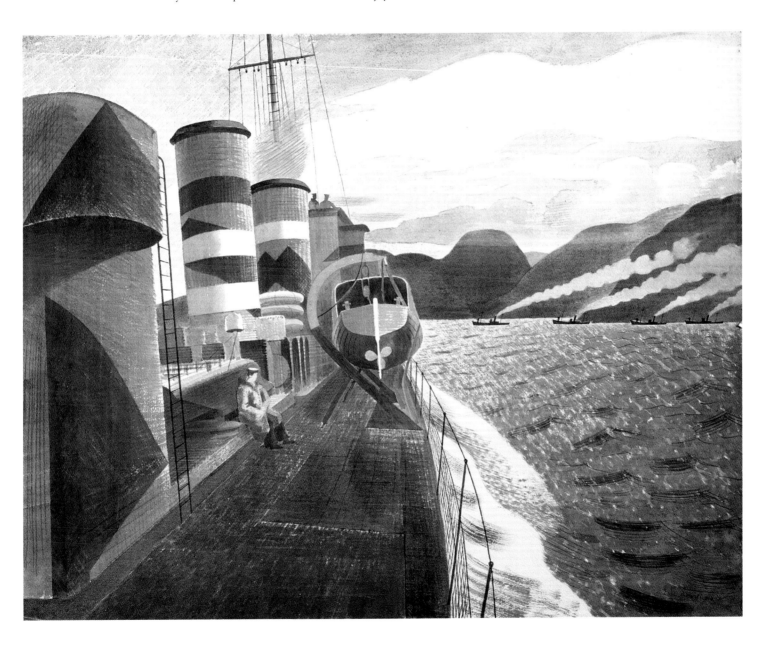

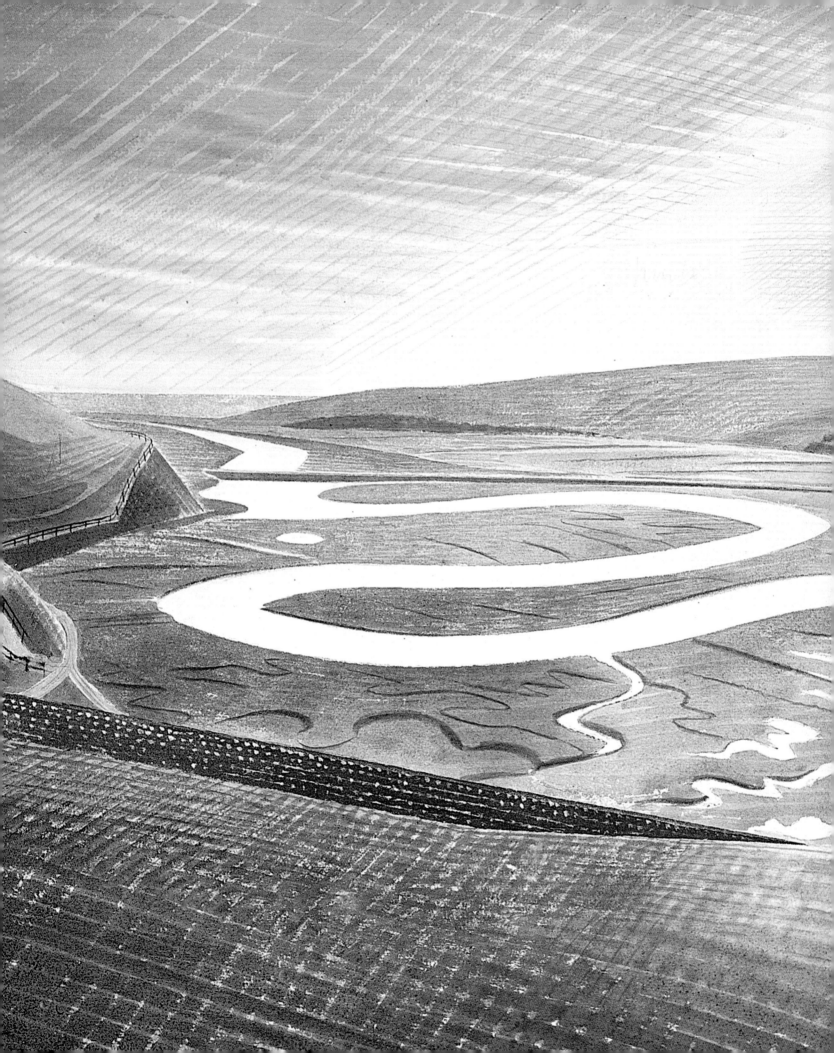

CHANGING PERSPECTIVES

CUCKMERE HAVEN

1939, watercolour on paper, 41.4 × 57.5 cm, private collection, courtesy of Towner, Eastbourne.

How do you set about painting well-known landmarks in an original but recognizable way? Thanks to the outpouring of guide books for motorists, and to pioneering developments in aerial photography, the meanders of Cuckmere Haven and the chalk horse of Westbury were as familiar in the 1930s as they are today.

This view of Cuckmere is still the favourite among photographers, but no photograph ever expressed the artificial nature of the famous waterway with such daring. These meanders could have been carved into the chalk, and the foreground resembles a kind of meshwork – as if the land itself had been roughly modelled and the underlying structure left showing.

A similar technique emphasizes the uneven contours of the hillside into which the white horse is carved. Beyond the humped green hill a train is crossing a flat colourless plain, preserved for all time in the split second before it disappears.

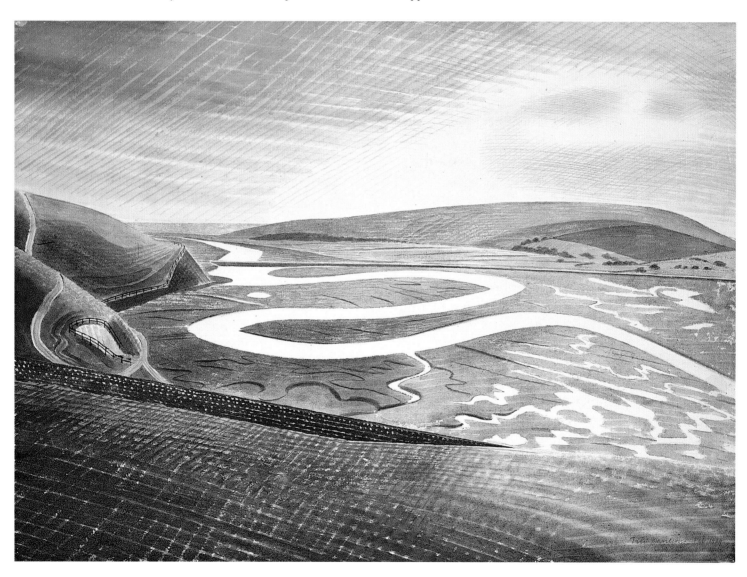

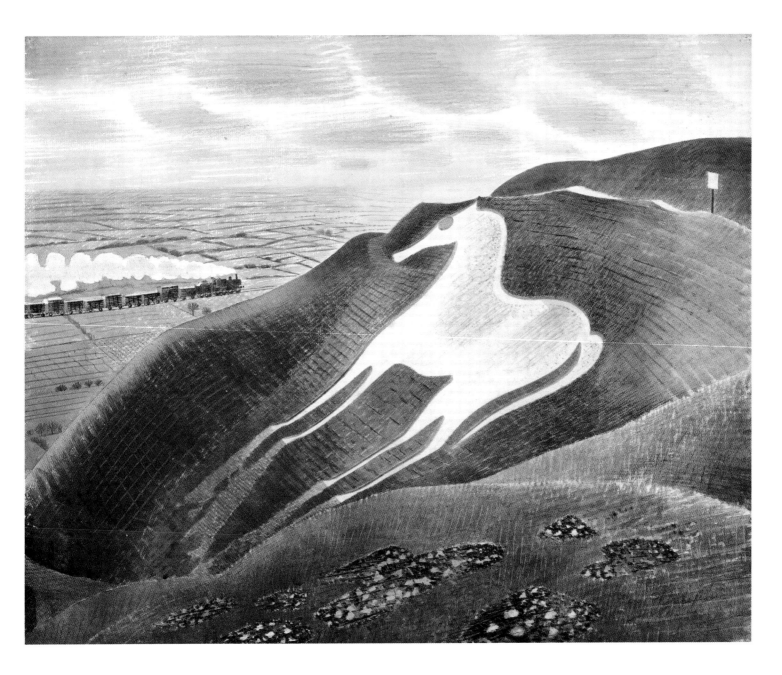

THE WESTBURY HORSE

1939, watercolour and pencil on paper, 44.6 × 54.4 cm,
private collection, courtesy of Towner, Eastbourne.

THE WILMINGTON GIANT

1939, watercolour and pencil on paper, 44.7 × 53.7 cm, Victoria & Albert Museum.

An easy cycle ride from his boyhood home and clearly visible from the window of the Eastbourne–Lewes train, the Long Man of Wilmington intrigued Ravilious greatly. In a rare piece of published writing he mused on its origins, suggesting that it might be a representation of Virgo, and he always referred to the figure by its less gender-specific name.[54] He included it in the Morley College murals and in a wood engraving of the same period, but perhaps waited until he had the technical ability in watercolour to make the figure his own.

He painted the landscape with a dry brush, leaving plenty of white paper showing through and using a range of textures to suggest distant hillside and grass underfoot. From the depths of this landscape, almost at the giant's feet, a fence comes swooping out to meet us, the posts and barbed wire taut and purposeful, while the wayward squares of mesh seem almost to dance away from us down the hill. A stand of corn on the left tells us the season and teasingly suggests a crowd of onlookers, leaning towards the chalk figure, while a single fence post, dark and square, and by far the biggest object in the painting, leans towards it from the right. From this post three perfectly uneven strands of wire extend across the painting, not so much framing as snaring the giant – trapping the moment.

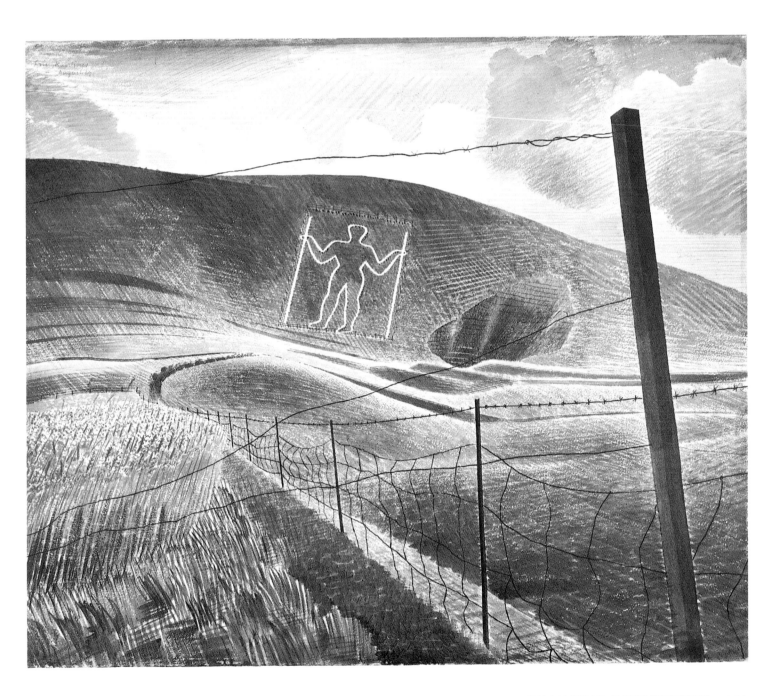

THE CERNE ABBAS GIANT

1939, watercolour and pencil on paper, 44.5 × 54.6 cm, private collection.

Of all the chalk figures painted by Ravilious in 1939 this is the most perplexing. As with his other giant, he has opted to place the figure itself in the background, so that it is dwarfed by a row of crooked fence posts. There is no path leading to this giant's feet; rather, hedges and wire form barriers.

Low grey clouds conceal much of the hillside, and the areas that are visible are barely discernible through the mist. And then there is the giant, a well-known and popular (if mildly scandalous) figure in the early decades of motoring, used to advertise Shell products and much-reproduced on postcards and in books of aerial photography. So anyone seeing this painting would have known that this artist has got it wrong: the giant is supposed to be light on dark, not dark on light.

The following year saw a mass turfing-over of chalk figures, to prevent enemy airmen using them as landmarks. They were made to disappear from the landscape, in other words, but this figure leaps out from it, the antithesis of the Wilmington Giant – dark, unruly, warlike.

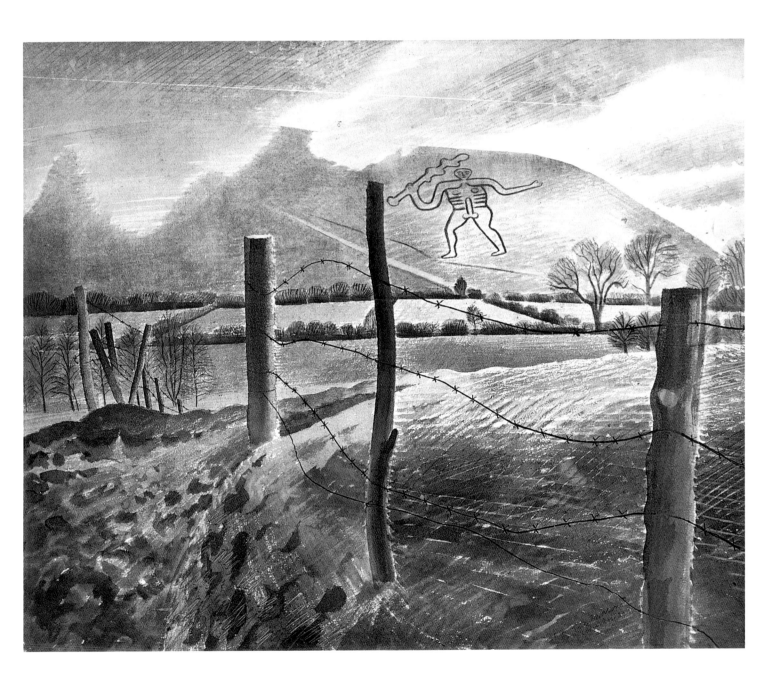

CHANNEL FISHER

1940–42, watercolour and pencil on paper,
51 × 55.6 cm, Ferens Art Gallery, Hull Museums.

It is hard to imagine that this radiant
watercolour was painted in November,
during wartime. Aside from the distant
barrage balloons there is no evidence of
the war. Instead, we can find much to
enjoy here, from the beautiful black-and-
white-striped mooring posts to the terns
standing around on the quayside. Ravilious
had previously used the stripes of mown
grass or harrowed fields to give structure
and a sense of perspective to paintings;
here we are drawn into the picture along
the lines of decking, towards the famous
cantilevered towers of the Forth Bridge.
The sky seems to have been quickly
sketched in, but this remains a breezy,
uplifting painting.

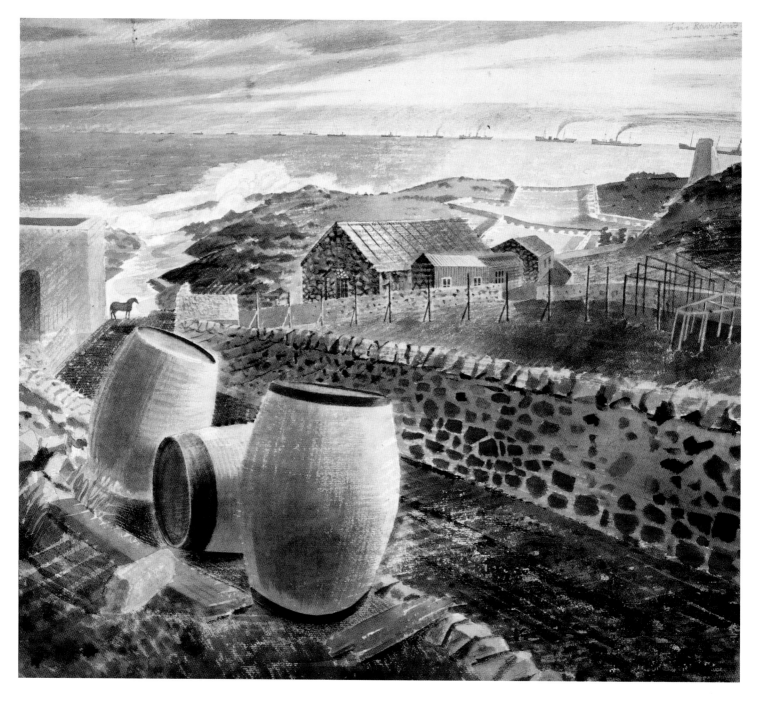

CONVOY PASSING AN ISLAND

1941, watercolour and pencil on paper, 49.5 × 54 cm, British Council Collection. Presented to the British Council Collection by the War Artists' Advisory Committee in 1946.

In November 1941 Ravilious took advantage of an offer from his friends John and Christine Nash to stay with them near Edinburgh, and while there spent a few days on May Island in the Firth of Forth. The weather was wild, the wind bitter, but the sense of freedom in the two paintings he made on the trip is palpable. Yes, there is a convoy massing on the horizon in each picture to remind us of the war, but in *Convoy Passing an Island* it is the island itself with its fish-drying racks, seventeenth-century beacon and cross-shaped sheepfold that is the real subject.

In *Storm*, the working party busy beyond the breakwater is dwarfed by the skiff in the foreground. Faintly haloed, the boat might remind us of a Hokusai fishing boat caught in a great wave, but whereas the Japanese artist treated water and vessel in the same stylized manner, Ravilious contrasts a formless sea with the small craft's elegant design. Order out of chaos? Or – perhaps – a reflection of his pleasure in finding such a beautiful craft in the midst of wartime uniformity?

STORM

1941, watercolour and pencil on paper, 49.5 × 54.6 cm, British Council Collection. Presented by the War Artists' Advisory Committee in 1946.

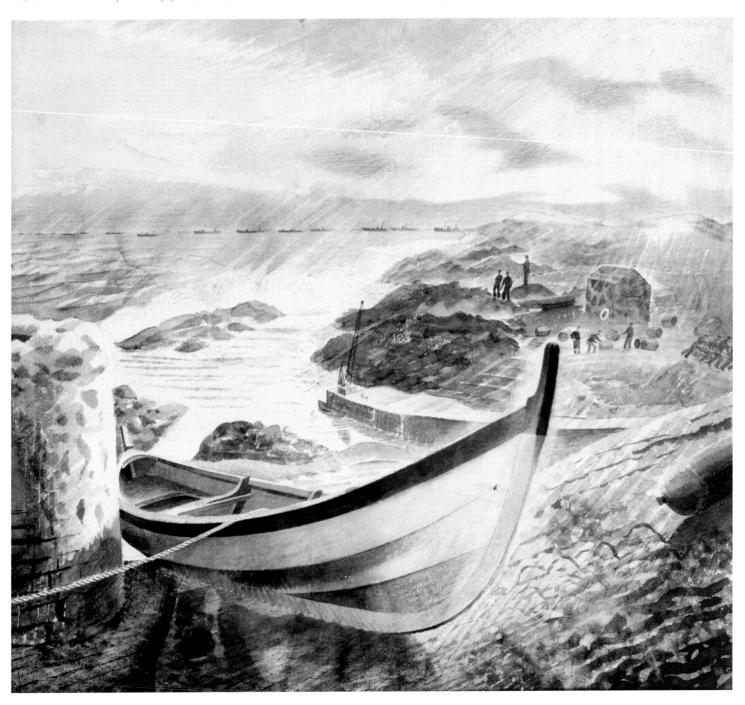

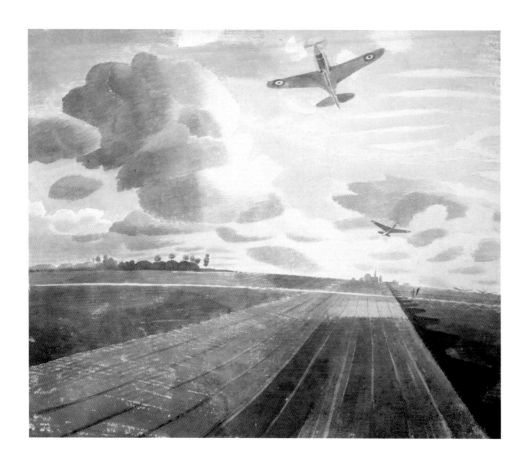

RUNWAY PERSPECTIVE

1942, watercolour and pencil on paper, 45.7 × 54.2 cm, Imperial War Museum.

The flat, featureless fields north of Sawbridgeworth made an ideal site for an airfield, but for a painter the absence of variety in the landscape was problematic. Faced with a monotonous plain ending in a flat horizon, and with the challenge of capturing aircraft in flight, Ravilious found an inventive solution, building the composition around lines radiating out from the church spire towards the right-hand side of the horizon.

Lines rush out towards us along the runway, in both directions along the slightly tilted horizon, and up through both aircraft and the large cumulonimbus, the explosive geometry lending a feeling of speed and energy to the aircraft, so that the closest one seems to be roaring overhead. A tiny figure with a windsock intensifies the sense of distance established already by the miniature church on the horizon. In reality the plain is so broad that the church spire is almost invisible from the spot where Ravilious made this drawing; he has exaggerated its size, rather than reduced it.

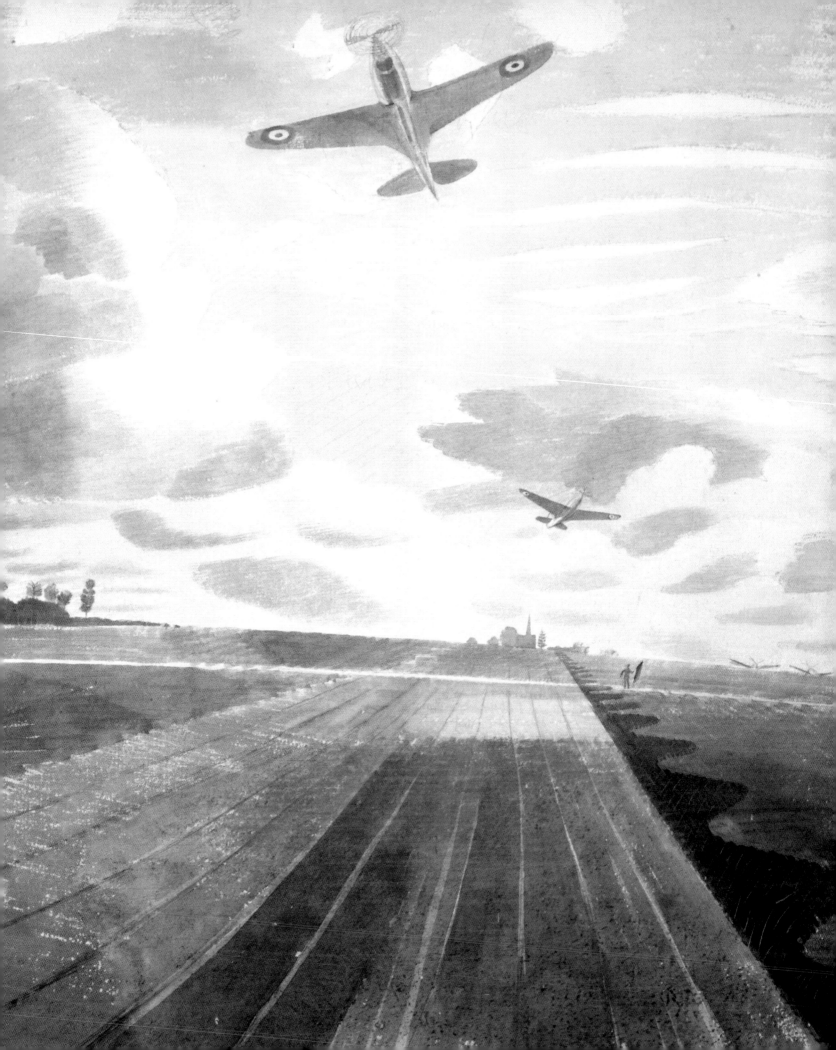

HURRICANES IN FLIGHT

c. 1942, watercolour and pencil on paper, 43 × 56 cm, private collection.

Influence is a tricky subject. Artists are often keen to acknowledge their debt to certain predecessors, while perhaps not even recognizing what they have picked up from others. It is often impossible to show that one artist took an idea from another, even when the likelihood seems high. For example, this drawing bears a resemblance to the 'In the Air' series of lithographs made by C.R.W. Nevinson during World War I. Ravilious might have taken his cue from his predecessor, or he might not have. After all, the patchwork of fields had changed little in twenty years, and when he sketched from the rear seat of a Tiger Moth biplane he saw much the same structure of wing, strut and stay.

But the existence of these two bodies of work does open up intriguing questions.

Ravilious did not shout out admiration for Nevinson, but there is a kinship between them. The older man began his career trying to impose his aggressive sense of design onto everything he saw, then abandoned this approach in favour of more naturalistic landscape painting. The younger found ways of combining structure and nature – borrowing the occasional idea here and there.

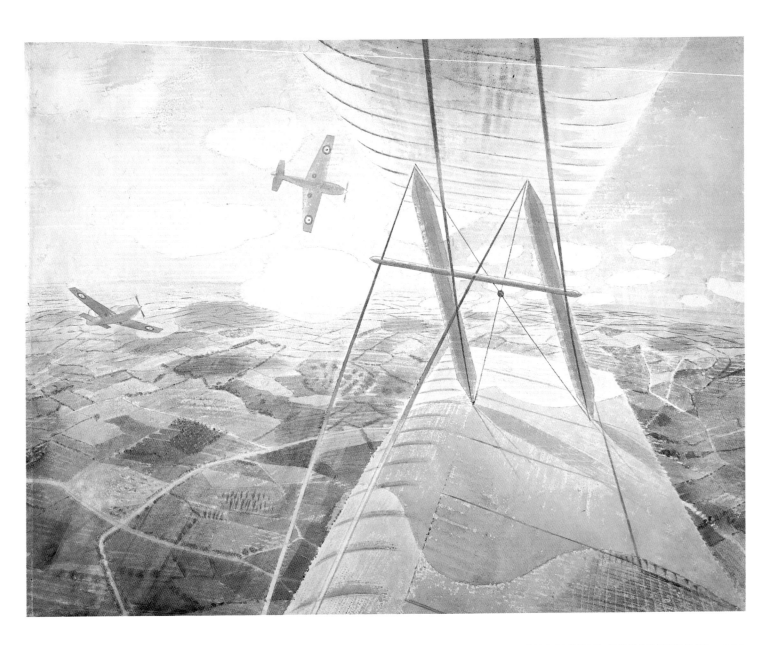

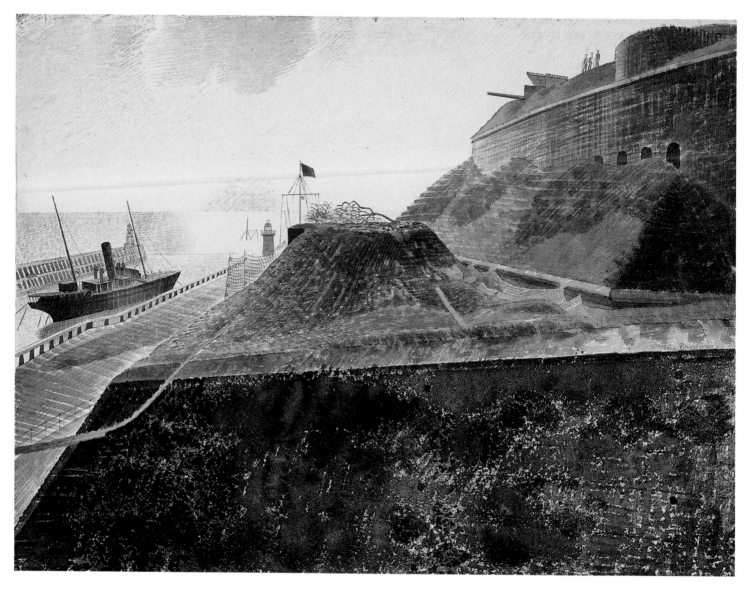

COASTAL DEFENCES

1940, watercolour and pencil on paper, 44 × 58.8 cm, Imperial War Museum.

Ravilious returned to paint in Newhaven repeatedly, but his most intensive period of study took place in the autumn of 1940, when he was sent there by the Admiralty to paint coastal defences. Clambering about on the ramparts of Newhaven Fort, with a heavy service revolver and tin hat in case of enemy attack, he produced paintings from a range of viewpoints, by day and by night. As with the cement works, this was landscape writ small, offering striking contrasts between the massive defences and the harbour below.

In *Coastal Defences* the perspective is similar to that of an earlier picture, *The Stork at Hammersmith*, where (perhaps to avoid the cliché of a conventional river view) walls and fencing stand in front of the boat, which almost melts into the hazy background of buildings and trees.

In the wartime painting we see echoes of other peacetime work, particularly *Newhaven Harbour*, but the pleasures of steamer, sea wall and lighthouse are as distant as memory. Instead our immediate focus is on a great slab of concrete wall, represented in wonderfully textured paint.

THE STORK AT HAMMERSMITH

1932, watercolour and pencil on paper, 37.5 × 57 cm, Towner, Eastbourne.

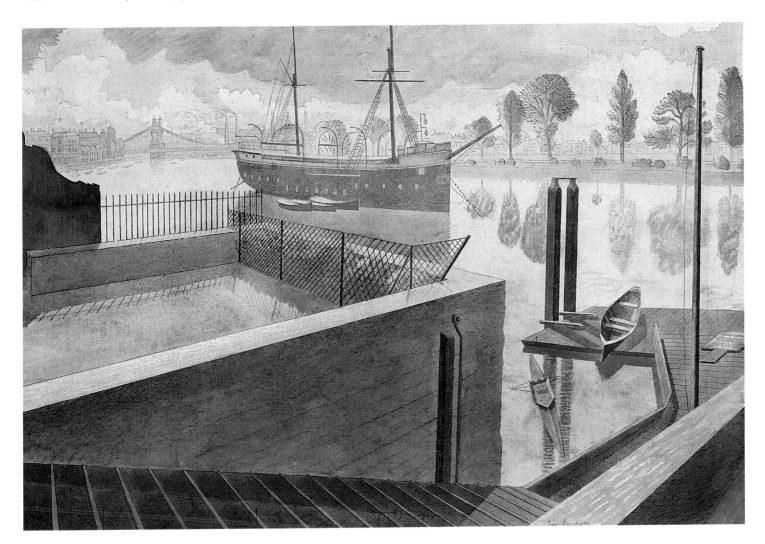

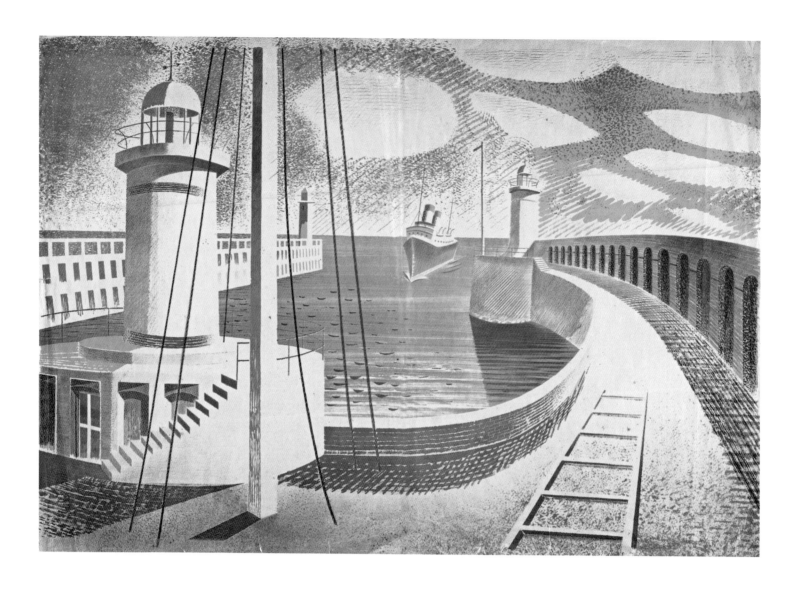

NEWHAVEN HARBOUR

1937, lithograph, 51 × 76 cm, private collection, courtesy of Towner, Eastbourne.

COASTAL DEFENCES

1940, watercolour and pencil on paper, 45.7 × 60.9 cm, Imperial War Museum.

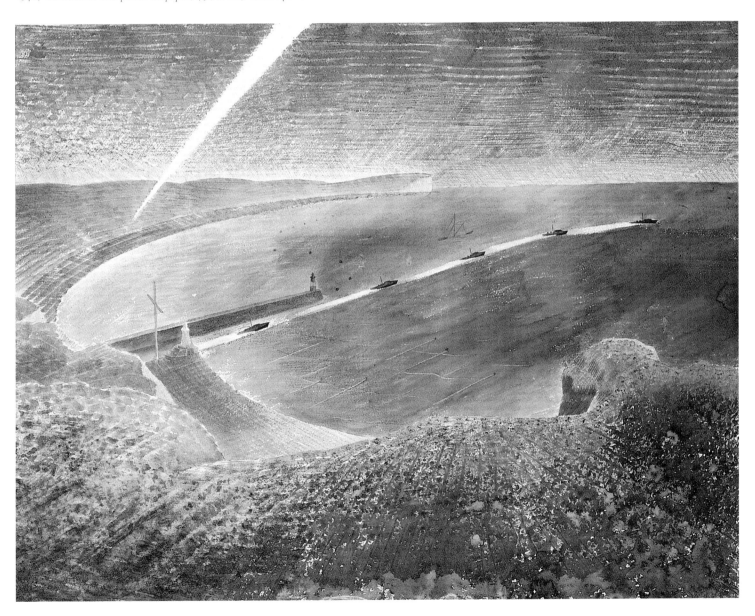

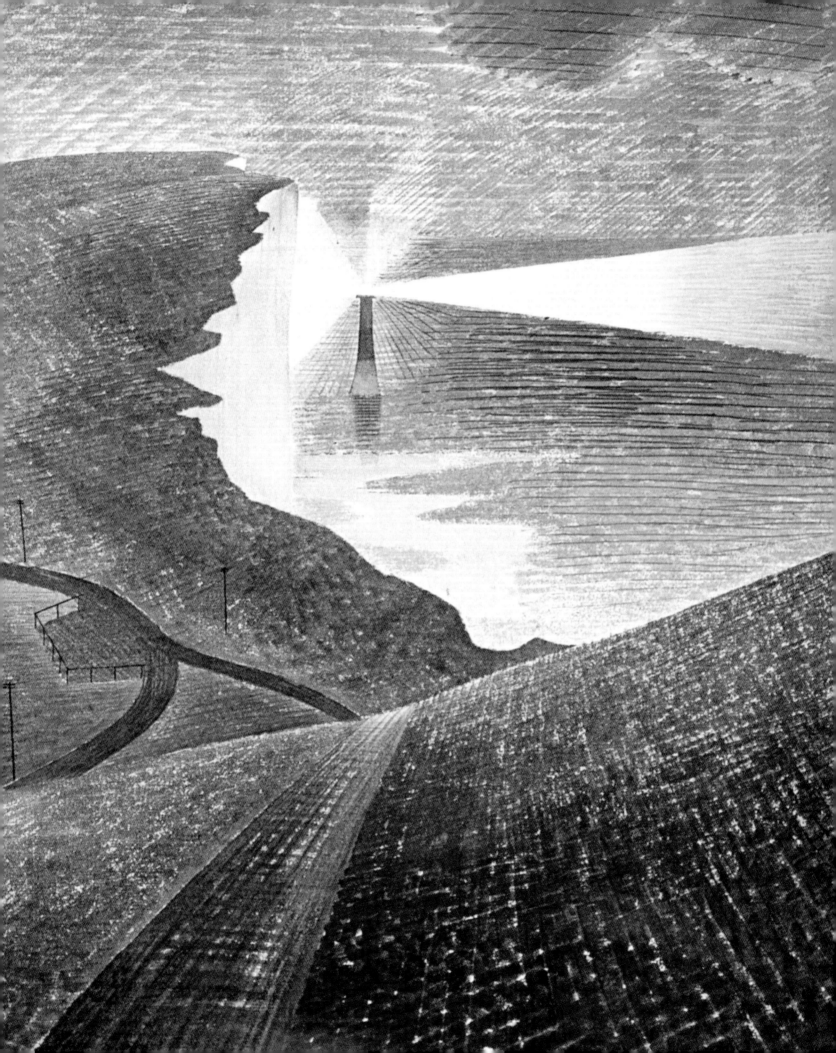

DARKNESS & LIGHT

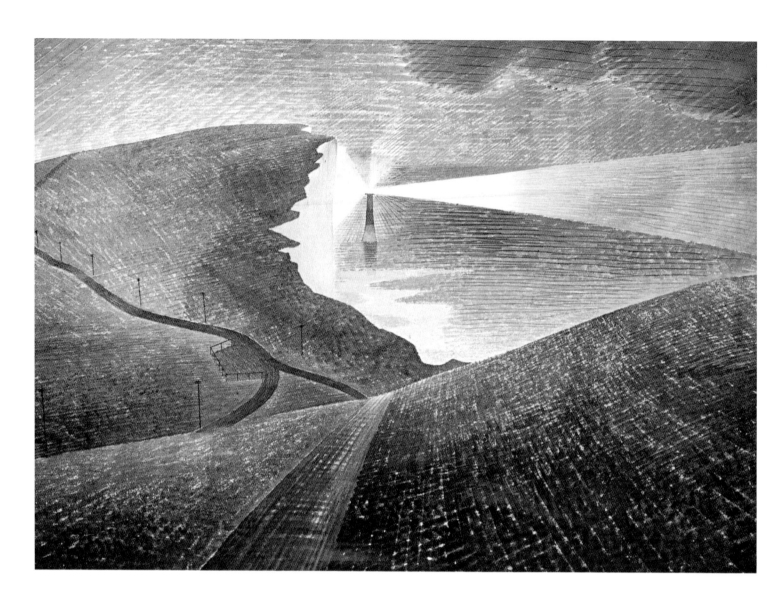

BEACHY HEAD

1939, watercolour and pencil on paper, 57.1 × 72.7 cm, private collection.

According to his friend and fellow artist Douglas Percy Bliss, Ravilious spent his student years 'educating himself, finding in the indigestible superabundance of the great city's art the particular nourishment he needed ... In the great dish of Art confronting us in South Kensington, like Mrs Todgers, he "dodged about among the tender pieces with a fork".'[55] This he continued to do, visiting gallery exhibitions and returning repeatedly to the print rooms of London museums, throughout his life.

Although confessing admiration for only a few artists, he saw and absorbed the work of many, both dead and living, British, European and Asian. The beams of light from the lighthouse here have the geometric elegance of Nevinson's *Bursting Shell*, but the lighthouse is only part of the story; it does not dominate the scene but instead appears small and rather human compared to the vast, uneven geometries of the cliffs.

Another artist might have stressed the contrast between light and dark. Instead this vision of night on the south coast is alive with points and glimmers of light, like a modern version of an engraving by Blake or Palmer.

BELLE TOUT INTERIOR

1939, watercolour and pencil on paper, 42.5 × 57.2 cm, private collection.

Given that he had included lighthouses in so many of his coastal paintings, Ravilious must have been delighted when asked to paint inside the lantern of the former Belle Tout lighthouse. When the new Beachy Head lighthouse was built down on the coast the old one was sold off and became a private house, and evidently the disused lantern was done up as a sort of summer house.

The early spring of 1939 was bitterly cold but bright. Staying in Eastbourne with his parents and working flat out on paintings for the Tooth's exhibition in May, Ravilious made studies of Beachy Head lighthouse by night while spending the days working on this watercolour. Painted from almost the same spot, it makes a playfully contrasting companion piece to *Beachy Head*, with bright sunlight bursting *into* the lantern, but both paintings show equal daring and technical ability. The composition here is outrageously bold, the surfaces of land and sea dappled and striated, and the sun's rays almost a physical presence. Towards the lower right of the painting, where the sunlight is brightest, details are left unfinished, as if the bright light makes them too difficult to see.

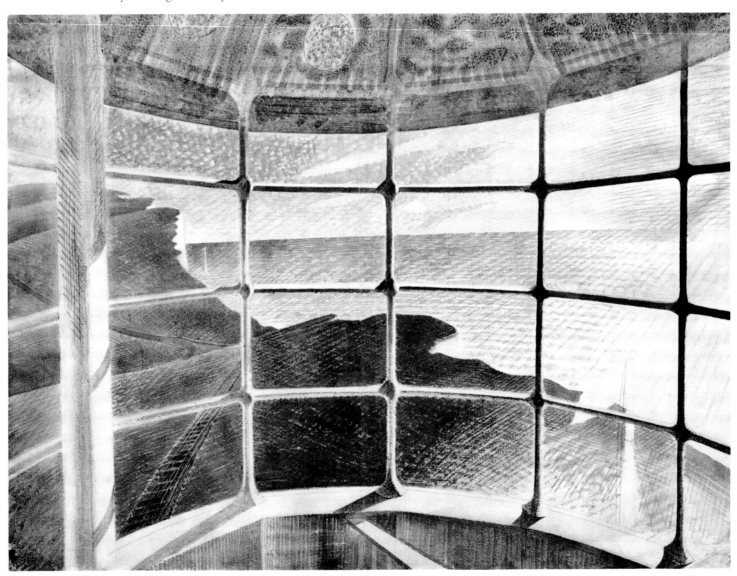

LIFEBOAT

1938, watercolour and pencil on paper, 43 × 52 cm, private collection, courtesy of Towner, Eastbourne.

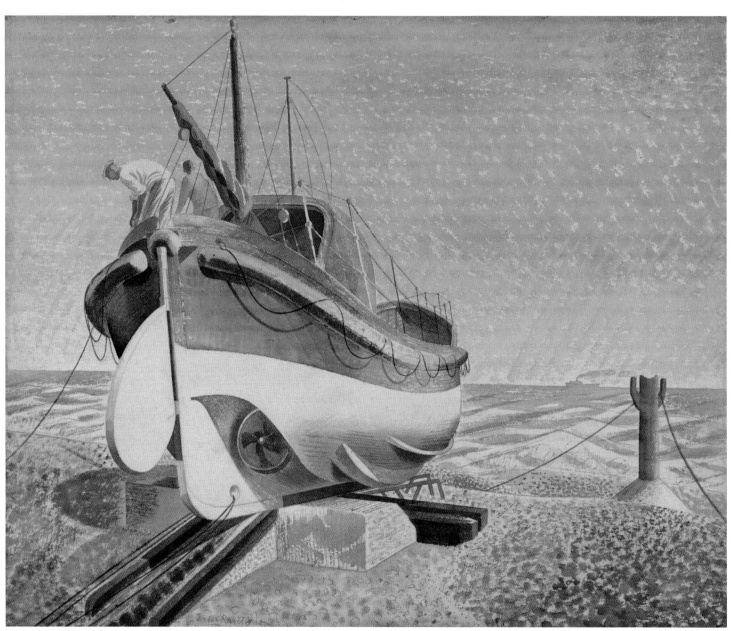

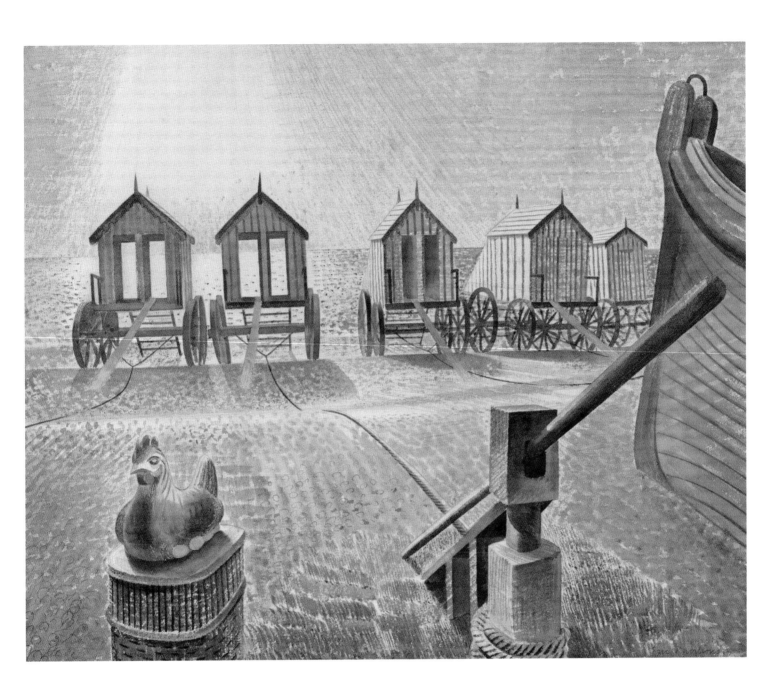

BATHING MACHINES

1938, watercolour and pencil on paper, 44 × 52.2 cm, private collection, courtesy of Towner, Eastbourne.

What inspires an artist to paint in the way he or she does? Or to change the way they paint? Tirzah believed that there was a link between her husband painting in a brighter key and his relationship with Diana Tuely, and the evidence tends to support her view. Their reunion in the summer of 1938 coincided with a step up in his work. The compositions grew bolder, the colours stronger and the treatment of light more inventive.

In late August Ravilious spent a weekend in Aldeburgh, Suffolk. Of his stay about the only thing we know is that he slept on a sofa; there is no mention in his surviving correspondence of the bright blue lifeboat, or of the bathing machines which he studied with such evident pleasure.

BATHING MACHINES, ALDEBURGH

1938, watercolour and pencil on paper, 41 × 52 cm, Daniel Katz Gallery, London.

Here we see the same bathing machines approached in a different way; the composition is centred on the parking sign and its shadow, around which the other objects (and the attendant) are carefully arranged so that the eye keeps moving from one to the next as if around a dial. An important feature of Edwardian seaside culture, bathing machines enabled people to enter and leave the water unobserved. As a boy Ravilious would have seen them on the beach at Eastbourne, but by the late 1930s these eccentric wheeled tents were a rarity; so too were seaside curiosities like the chicken – in fact a vending machine filled with egg-shaped chocolates.

Dawn was this artist's preferred time for outdoor work, and in many watercolours it is the radiant early morning light that seems his true subject. The striated iridescent sky would become a feature of Ravilious's finest wartime paintings, but this is peacetime, and the scene is set for a holiday.

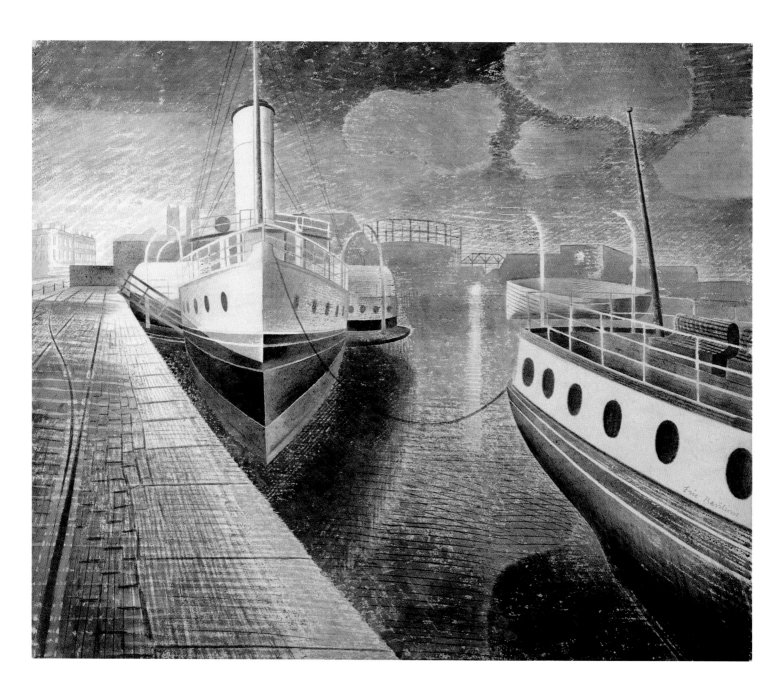

PADDLE STEAMERS AT NIGHT

1938, watercolour and graphite on paper, 45.7 × 53.3 cm, The Mercer Art Gallery, Harrogate Borough Council.

Is it surprising that Ravilious did not paint at night more often? Night, like winter, offered a world stripped bare, with colours simplified and a good deal of extraneous detail dimmed out. We might expect him, as an admirer of Samuel Palmer, to have painted by moonlight, but, unlike the sun, the moon is a rare visitor in his work. Those few nocturnal subjects that he did paint are generally lit artificially.

In November 1938 John Nash took him to Bristol, where they stayed on Cornwallis Crescent and descended the hill after dinner to draw the paddle steamers moored up for the winter. In those days the city docks buzzed with activity by day and by night, under blazing electric lights, enabling Ravilious to create a watercolour that is almost monochrome: a clean design in black and white that might without too much difficulty have been turned into a wood engraving.

A designer's eye is evidently at work. Look, for instance, at the bow of the vessel facing us. The right-hand side is shadowed, the left brightly lit, and yet we see an alternating pattern of dark and light areas centred on the impossibly fine line of the bow itself. This is recognizably pre-war Bristol, but in contrast to *River Thames at Hammersmith* the painting is less a document of a time and place than a work of art that endeavours to transcend history.

TRAIN GOING OVER A BRIDGE AT NIGHT

c. 1935, watercolour and pencil on paper, 40 × 50 cm, private collection, courtesy of Towner, Eastbourne.

Although not generally known for his bold palette, Ravilious did use yellow to striking effect in a number of paintings, often contrasting a single bright object – a propeller, a funnel or a biplane – with a muted background. This is the case here, with yellow adding the excitement of electric light to a night-time scene. A pale blurring between the windows of the train helps to convey a sense of motion, but the scene stealer is the great plume of smoke, lit perhaps by the fire within, billowing out and back in the most natural way.

This is reminiscent of the fiery smoke plumes which provide such bold decoration to the prints of paddle steamers on the Mississippi produced by Currier and Ives; Ravilious owned one, and it hung on the wall at Bank House, Castle Hedingham, a few hundred yards from the scene of this painting.

NOVEMBER 5TH

1933, watercolour and pencil on paper, 70.5 × 96.5 cm, private collection.

This strange and wonderful painting was created in the aftermath of the Morley College commission and may have been intended as a study for a mural. As with the earlier work it shows an exuberant creative mind at work, transforming the annual ritual of Bonfire Night into an anarchic urban spectacle.

Among Ravilious's favourite books was *A History of Fireworks* by Alan St Hill Brock, whose family first began manufacturing fireworks in London in the late seventeenth century. That was the age of the capital's first great displays, when aristocrats vied to create the biggest spectacle and artists sought ways of conveying the momentary excitement of an exploding firework. One particularly impressive illustration shows the Duke of Richmond's display on the Thames in May 1749, with long-stemmed flowers of light not unlike those in the background here.

Likewise the 1749 illustration shows every firework going off simultaneously, but there the resemblance ends. There is nothing formal about the Ravilious display, nothing controlled. As Tirzah recalled later, 'He loved occasions such as the Coronation or Guy Fawkes' night for their fun and their unexpected beauties – children dancing round in a circle in the dark, waving sparklers.'[56]

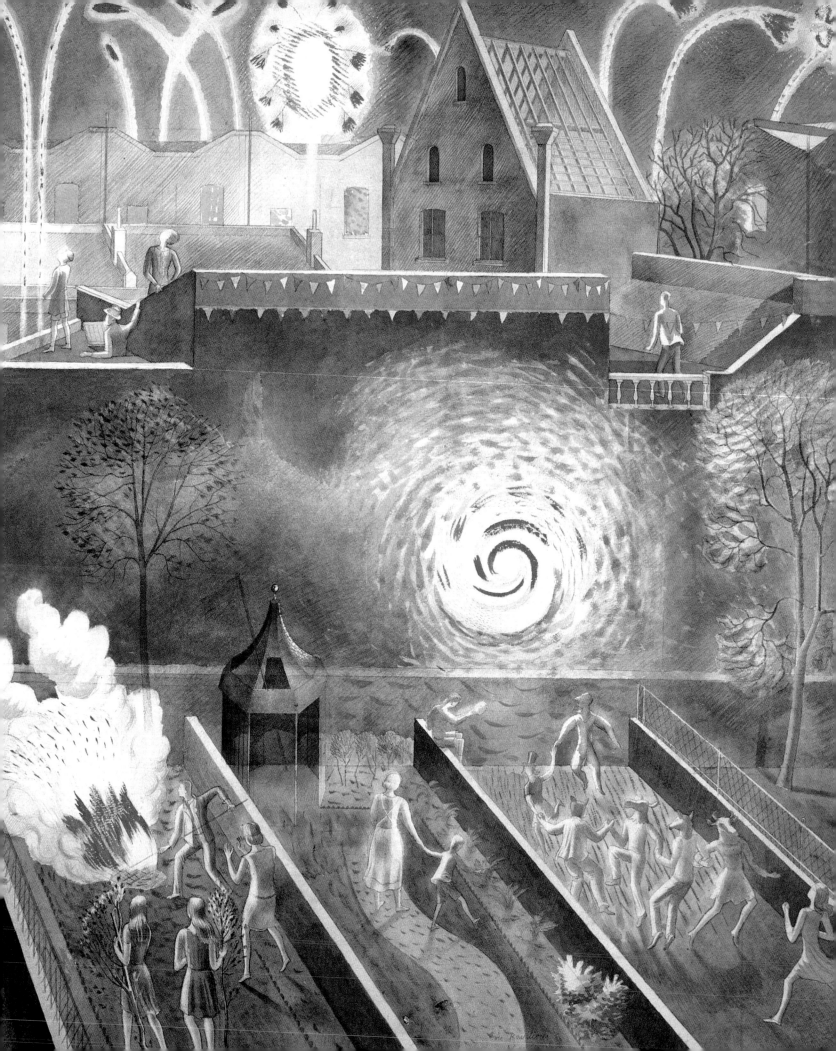

HMS ARK ROYAL IN ACTION

1940, watercolour and pencil on paper, 43.5 × 58 cm, Imperial War Museum.

The aircraft carrier HMS *Ark Royal* fires a broadside during the retreat of Allied forces from Narvik on 9 June 1940. A second carrier, HMS *Glorious*, had been sunk by enemy fire the night before, and there was no guarantee that there would not be further losses. But while there is more smoke and fire than in the later painting of coastal artillery in action, the blaze of guns in the Arctic night is still a thing of beauty.

Ravilious himself likened wartime explosions to fireworks, and this is in one sense a glorious firework display, four white-hot balls of flame haloed by clouds of orange smoke.

It is the spectacle he is drawn to, rather than the military significance of the moment, which is why he was less a war artist than an artist who happened to find himself caught up in a war. His work is closer in spirit to John Piper's paintings of Coventry Cathedral in ruins than to Edward Ardizzone's wartime sketches, since he continued to be inspired in wartime by the same strange, decorative subjects that had caught his attention in peacetime. Here, the intensity of the moment comes over not in blood-and-guts realism but through the vivid contrast of dark and light.

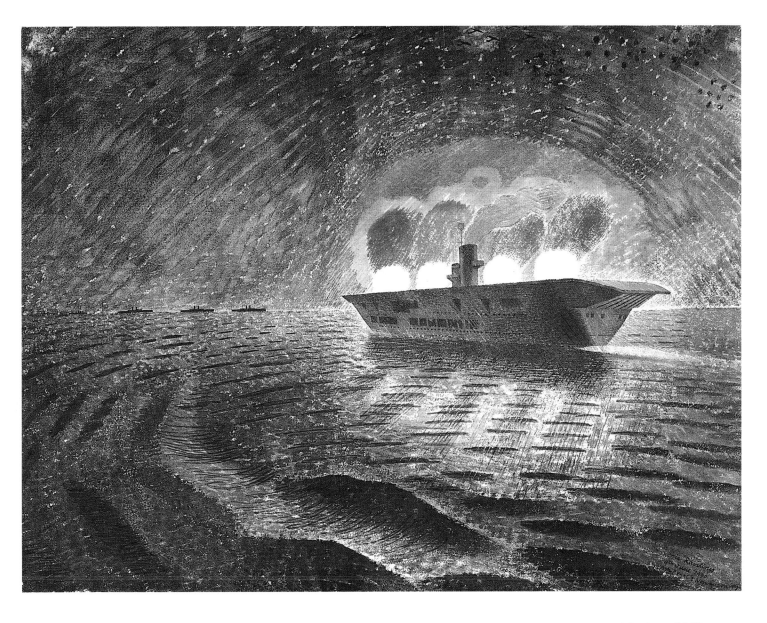

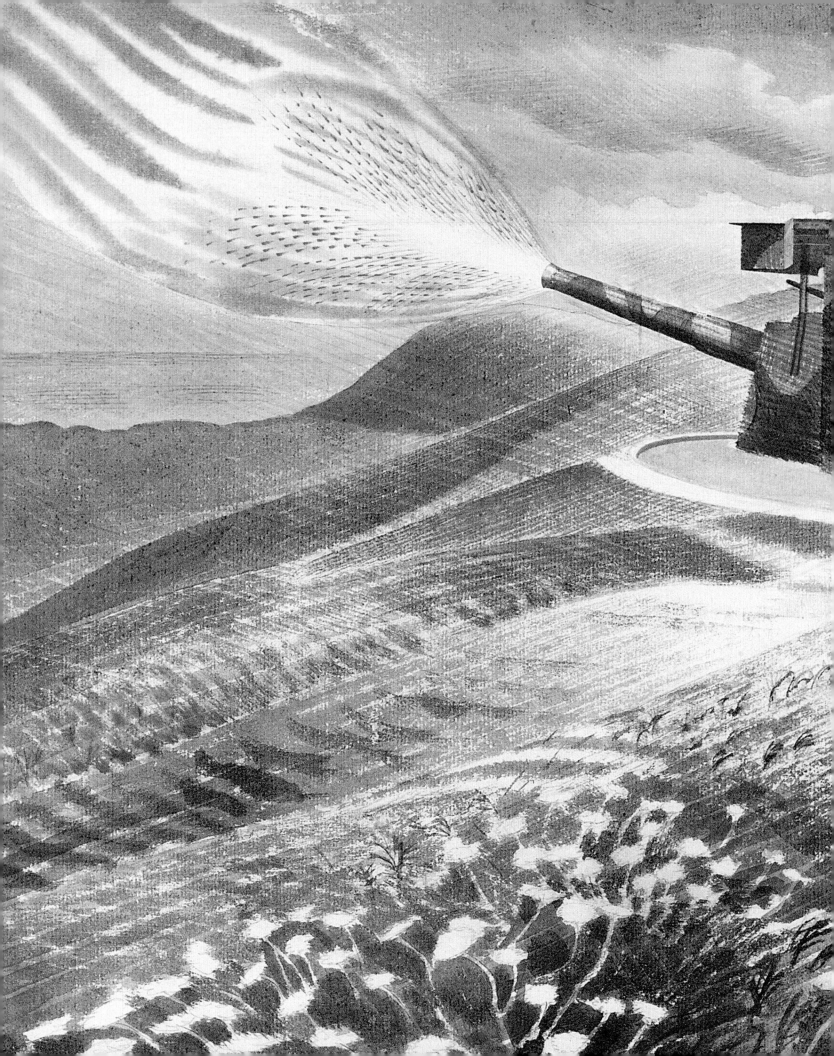

FIRING A 9.2 GUN

1941, watercolour and pencil on paper, 41.2 × 52.7 cm, Imperial War Museum.

Not long after his appointment as a war artist, Ravilious visited John Nash and found Barnett Freedman there too. The three friends hammed it up for the camera in their new uniforms (see p. 160), and when Freedman complained that the War Office had refused his request for a gun, Ravilious offered him his whistle instead.

The title of the painting may give the impression that Ravilious was fascinated by ordnance, but the picture itself must have left artillerymen scratching their heads. Gunfire is all smoke, noise and confusion, but there is no smoke here, just a flower of flame – a momentary spectacle preserved in a stylized form. Delicately structured, almost feather-like, the flame resembles eighteenth-century etchings of firework displays, but it is powerful as well as being decorative. This flame seems alive, even wrathful. Had William Blake ever painted a 9.2 gun in action, the result might have looked something like this.

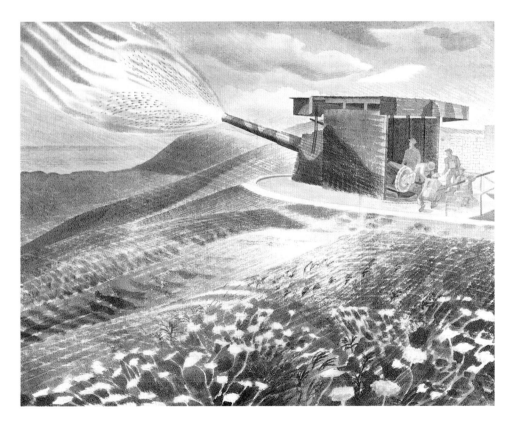

RYE HARBOUR

1938, watercolour and pencil on paper, 42.2 × 50.8 cm, The Ingram Collection of Modern British and Contemporary Art.

Like many other small ports and seaside towns, Rye Harbour enjoyed a boom in popularity among artists in the 1930s. Alongside the widespread interest in landscape painting was a related vogue for nautical style; both phenomena grew out of a renewed fascination for British places and customs, inspired partly by the new hobby of motor-touring. John Piper was both the author of an influential magazine feature on nautical style and an occasional visitor to Rye Harbour, and he probably suggested Ravilious visit the port.

There he met Edward Le Bas, a wealthy artist (elected to the RA in 1954) and collector who had a house nearby. Though much younger than them, he had become a great champion of the Camden Town Group, particularly Harold Gilman and Charles Ginner, and also had a formidable collection featuring Edouard Vuillard, whose paintings his own work emulated.

He bought this painting on the spot, drawn perhaps to the wonderful representation of light on water and the sense of distance melting into nothingness.

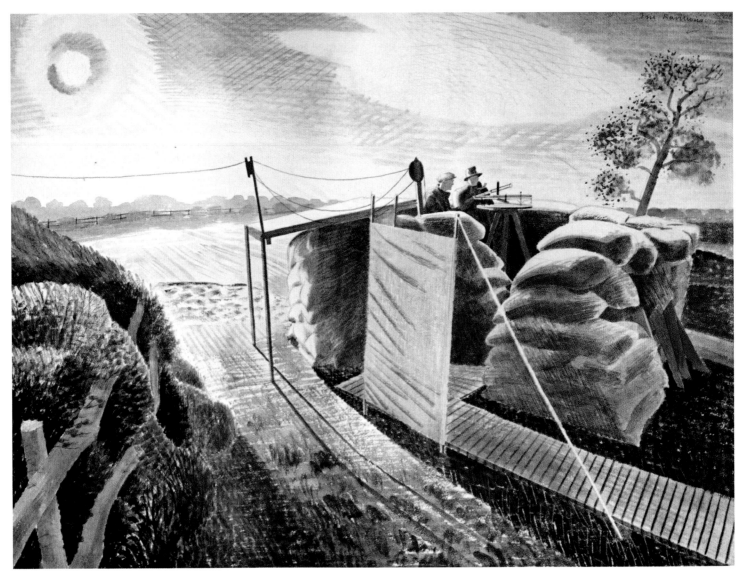

OBSERVER'S POST

1939, watercolour and pencil on paper, 57.7 × 72.4 cm, Cecil Higgins Art Gallery, Bedford.

Geometric shapes and angles played an important part in Ravilious's work, contributing structure, tension and sometimes a sense of urgency. In *Morning on the Tarmac*, for example, the wings of the furthest Walrus aircraft and the shadow of those wings generate a pair of converging lines that frame the group of airmen. If we look again at that shadow we see that it is in the wrong place, relative to the sun, but it fits perfectly within a composition that is made as much of shadows as it is of concrete things. We are caught up in the play of light and shadow, our gaze held within the picture, and an ordinary morning in wartime is preserved.

Painted at the very beginning of the war, *Observer's Post* achieves the same purpose in a different way, by shining the floodlight of dawn over a most peculiar scene. Leaving aside the sandbags and wires, these two men might be scientist friends of Gilbert White, studying some cosmic event in Selborne. It's hard to believe that they are the eyes and ears of Britain's air defence, observing aircraft with the aid of a sextant-like device called simply 'the Instrument'.

MORNING ON THE TARMAC

1941, watercolour and pencil on paper, 49.5 × 54.6 cm, Imperial War Museum.

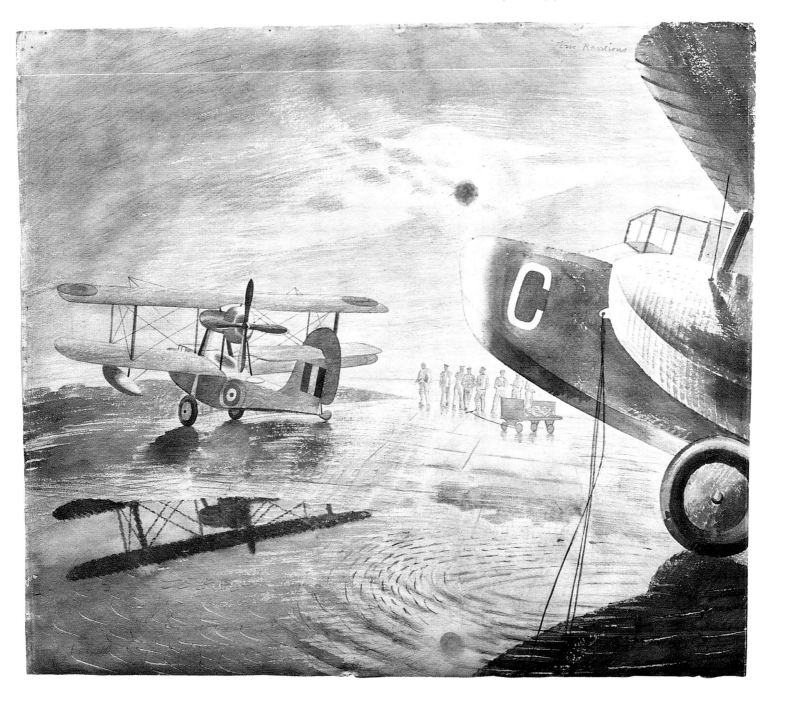

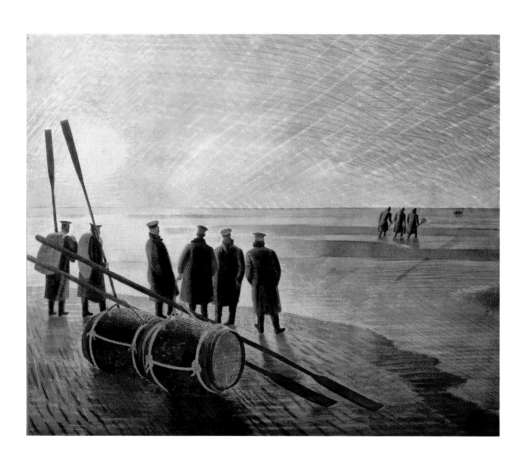

DANGEROUS WORK AT LOW TIDE

1940, watercolour and pencil on paper, 67 × 75.5 cm, Ministry of Defence Art Collection.

Two stories are told in this mesmerizing wartime watercolour. Within the frame of the picture itself we see a group of men watching three others walking towards a distant object. This trio are Commander Edward Obbard, Lieutenant Harold West and Lieutenant Commander G.A. Hodges, an expert in mine disposal, and the object ahead of them in the shallows is a magnetic mine dropped off Whitstable Sands by a German aircraft. Instead of blowing up a British ship it had washed up here, and Ravilious was on hand to record the moment when it was successfully made safe.

So this painting documents a dramatic moment, but what of the second story? This concerns the painter, who, having endured a trying few weeks among the admirals and sentries of Chatham Dockyard, saw this outing to Whitstable at dawn as an adventure, and an opportunity to continue his study of light effects. Look at that sky, the sun a ball of pale fire, the sky striped with rays and then scratched over vigorously in pencil to suggest the haze of early morning.

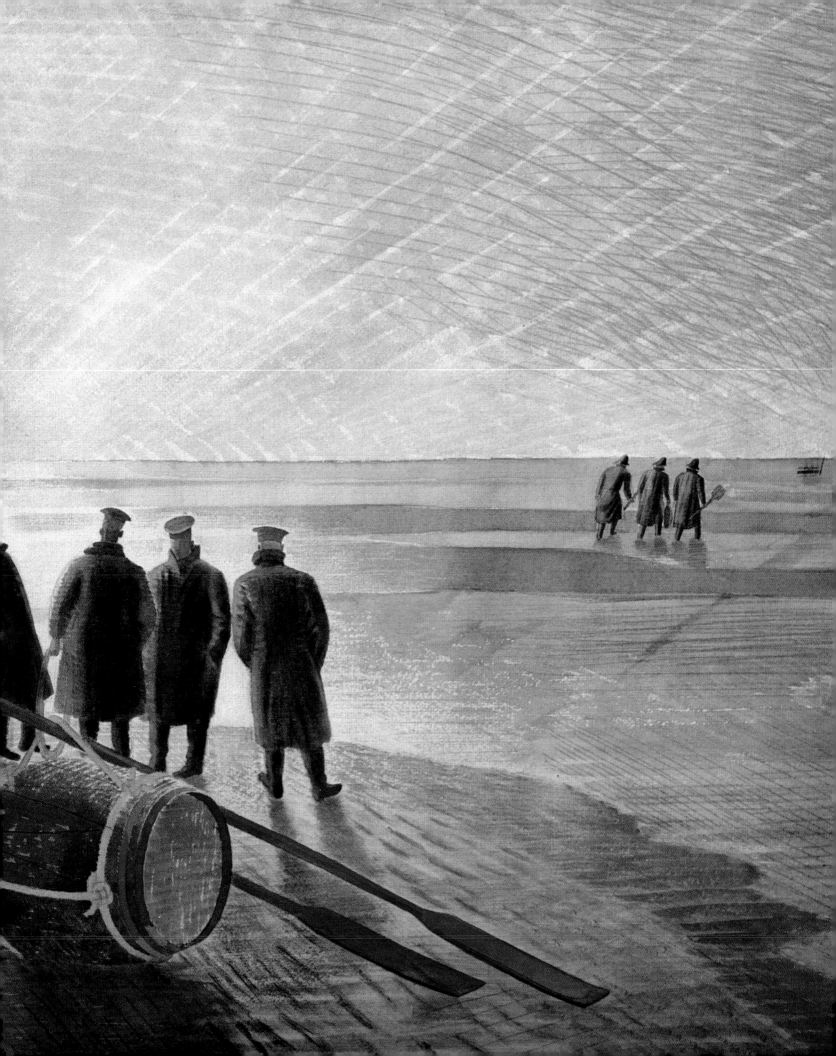

MIDNIGHT SUN

1940, watercolour and graphite on paper, 47 × 59.1 cm, Tate: presented by the War Artists Advisory Committee 1946.

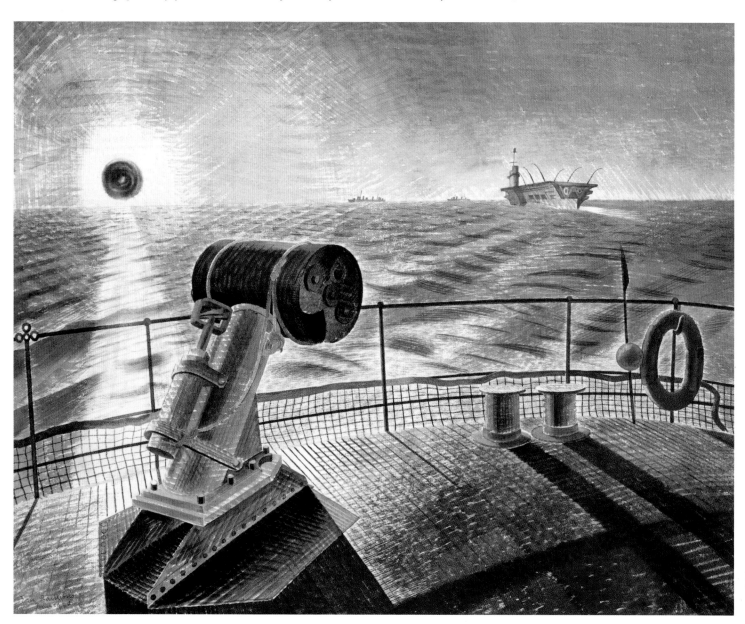

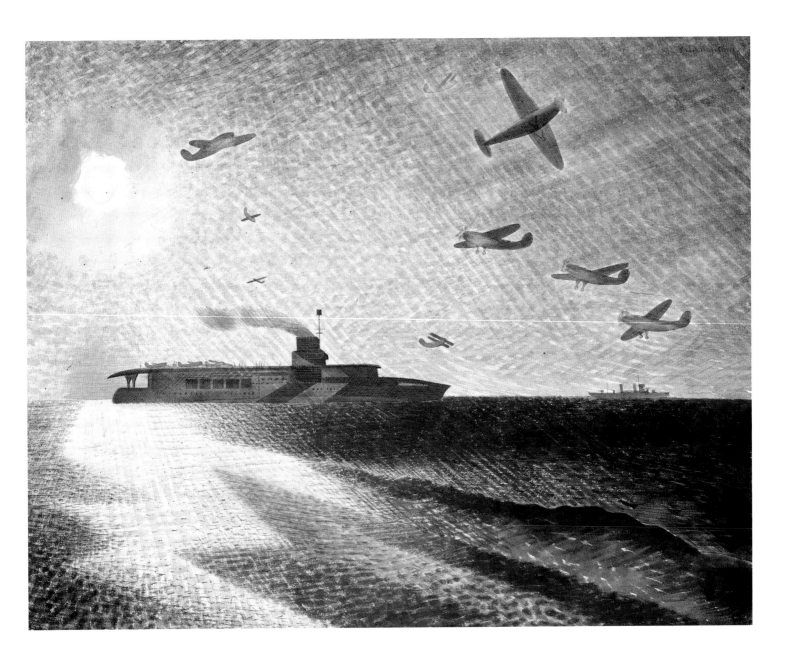

HMS GLORIOUS IN THE ARCTIC

1940, watercolour and pencil on paper, 45 × 56.8 cm, Imperial War Museum.

Produced in spite of 'excitements from above and below' during the voyage to Norway in the early summer of 1940, these paintings show Ravilious rather more interested in the marvellous Arctic light than in ships and aircraft. In *HMS Glorious* light jags across the dappled surface of the water, playfully echoing the aircraft carrier's camouflage, while the sun itself is surrounded by a great yellow aura.

Rarely did he get as close to the intense solar symbolism of a late Paul Nash painting as he does in *Midnight Sun*, but typically the precise representation of machinery keeps the sublime at bay; a depth charge on its launcher points (for compositional rather than military reasons) towards HMS *Ark Royal*. An accompanying letter, written after the artist's safe return to British waters, suggests that he had enjoyed his trip to the far north. 'We have been in the Arctic as high as 70 30 ... I simply loved it, especially the sun. It was so nice working on deck long past midnight in bright sunshine. It never fell below the horizon.'[57]

NORWAY

1940, watercolour and gouache on paper, 45.1 × 55.9 cm, Laing Art Gallery, Newcastle upon Tyne (Tyne & Wear Archives and Museums).

At a party in the early summer of 1942, Ravilious met Kenneth Clark, Director of the National Gallery and Chairman of the War Artists' Advisory Committee, who praised his Norwegian paintings and agreed that he should return to the Arctic. It would be fascinating to know which of the pictures Clark admired most, since this one is quite different from the rest, with a grandeur that the artist rarely aspired to, and a cold beauty that anyone who has visited the region will recognize as authentic.

The surface of the water has almost as much light in it as dark, but it is a cold light from a hidden sun, and the grey sky above is troubled by jagged shapes and brooding shadows. Ravilious described the painting simply as 'gloomy',[58] but to those who know his work intimately this watercolour ranks among his best. It was produced under the most difficult conditions, in physical and emotional terms, but for an artist fascinated by light effects of a certain kind – found, for example, in a downland winter dawn – and able to absent himself from the terrors of war, such constraints meant nothing compared to the excitement of discovering this extraordinary new world.

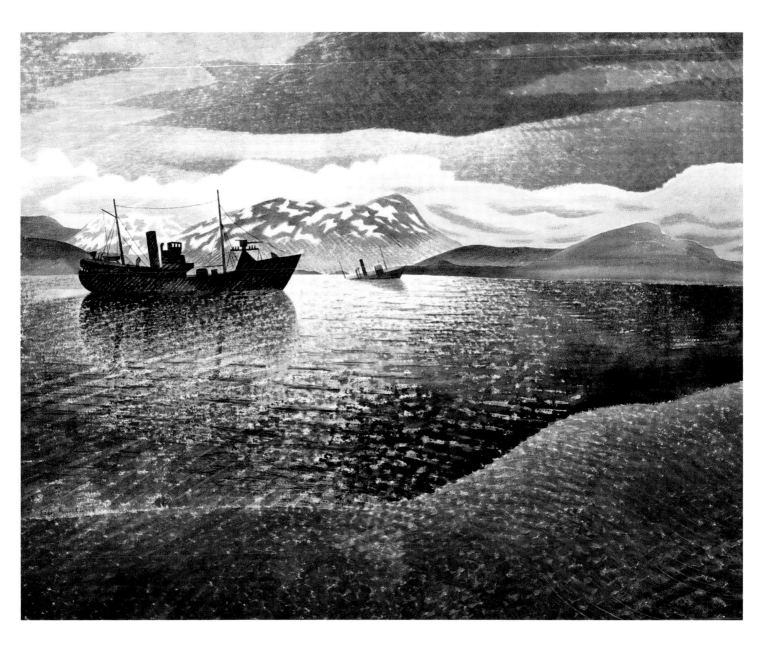

EXHIBITIONS

ZWEMMER GALLERY, 1936

1 Kirby Hall Fields
2 Dolly Engine
3 Coalyard
4 *Caravans*
5 *Cyclamen and Tomatoes*
6 *Vicarage*
7 Hull's Mill
8 Cucumber House
9 Newhaven Harbour
10 *Mount Caburn*
11 Halstead Road in Snow
12 Baker's Cart
13 Cab
14 Lombardy Poplars
15 Floods at Lewes
16 *Vicarage in Winter*
17 Chalk Paths
18 Lighthouses at Newhaven
19 Waterwheel
20 'The James' and 'The Foremost Prince'
21 Poultry
22 Backgardens
23 Brickyard
24 Dredgers
25 *Winter Landscape, Sussex**
26 Garden Path
27 *29 Bus*
28 Alpha Cement Works
29 Friesian Bull
30 Two Cows
31 Lane in Sussex
32 Channel Steamer Leaving Harbour
33 *Furlongs*
34 *Talbot-Daracq*
35 'Brighton Queen' at Night
36 Decoration for Wall Painting
37 Design for Decoration on Glass

ARTHUR TOOTH & SONS, 1939

1 New Year Snow
2 *Rye Harbour*
3 *Wet Afternoon*
4 Cliffs in March
5 *The Duke of Hereford's Knob*
6 Mackerel Sky
7 Hill Farm
8 *Anchor and Boats*
9 *Waterwheel*
10 Salt Marsh
11 Hedingham Sandpit
12 *Lifeboat*
13 Late August Beach
14 *Beachy Head*
15 Lighthouse and Fort
16 *Room at the 'William the Conqueror'*
17 *Paddle Steamers at Night*
18 *Farmhouse Bedroom*
19 Dungeness
20 *Cuckmere Valley*
21 *Early Morning on the East Coast***
22 *Wiltshire Landscape*
23 *Aldeburgh Bathing Machines*
24 *Geraniums and Carnations*
25 Bristol Quay
26 Pilot Boat
27 *Yellow Funnel*

Paintings in italics included in the 2015 Dulwich exhibition

* known today as *Downs in Winter*.
** Probably the painting known for many years as *Aldeburgh Bathing Machines*, until that painting (above) came up for auction, complete with Tooth's label, in 2014.

TIMELINE

1903	22 July: Eric Ravilious born at 90 Churchfield Road, Acton, London
1907	Ravilious family living in Hampden Park, Eastbourne, East Sussex
1914	Began studying at Eastbourne Boys' Municipal Secondary School
1919	Awarded a scholarship to Eastbourne School of Art
1922	Autumn: scholarship to Design School of Royal College of Art, resulting in friendships with Edward Bawden, Douglas Percy Bliss, Helen Binyon, Peggy Angus, Cecilia Dunbar-Kilburn, Barnett Freedman and Henry Moore
1924	Summer: passed diploma exam with distinction and awarded Design School Travelling Scholarship to Italy
	Autumn: returned for a final year at Royal College; taught by part-time tutor Paul Nash, who encouraged interest in watercolour and shared his technical know-how
1925	Teaching part-time at Eastbourne School of Art where he met Tirzah Garwood, a talented student
	Proposed by Paul Nash for membership of the Society of Wood Engravers, and accepted
1926	Wood engravings for *Desert*, by Martin Armstrong (Jonathan Cape)
1927	Watercolours exhibited at St George's Gallery, London, first in May with Modern English Watercolour Society, then in October with Edward Bawden and Douglas Percy Bliss
1928	Commissioned with Edward Bawden to paint murals in the refectory at Morley College; work began in September
1929	Numerous wood engravings published, including illustrations for Lanston Monotype Corporation *Almanack*
1930	February: Morley College murals officially opened by Stanley Baldwin, amid widespread publicity
	July 5: following engagement in January, Eric and Tirzah married in London; honeymoon in Cornwall, followed by move to the top-floor flat, 35 Stratford Road, Kensington, London
	Cycling tour of north-west Essex with Edward Bawden culminated in the discovery of Brick House, Great Bardfield

18 Cecilia Dunbar-Kilburn, Eric Ravilious and Anthony Betts in the RCA Common Room, *c.* 1924.

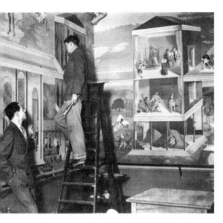

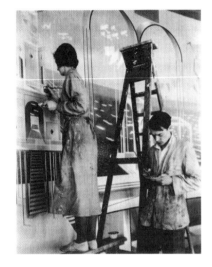

Teaching part-time at Royal College and at Ruskin School, Oxford

1931 Move to ground floor flat at 48 Upper Mall, Hammersmith, overlooking the River Thames; first letter written from Brick House

Working on wood engravings for Golden Cockerel Press edition of *Twelfth Night*

1932 Living part-time in Great Bardfield with Charlotte and Edward Bawden

Exhibited in Paul Nash's design exhibition *Room and Book*, at Zwemmer Gallery, London

1933 Numerous wood engravings, including illustrations for *The Famous Tragedy of the Rich Jew of Malta* (Golden House Press)

Spring: travelled with Tirzah to Morecambe, to paint murals in the circular tea room of the new Midland Hotel; the hotel opened in July

November: first one-man exhibition at Zwemmer Gallery featured 36 watercolours painted mostly in London and Essex

First meeting with Diana Low in Great Bardfield

1934 Spring: invited by Peggy Angus to stay at Furlongs, her cottage in the South Downs between Lewes and Eastbourne; repeated visits through the year saw a rapid development in watercolour technique, while friendship with Helen Binyon developed into a love affair

Repairs to Midland Hotel murals, and new murals at Colwyn Bay Pier Pavilion

Discovery and renovation of two Boer War-era caravans, used subsequently as accommodation at Furlongs

Autumn: move from Brick House, Great Bardfield, to Bank House, Castle Hedingham; gave up flat in Hammersmith

1935 Numerous wood engravings published, including illustrations for *The Hansom Cab and the Pigeons* by LAG Strong (Golden Cockerel Press)

Opening of design emporium Dunbar Hay by Cecilia Dunbar-Kilburn

21 June: birth of John Ravilious (who died in 2014)

August: painting expedition to Newhaven with Edward Bawden

1936 February: second one-man exhibition at Zwemmer Gallery, featuring 35 watercolours painted mostly in Essex and Sussex

First ceramic designs for Wedgwood, including the Coronation mug designed initially for the Coronation of Edward VIII, and amended after the Abdication

First lithograph, *Newhaven Harbour*, at Curwen Press, Plaistow

1937 Gave up teaching

Designed *Tennis* exhibit for the British Pavilion of the Paris International Exhibition, and also the catalogue cover

Working on *High Street*, which was now to be illustrated with lithographs, rather than wood engravings as originally envisaged

1938 Last major set of wood engravings, to illustrate *Gilbert White of Selborne* (Nonesuch Press)

Publication of *High Street*, to favourable reviews

End of affair with Helen Binyon and renewed acquaintance with Diana Low, now Tuely

Winter: prolonged stay in Capel-y-ffin, Wales, and painting with renewed vigour despite poor weather; visited by John and Myfanwy Piper

Summer/autumn: travelled in search of 'a good place' to Wittersham (Kent),

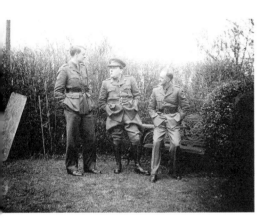

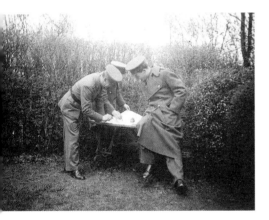

Tollesbury (Essex), Aldeburgh, Rye Harbour and Dungeness, the resulting watercolours showing a new boldness of vision

November: trip to Bristol with John Nash; narrowly avoided being run over by a train in the City Docks

1939 Spring: painting on Beachy Head, near Eastbourne, and then in Le Havre, France

May: Third major exhibition of watercolours, at Arthur Tooth and Sons, with 27 works painted during previous year's travels; enthusiastic reviews in *The Sunday Times* and *The Observer*

August: last visit to Furlongs

22 August: birth of James Ravilious (who died in 1999)

3 September: at declaration of war volunteered for the Observer Corps in Castle Hedingham, having been dissuaded by John Nash from enlisting with the Artist's Rifles

December: whirlwind tour of Downland chalk figures

24 December: invited by the Admiralty to become an Official War Artist

1940 February: first six-month contract as Official War Artist began; posted to Chatham, and visited Sheerness and Whitstable

Spring: further postings to Hull and Grimsby

May–June: travelled aboard destroyer HMS *Highlander*, escort to HMS *Glorious* and HMS *Ark Royal* during Narvik campaign; first experience of the Arctic

Summer: paintings from Norway included in first exhibition of *War Artists' Work* at the National Gallery

Working aboard training submarine at HMS *Dolphin*, Gosport

Autumn: drawing coastal defences at Newhaven

October: Tirzah diagnosed with breast cancer

November: destruction of Morley College murals during the Blitz

1941 Winter: intense work on Submarine Lithographs at W&S Cowell, Ipswich, followed by exhibition at Leicester Galleries

25 February: death of Emma Ravilious (Eric's mother), aged 77

1 April: birth of daughter Anne Ravilious, followed by move from Castle Hedingham to Ironbridge Farm, Shalford, Essex – the rent to be paid partly in watercolours

Summer: painting coastal defences in Dover

Autumn: invited to stay with John and Christine Nash near Edinburgh. Visited May Island in the Firth of Forth, then RNAS station in Dundee, and flew for the first time aboard a Walrus seaplane

1942 Spring: with the RAF in Yorkshire, but transferred to RAF Sawbridgeworth (Herts) after Tirzah underwent an emergency mastectomy

July: visit to RNAS training station, Westonzoyland, Somerset

28 August: posting to RAF station at Kaldadarnes, Iceland

2 September: volunteered to join air-sea rescue mission, which failed to return; reported missing, presumed dead, at age 39

1943 30 January: death of Frank Ravilious (Eric's father)

1948–9 *Eric Ravilious 1903–42: A Memorial Exhibition of Watercolours, Wood Engravings, Illustrations, Design etc*, Arts Council of Great Britain

1951 27 March: death of Tirzah Garwood, at age 42

NOTES

Unless indicated otherwise, letters written before the end of 1939 are published in *Eric Ravilious: Landscape, Letters and Design*; letters written from September 1939 to September 1942 can be found in *Ravilious at War*.

1. Eric Newton, 'Eric Ravilious: Personality in Watercolour', *In My View*, Longman, London, 1950, p. 109 (originally appeared in *The Sunday Times*, 21 May 1939).
2. Jan Gordon, 'Influences and Fusion', *The Observer*, 14 May 1939, p. 14.
3. Astonishingly, there is not even a mention of Ravilious in the index to the 400-page *English Art 1870–1940*, written by Dennis Farr as part of the *Oxford History of English Art*, Oxford University Press, Oxford, 1978.
4. 'They wanted me to go to Alexandra Palace and take some drawings to televise (with one of those Wireless comperes – Tell me, Mr Ravilious, do you prefer working by night?): I thought no, not in this heat.' Ravilious to Diana Tuely, 3 June 1939.
5. In an undated letter of 1942, Ravilious told Richard Seddon that he had 'a tendency to paint in sequences (groups of broken down tractors and old cars and buses in fields, the discarded machinery of Essex) a series of Sussex hills, a set of the chalk figures such as the Aylesbury White Horse [*sic*], lighthouses, rowing boats, beds, beaches, greenhouses.'
6. Richard Seddon, Introduction, exh. cat. *Eric Ravilious 1903–42: A Memorial Exhibition of Water-Colours, Wood Engravings, Designs*, Graves Art Gallery, Sheffield, 1958.
7. John Rothenstein, 'Eric Ravilious 1903–42', *Modern English Painters*, Volume 3: *Hennell to Hockney*, Macdonald, London, 1984, p. 31.
8. Enid Marx, recollection of Eric Ravilious, in exhibition catalogue *Eric Ravilious, 1903–42*, The Minories, Colchester, 1972.
9. Tirzah Garwood, *Long Live Great Bardfield and Love To You All: Her Autobiography, 1908–43*, edited by Anne Ullmann, Fleece Press, Upper Denby, 2012, p. 223.
10. Martin Armstrong, *Desert*, Jonathan Cape, London, 1926.
11. Douglas Percy Bliss, *A History of Wood Engraving*, J.M. Dent, London, 1928, p. 225.
12. Douglas Percy Bliss, 'The Work of Eric Ravilious', *Artwork*, vol. 4, no. 13, 1928, p. 64.
13. Cecilia Lady Sempill, recollection of Eric Ravilious, in *Eric Ravilious, 1903–42*.
14. 'He often doctored paintings that went wrong and when he painted two attempts of the railway carriages on the Eastbourne and Hastings train, neither of them of which he wholly approved, I cut them up and joined together the best bits and made a satisfactory whole.' Tirzah Garwood, quoted in *Eric Ravilious: Landscape, Letters and Design*, edited by Anne Ullmann, Christopher Whittick and Simon Lawrence, Fleece Press, Upper Denby, p. 509.
15. 'Cotman's Strength and Weakness', *The Times*, 8 April 1922, p. 10.
16. Helen Binyon, *Eric Ravilious: Memoir of an Artist*, Lutterworth Press, Cambridge, 1983, p. 43.
17. Ravilious to Peggy Angus, 15 May 1939.
18. Garwood, *Long Live Great Bardfield*, p. 157.
19. Ibid., p. 141.

20. Ibid., p. 160.

21. Ravilious to Helen Binyon, 13 September 1936.

22. 'If one wanted a single word for these impressions of Mr Ravilious (on which, it seems, he has spent a year) it would be "hilarious"; there is wit and elegance, as well as gaiety, in every line.' G.W. Stonier reviewed *High Street* in his article 'Cigarette Cards of London', *New Statesman*, 19 November 1938, p. 834.

23. 'He is a fickle, impish person, but very charming.' Christine Nash described Ravilious thus in her diary, 13 October 1938, quoted in Garwood, *Long Live Great Bardfield*, p. 206.

24. Ibid., p. 204.

25. 'He has also just painted 6 stunners in the last month which is encouraging because working conditions haven't been too good.' Tirzah Garwood to Gwyneth Lloyd Thomas, 31 December 1939, quoted in ibid., p. 227.

26. 'This morning I've had an invitation to be a war artist, a sort of Christmas present from the Admiralty. It will be odd to join the Navy and see the World after being tethered to my Observation post for so long. I do look forward to it immensely.' Ravilious to his father-in-law, Colonel Garwood, 24 December 1939.

27. John Nash, recollection of Eric Ravilious, in *Eric Ravilious, 1903–42*.

28. Edward Bawden, recollection of Eric Ravilious, in ibid.

29. Helen Binyon met Ravilious near Bath in July 1942. 'It gradually came out that he had been deeply disturbed by something that had happened while he was watching a training session of the new young pilots. Their seaplanes were following each other in turn, flying in a straight line over the sea. Suddenly one of them lost control, and dived nose down into the sea. … Eric had talked to and liked the young man so suddenly drowned before his eyes. He couldn't forget the shock of it.' Binyon, *Eric Ravilious*, p. 136.

30. Quoted in Binyon, *Eric Ravilious*, p. 136.

31. Ravilious to Helen Binyon, 17 December 1940.

32. Garwood, *Long Live Great Bardfield*, p. 143.

33. Ibid., p. 142.

34. Ravilious to Helen Binyon, 28 November 1935.

35. Garwood, *Long Live Great Bardfield*, p. 158.

36. 'A water wheel (homemade by the son of the farmer out of chunks of wood and the bottoms of petrol-tins) is now almost finished and looks rather well; and a bit Chinese; also there are four geese in the picture and the time is eight in the morning.' Ravilious to Helen Binyon, 9 March 1938.

37. Ravilious to Diana Tuely, 15 March 1939.

38. Ravilious to Colonel Garwood, 15 March 1939.

39. Ravilious to Helen Binyon, 8 May 1942.

40. Ravilious to Helen Binyon, 16 June 1942.

41. Ravilious to E.M.O'R. Dickey, 11 December 1941.

42. Ravilious to Helen Binyon, 16 June 1942.

43. 'Morley College Paintings', *The Times*, 7 February 1930, p. 16.

44. Garwood, *Long Live Great Bardfield*, pp. 141–2.

45. Ravilious to Helen Binyon, 2 August 1940.

46. Garwood, *Long Live Great Bardfield*, p. 134.

47. Ravilious to Helen Binyon, 8 May 1942.

48. Garwood, *Long Live Great Bardfield*, p. 157.

49. John Rothenstein, *Modern English Painters*, Volume 3, p. 30.

50. Ravilious to Cecilia Dunbar Kilburn, 16 November 1939.

51. Ravilious to Helen Binyon, 15 January 1935.

52. Ravilious to Helen Binyon, 22 July 1938 (possibly 1939).

53. Ravilious to Helen Binyon, 28 February 1940.

54. Ravilious discussed the Wilmington Giant in his 'Preface by the Engraver', in the *Lanston Almanack 1929*, Lanston Monotype Corporation, London, 1928.

55. Douglas Percy Bliss, recollection of Eric Ravilious, in *Eric Ravilious, 1903–42*.

56. Tirzah Garwood was discussing Ravilious's life and work for 'In Memoriam', broadcast by the BBC Third Programme on 20 January 1948. The transcript was subsequently published in *Cockalorum*, Golden Cockerel Press, London, 1950, p. 81.

57. Ravilious to Helen Binyon, 30 May 1940.

58. Ravilious to Helen Binyon, 19 June 1940.

SELECT BIBLIOGRAPHY

CATALOGUES

Eric Ravilious 1903–42: A Memorial Exhibition of Watercolours, Wood Engravings, Illustrations, Designs, etc., with an introduction by J.M. Richards, Arts Council of Great Britain, London, 1948

Eric Ravilious 1903–42: A Memorial Exhibition of Water-Colours, Wood Engravings, Designs, with an introduction by Richard Seddon, Graves Art Gallery, Sheffield, 1958

Eric Ravilious, 1903–42, with recollections by Edward Bawden, Douglas Percy Bliss, Cecilia Lady Sempil, Helen Binyon and John Nash, The Minories, Colchester; Ashmolean, Oxford; Morley Gallery, London; Towner Art Gallery, Eastbourne, 1972

LETTERS

Ullmann, Anne, with Christopher Whittick and Simon Lawrence, *Eric Ravilious: Landscape, Letters and Design*, Fleece Press, Upper Denby, 2008

Ullmann, Anne, with Barry and Saria Viney, Christopher Whittick and Simon Lawrence, *Ravilious at War: The Complete Work of Eric Ravilious, September 1939–September 1942*, Fleece Press, Upper Denby, 2002

BOOKS AND ARTICLES

Binyon, Helen, *Eric Ravilious: Memoir of an Artist*, Lutterworth Press, Cambridge, 1983

Binyon, Laurence, *English Watercolours*, 2nd edn, A&C Black, London, 1944

————, *The Followers of William Blake: Edward Calvert, Samuel Palmer, George Richmond and Their Circle*, Halton, London, 1925

————, *Landscape in English Art and Poetry*, Cobden-Sanderson, London, 1931

Bliss, Douglas Percy, *A History of Wood Engraving*, J.M. Dent, London, 1928

————, 'The Work of Eric Ravilious', *Artwork*, vol. 4, no. 13, 1928, pp. 64–5

Clark, Kenneth, 'War Artists at the National Gallery', *Studio*, CXXIII, January 1942

Constable, Freda, with Sue Simon, *The England of Eric Ravilious*, Scolar Press, London, 1982

Coombs, Katherine, *British Watercolours, 1750–1950*, V&A Publishing, London, 2012

Garwood, Tirzah, *Long Live Great Bardfield and Love to You All: Her Autobiography, 1908–43*, edited and with notes by Anne Ullmann, Fleece Press, Upper Denby, 2012

Gordon, Jan, 'Influences and Fusion', *The Observer*, 14 May 1939, p. 14

Neve, Christopher, *Unquiet Landscape: Places and Ideas in 20th Century English Painting*, Faber & Faber, London, 1990

Newton, Eric, 'Eric Ravilious, Personality in Watercolour', *Sunday Times*, 21 May 1939, p. 14, republished in Eric Newton, *In My View*, Longman, London, 1950

Parkinson, Ronald, *British Watercolours at the Victoria and Albert Museum*, V&A Publishing, London, 1998

Powers, Alan, *Imagined Realities*, Philip Wilson Publishers with the Imperial War Museum, London, 2003

————, *In Place of Toothpaste: Eric Ravilious and the English Watercolour Revival*, Incline Press, Oldham, 2003

————, *Eric Ravilious: Artist and Designer*, Lund Humphries, London, 2013

Powers, Alan, with James Russell, *Eric Ravilious: The Story of High Street*, Mainstone Press, Norwich, 2008

Ravilious, Eric, 'Preface by the Engraver', *Lanston Almanack 1929*, Lanston Monotype Corporation, London, 1928

Richards, J.M., *Memoirs of an Unjust Fella*, Weidenfeld & Nicolson, London, 1980

Rothenstein, John, 'Eric Ravilious 1903–42', *Modern English Painters*, Volume 3: *Hennell to Hockney*, Macdonald, London, 1984

Russell, James, *Ravilious in Pictures: Sussex and the Downs*, Mainstone Press, Norwich, 2009

————, *Ravilious in Pictures: The War Paintings*, Mainstone Press, Norwich, 2010

————, *Ravilious in Pictures: A Country Life*, Mainstone Press, Norwich, 2011

————, *Ravilious in Pictures: A Travelling Artist*, Mainstone Press, Norwich, 2012

————, *Ravilious: Submarine*, Mainstone Press, Norwich, 2013

————, *Ravilious: Wood Engravings*, Mainstone Press, Norwich, 2013

————, *Peggy Angus: Designer, Teacher, Painter*, Antique Collectors' Club, Woodbridge, with Towner, Eastbourne, 2014

Sandford, Christopher, 'In Memoriam', featuring Tirzah Ravilious and John O'Connor, BBC Third Programme, 1948, transcript published in *Cockalorum*, Golden Cockerel Press, London, 1950

Spalding, Frances, *Ravilious at the Fry*, Fry Art Gallery, Saffron Walden, 2012

Ullmann, Anne, *The Wood Engravings of Tirzah Ravilious*, Gordon Fraser, London and Bedford, 1987

Ullmann, Anne, with Barry and Saria Viney, Christopher Whittick and Simon Lawrence, *Ravilious at War: The Complete Work of Eric Ravilious, September 1939–September 1942*, Fleece Press, Upper Denby, 2002

Ullmann, Anne, with Christopher Whittick and Simon Lawrence, *Eric Ravilious: Landscape, Letters and Design*, Fleece Press, Upper Denby, 2008

Yorke, Malcolm, *Edward Bawden and His Circle: The Inward Laugh*, Antique Collectors' Club, Woodbridge, 2007

ACKNOWLEDGEMENTS

I am indebted to Anne Ullmann for her help, advice and support, and for putting together such marvellous books about her parents. I am extremely grateful to Tim Mainstone, of the Mainstone Press, both for his help with this catalogue and for making our decade-long collaboration such an adventure.

At Dulwich I owe thanks to Sackler Director Ian A.C. Dejardin, Arturo and Holly Melosi, Chief Curator Xavier Bray, Head of Exhibitions Clare Simpson, and particularly to Exhibitions Officer Sarah Creed, who was a model of efficiency and calm throughout. It was a pleasure to work with Anne Jackson and David Hawkins of Philip Wilson Publishers, and with designer Lucy Morton.

Private owners of Ravilious watercolours were unfailingly generous, not only agreeing to live without their paintings for the duration of the exhibition but also helping with images and information. Public galleries and museums were also tremendously supportive, as they have been so often in the past. I would like to thank all those who helped to make the exhibition possible, particularly Sara Cooper and Karen Taylor of Towner, Claire Brenard of the Imperial War Museum, Nigel Weaver, Iris Weaver and David Oelman of the Fry Art Gallery, and Christopher Whittick of the East Sussex Record Office.

Of the previous authors who have written about Ravilious I am especially grateful to the late Helen Binyon and to Alan Powers. Thanks are also due to Barry and Saria Viney for their research work and to Simon Lawrence, publisher at the Fleece Press, whose books on Eric Ravilious and Tirzah Garwood are an invaluable resource.

For help, support and conversation over the years I would like to thank Robin Ravilious, Ben and Kiran Ravilious, Louis Ullmann, Tom Ullmann, Tamsin Meddings, Neil Jennings, Gordon Cooke, Robert Upstone, Wayne Bennett, David Boyd Haycock, Gemma Brace, Brian Webb, Peyton Skipwith, Drusilla Marland, Sarah Lewis, Adrian Corder-Birch, David Heath, Jonathan Mercer and Kate Fishenden.

Finally, thanks to Dayna, Miranda and Ollie, with love.

IMAGE CREDITS

INDEX